T0115664

BART SIMPSON'S TREEHOUSE OF HORROR

HEEBIE-JEEBIE
HULLABALOO

HarperPerennial
A Division of HarperCollinsPublishers

IN LOVING MEMORY OF SNOWBALL I:
WHEREVER YOU ARE, WE HOPE THERE'S A WARM
SAUCER OF MILK FOR YOU...BUT NOT TOO WARM.

BART SIMPSON'S TREEHOUSE OF HORROR HEEBIE-JEEBIE HULLABALOO.
Copyright © 1995, 1996, 1997, 1999 by Bongo Entertainment, Inc. and Matt Groening Productions, Inc. All rights reserved.
Manufactured in China. No part of this book may be used or reproduced in any manner whatsoever
without written permission except in the case of brief quotations embodied in critical articles and reviews.
For information address HarperCollins Publishers, Inc.
195 Broadway, New York, NY 10007.

HarperCollins books may be purchased for educational, business, or sales promotional use.
For information please write: Special Markets Department, HarperCollins Publishers, Inc.,
195 Broadway, New York, NY 10007.

First Edition

ISBN 978-0-06-098762-6

23 SCP 20 19 18 17

Publisher
Matt Groening

Editor/Art Direction
Bill Morrison

Managing Editor
Terry Delegeane

Director of Operations
Robert Zaugh

Production/Design
Christopher Ungar and Karen Bates

Production Assistance
Chia-Hsien Jason Ho

Legal Guardian
Susan A. Grode

Contributing Writers
Mike Allred, Neil Alsip, Peter Bagge, Paul Dini, Evan Dorkin, Bill Morrison, James Robinson, and Jeff Smith

Contributing Artists
Mike Allred, Laura Allred, Alvin White Studio, Norm Auble, Karen Bates, Tim Bavington, Jeannine Crowell Black, Luis Escobar,
Stephanie Gladden, Chia-Hsien Jason Ho, Nathan Kane, James Lloyd, Bill Morrison, Robert Oliver, Phil Ortiz, Rhea Patton,
Julius Preite, Chris Roman, Aaron Rozenfeld, Mike Sakamoto, Jeff Smith, Steve Steere, Jr., and Christopher Ungar

HarperCollins Editors
Susan Weinberg, Trena Keating, and Susan Hoffner

Special thanks to:
Annette Andersen, Serban Cristescu, Claudia De La Roca, N. Vyolet Diaz, Deanna MacLellan, Mike Rote, and Mili Smythe

TABLE OF CONTENTS

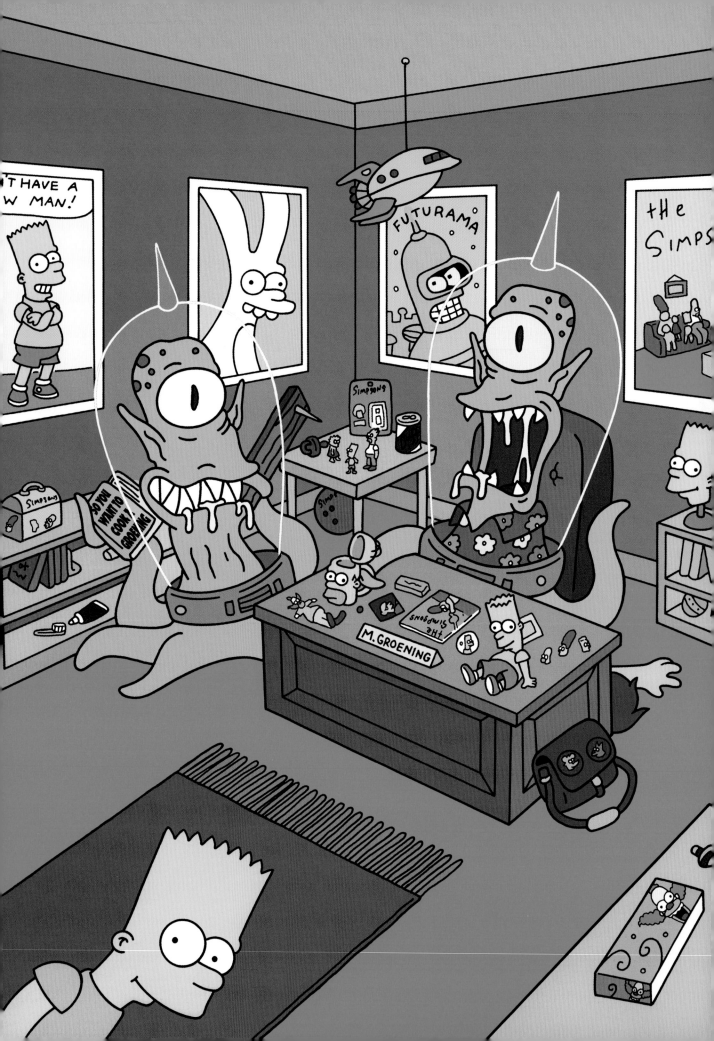

ATTENTION EARTHLINGS!

Greetings. I am the one they call Matt Groening, and this is my sister, the one they call Kodos... Groening. It is possible you have seen me before and are saying to yourselves, "Yes, he looks like Matt Groening, but something has changed." As is customary in your entertainment sector, I have had my face sliced open and reattached to enhance my appearance. Anyway, I'm definitely not shoved under this desk in a Xanthor 5134-J radiation cooking device. While you admire my appealing new exterior, I will talk to you about this book, this Heebie-Jeebie Hullabaloo.

We humans love horror. It's why you chose this book from the dispensary rather than oh, say, Defending Your Planet From Intergalactic Space Aliens by Bill Moyers. DO NOT READ THIS MOYERS BOOK! For some reason, it is pleasing to be frightened. As a young pupa in Oregon, my favorite recreational implement was an earthling-in-a-box. If I would crank the handle long enough, an earthling impaled on a spring would leap forth from the box, screaming and gasping for air. Oh, how we would laugh with fear. This book should also make you laugh with fear, for it contains many interesting examples of earthling edu-tainment. Furthermore, it is chock full of your people's favorite form of communication — the advertisement. Read these well, for as with all ads, someone has gone to great pains to send subliminal messages about your impending doom.

Yes, the Heebie-Jeebie Hullabaloo is a book that will often make you frightened. But it is the kind of fright coupled with the joy of knowing it is just pretend and everything is going to be okay. And everything will be okay as long as you do not read the Moyers book. DO NOT READ THE MOYERS BOOK! We suggest you sit back, relax in your favorite place (perhaps far away from your personal firearms... perhaps in a large bowl of plum sauce), and enjoy Heebie-Jeebie Hullabaloo like it was the last book you will ever read.

END COMMUNICATION,

The One Known As Matt Groening

FROM CARL JUNG TO JOSEPH CAMPBELL, EXPERTS BELIEVE THAT DEEP IN THE HUMAN PSYCHE LIES A COMMON SET OF PRIMITIVE EMOTIONS PASSED ALONG SINCE THE DAWN OF MANKIND. AND MOST PRIMITIVE OF ALL IS THE SENSE OF FEAR. WITH THIS FEAR, CULTURES HAVE CREATED GHOST STORIES, TALES BASED ON A UNIVERSAL FORMULA SO POWERFUL, AN INDIVIDUAL COULD MERELY PLUG IN SOCIETAL SPECIFICS AND A GHOST STORY WOULD ARISE LIKE SMOKE FROM THE VERY CAULDRON OF TIME.

BASICALLY, LISA, HOMER, GRAMPA, AND I ARE EACH GONNA REWRITE THE SAME GHOST STORY. LIKE MAD-LIBS WITHOUT THE COPYRIGHT INFRINGEMENT.

BART!... WELL, YOU'RE RIGHT. BUT I GET TO GO FIRST!

THE CURSE OF THE THING!

As told by *Lisa Simpson*

When young *Vonda Marbury* agreed to go on the *bird-watching expedition* deep in the heart of *the Okefenokee Swamp*, she had no idea of the terror that would befall her on that fateful night.

Led by world-famous *birder, Victor LaPlante*, the group had traveled by *boat* to the deepest part of *the swamp* to find *a rare bird called the black-crested gratch*. Coming around a bend, *Vonda* spied an old man *on the shore*. "Stay away from *Death's Head Cave*, for that is the home of *Caucohotec*." *Vonda* had heard this myth. Long ago, *Chief Caucohotec* had been *burned alive and eaten* by a rival *tribe*. Before he died, he swore his ghost would seek vengeance. Anyone he caught would *be burned and eaten as he had been*. But *Vonda* couldn't worry about myths. To find the *black-crested gratch*, they had to go to *Death's Head Cave*. As they left, they could hear the old man mutter, "*Caucohotec, tonight you shall be fed.*"

Because members of the group were scared, *Victor* agreed to sit up all night with his gun. "*See you tomorrow at breakfast*," he joked, "*unless I'm Caucohotec's dinner!*" Later that night, young *Vonda* was awoken by gunshots followed by a hideous scream. She ran to the spot where *Victor* had been. Instead she found his *broken rifle* and a *patch of scorched earth from a recent bonfire*. Suddenly, she heard a rustle in the bushes. THUMP, THUMP, SCRAPE... THUMP, THUMP, SCRAPE! Was it *Caucohotec*?! *Vonda* began running back through the inky darkness toward *the boat*. Once she reached it, she'd motor back to civilization and send for help. It seemed like an eternity, but she finally found it. Her passage to safety! And as if that weren't enough, there *on the prow of the boat* she could make out *a black crest of feathers*... She'd actually found *the black-crested gratch*! But as she got closer, she realized *the shadow of the bird* was much bigger than she had imagined. Could it be *the black crest* was actually *the feathers of an Indian headdress*?

That morning in the *Okefenokee* Gazette there was a short article near the back: "*Birding Expedition Missing, Feared Drowned*." An old man put down the paper and muttered to himself, "*Caucohotec has been sated.*"

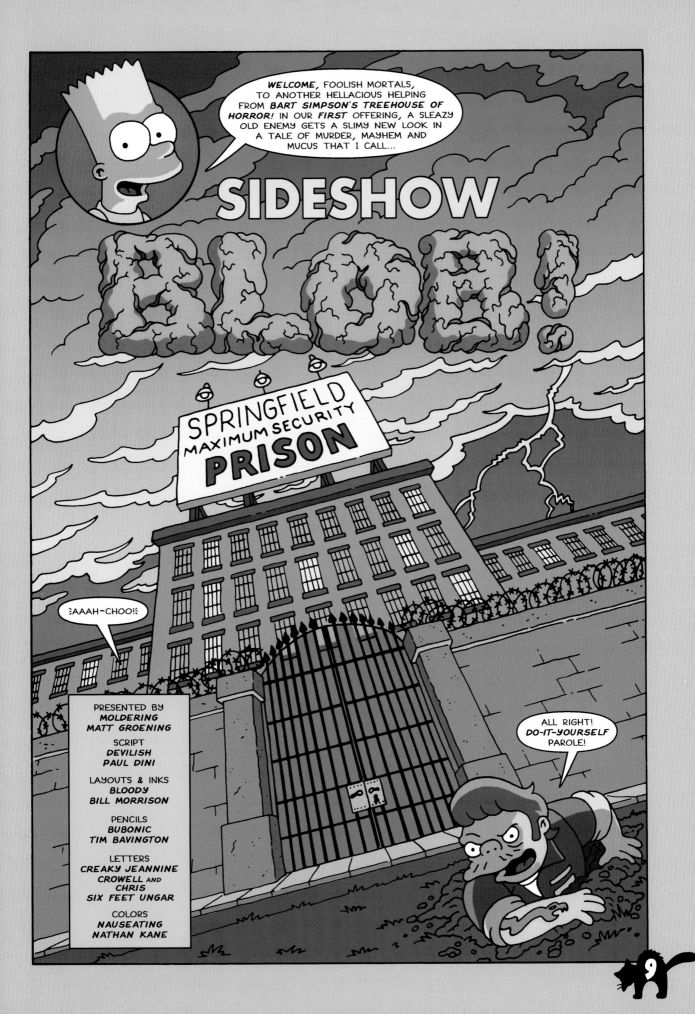

:SNIFF!:

:COUGH!:

INFIRMARY

:KAA-CHOO!: **BLAST** THIS COLD. RIGHT NOW I'D **KILL** FOR A DRAM OF NYQUIL.

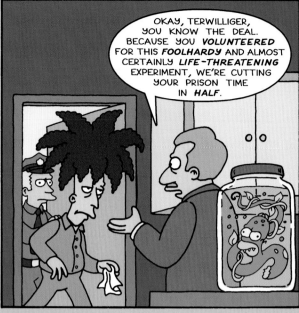

OKAY, TERWILLIGER, YOU KNOW THE DEAL. BECAUSE YOU **VOLUNTEERED** FOR THIS **FOOLHARDY** AND ALMOST CERTAINLY **LIFE-THREATENING** EXPERIMENT, WE'RE CUTTING YOUR PRISON TIME IN **HALF**.

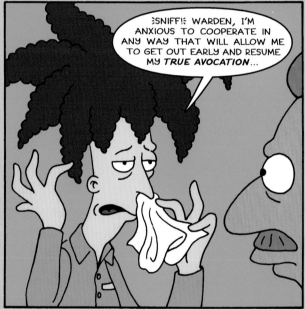

:SNIFF!: WARDEN, I'M ANXIOUS TO COOPERATE IN ANY WAY THAT WILL ALLOW ME TO GET OUT EARLY AND RESUME MY **TRUE AVOCATION**...

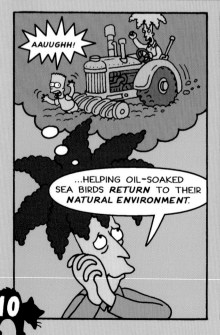

AAUUGHH!

...HELPING OIL-SOAKED SEA BIRDS **RETURN** TO THEIR **NATURAL ENVIRONMENT**.

:AAA-CHOOO!:

NO, PLAYING **GUINEA PIG** DOESN'T BOTHER ME, SO LONG AS I'M ASSURED THE SUPERVISING DOCTOR KNOWS WHAT HE'S DOING.

HI, EVERYBODY!

HI, DR. NICK!

:SNIFF!: ON SECOND THOUGHT, YOU MAY **RETURN** ME TO "THE HOLE."

NOW DON' BE SCARED, BOBBY! I'M HAPPY HYPO AN' ME AN' DR. NICK ARE GONNA HELP YOU BEAT NASTY OL' MR. COLD!

ONE LI'L JAB, AND ALL THOSE ICKY, DRIPPY MUCOUS MEMBRANES WILL BE HARMLESSLY *ABSORBED* INTO YOUR BODY. WON' THAT BE NICE?

⦂COUGH⦂ JUST GIVE ME THE *BLASTED SHOT.*

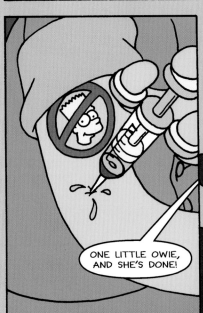

ONE LITTLE OWIE, AND SHE'S DONE!

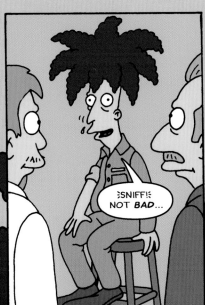

⦂SNIFF⦂ NOT *BAD*...

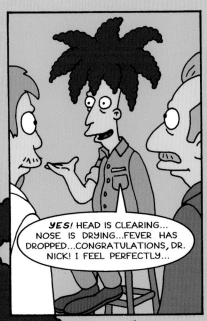

YES! HEAD IS CLEARING... NOSE IS DRYING...FEVER HAS DROPPED...CONGRATULATIONS, DR. NICK! I FEEL PERFECTLY...

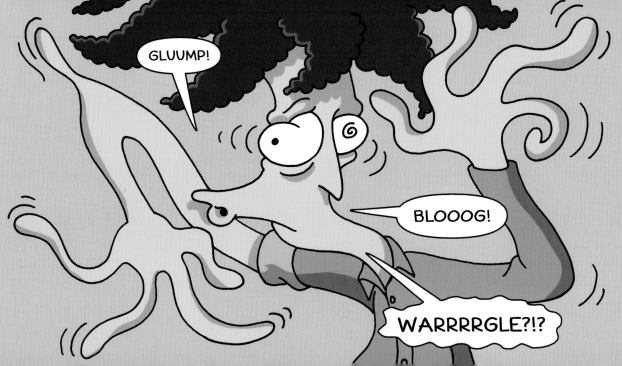

GLUUMP!

BLOOOG!

WARRRRGLE?!?

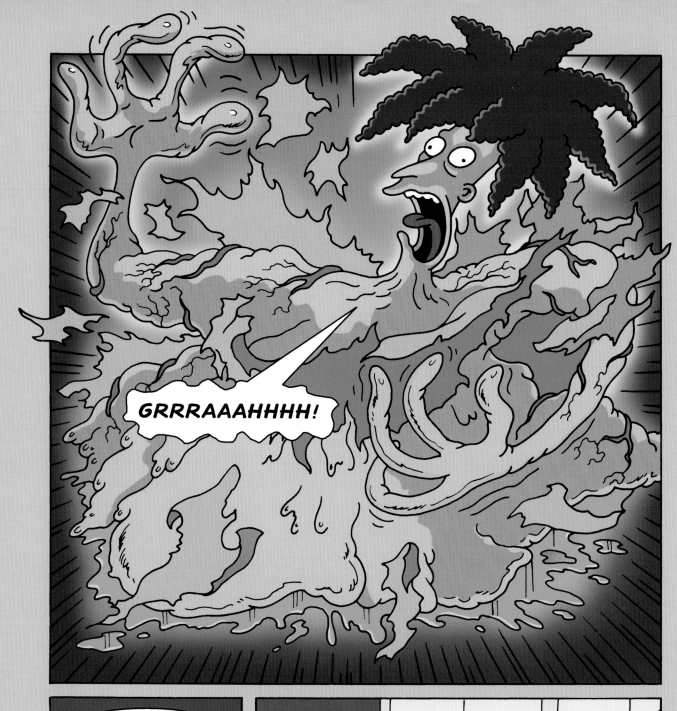

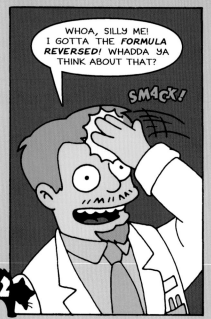

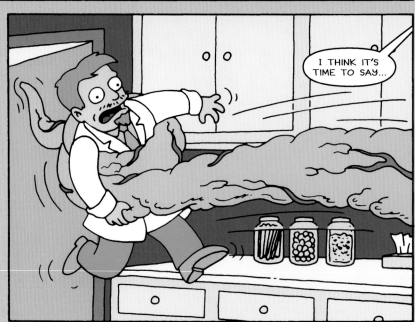

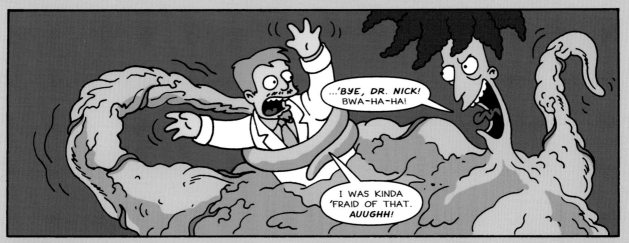

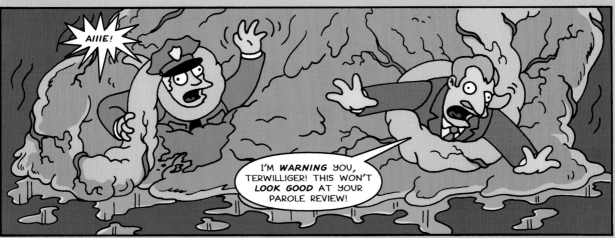

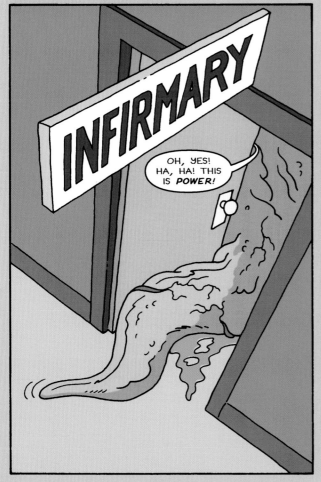

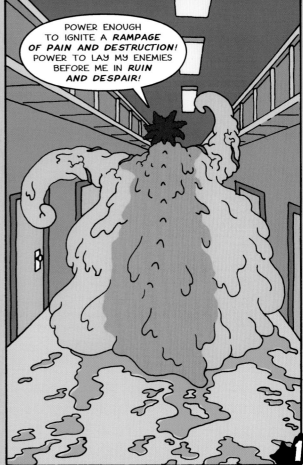

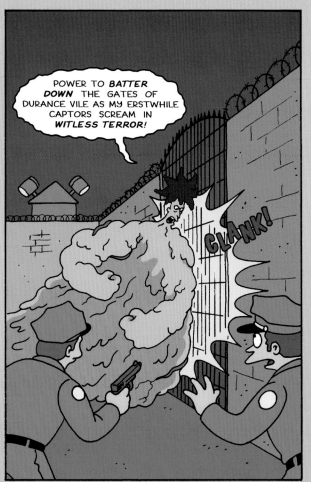

POWER TO **BATTER DOWN** THE GATES OF DURANCE VILE AS MY ERSTWHILE CAPTORS SCREAM IN **WITLESS TERROR!**

CLANK!

BLORCH!

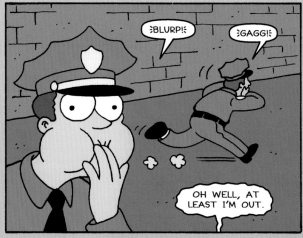

¡BLURP!

¡GAGG!

OH WELL, AT LEAST I'M OUT.

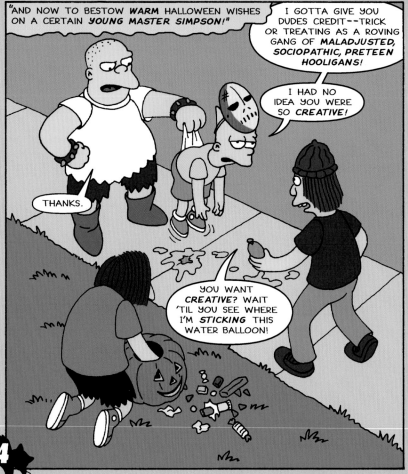

"AND NOW TO BESTOW **WARM** HALLOWEEN WISHES ON A CERTAIN **YOUNG MASTER SIMPSON!**"

I GOTTA GIVE YOU DUDES CREDIT--TRICK OR TREATING AS A ROVING GANG OF **MALADJUSTED, SOCIOPATHIC, PRETEEN HOOLIGANS!**

I HAD NO IDEA YOU WERE SO **CREATIVE!**

THANKS.

YOU WANT **CREATIVE**? WAIT 'TIL YOU SEE WHERE I'M **STICKING** THIS WATER BALLOON!

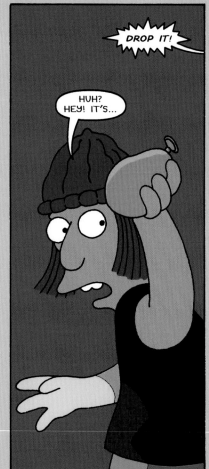

DROP IT!

HUH? HEY! IT'S...

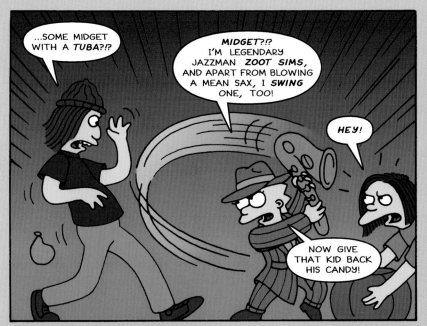

...SOME MIDGET WITH A *TUBA*?!?

MIDGET?!? I'M LEGENDARY JAZZMAN *ZOOT SIMS*, AND APART FROM BLOWING A MEAN SAX, I *SWING* ONE, TOO!

HEY!

NOW GIVE THAT KID BACK HIS CANDY!

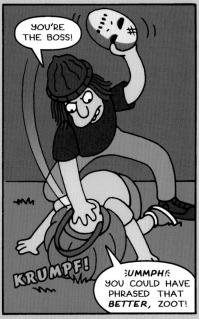

YOU'RE THE BOSS!

KRUMPF!

¿UMMPH? YOU COULD HAVE PHRASED THAT *BETTER*, ZOOT!

C'MON, MEN! SKINNER'S WINDOWS WON'T SOAP THEMSELVES!

YEAH!

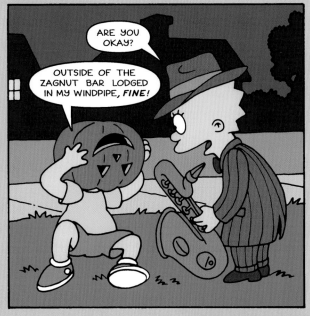

ARE YOU OKAY?

OUTSIDE OF THE ZAGNUT BAR LODGED IN MY WINDPIPE, *FINE!*

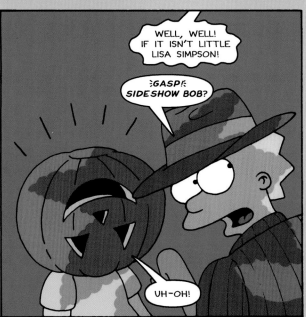

WELL, WELL! IF IT ISN'T LITTLE LISA SIMPSON!

¿GASP? SIDESHOW BOB?

UH-OH!

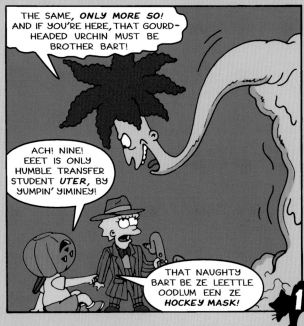

THE SAME, *ONLY MORE SO!* AND IF YOU'RE HERE, THAT GOURD-HEADED URCHIN MUST BE BROTHER BART!

ACH! NINE! EEET IS ONLY HUMBLE TRANSFER STUDENT *UTER*, BY YUMPIN' YIMINEY!

THAT NAUGHTY BART BE ZE LEETTLE OODLUM EEN ZE *HOCKEY MASK!*

15

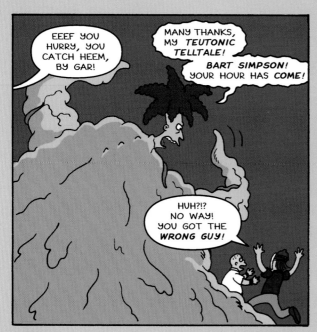

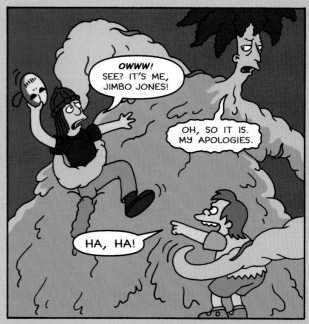

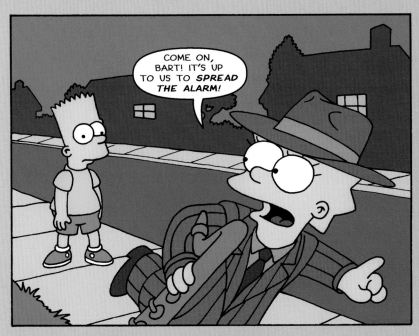

COME ON, BART! IT'S UP TO US TO *SPREAD THE ALARM!*

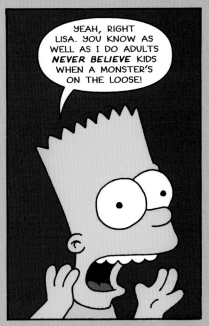

YEAH, RIGHT LISA. YOU KNOW AS WELL AS I DO ADULTS *NEVER BELIEVE* KIDS WHEN A MONSTER'S ON THE LOOSE!

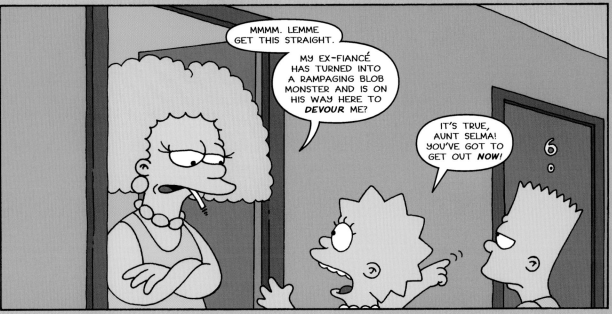

MMMM. LEMME GET THIS STRAIGHT.

MY EX-FIANCÉ HAS TURNED INTO A RAMPAGING BLOB MONSTER AND IS ON HIS WAY HERE TO *DEVOUR* ME?

IT'S TRUE, AUNT SELMA! YOU'VE GOT TO GET OUT *NOW!*

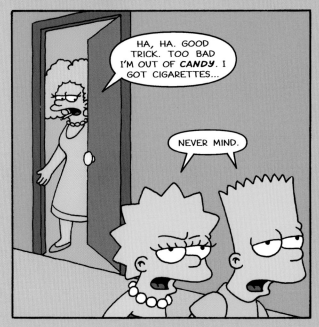

HA, HA. GOOD TRICK. TOO BAD I'M OUT OF *CANDY*. I GOT CIGARETTES...

NEVER MIND.

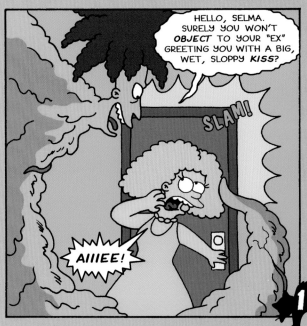

HELLO, SELMA. SURELY YOU WON'T *OBJECT* TO YOUR "EX" GREETING YOU WITH A BIG, WET, SLOPPY *KISS?*

SLAM!

AIIIEE!

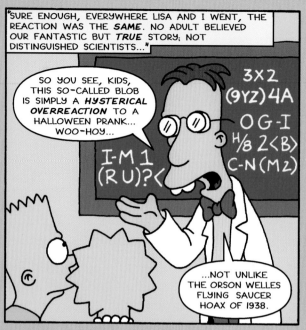

"SURE ENOUGH, EVERYWHERE LISA AND I WENT, THE REACTION WAS THE *SAME*. NO ADULT BELIEVED OUR FANTASTIC BUT *TRUE* STORY; NOT DISTINGUISHED SCIENTISTS..."

SO YOU SEE, KIDS, THIS SO-CALLED BLOB IS SIMPLY A *HYSTERICAL OVERREACTION* TO A HALLOWEEN PRANK... WOO-HOY...

3×2
$(9YZ)4A$
$OG-I$
$H/8 \ 2 < B >$
$C-N(M2)$
$I-M1$
$(RU)?<$

...NOT UNLIKE THE ORSON WELLES FLYING SAUCER HOAX OF 1938.

I BELIEVE I'VE FOUND SOME *HOLES* IN YOUR THEOREM, PROFESSOR.

AIIIEE!

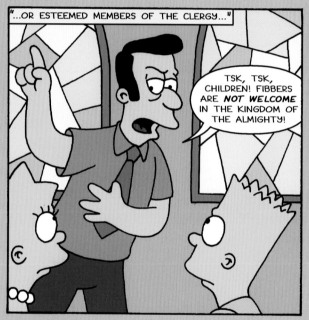

"...OR ESTEEMED MEMBERS OF THE CLERGY..."

TSK, TSK, CHILDREN! FIBBERS ARE *NOT WELCOME* IN THE KINGDOM OF THE ALMIGHTY!

BUT I'M SURE YOU'LL BE GREETED WITH *OPEN ARMS*, REVEREND.

AIIIEE!

"...OR EVEN BELOVED SHOW BUSINESS LEGENDS!"

NOTICING A PATTERN HERE, LISA?

AIIIEGLUMMPHH!

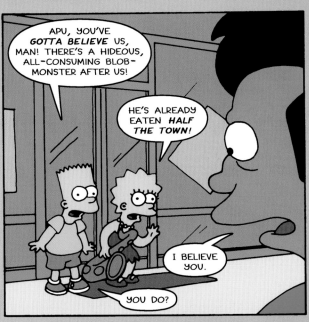

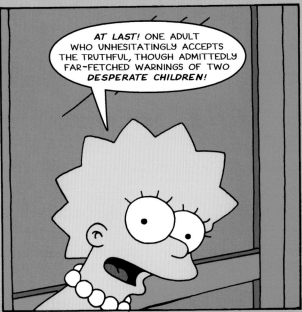

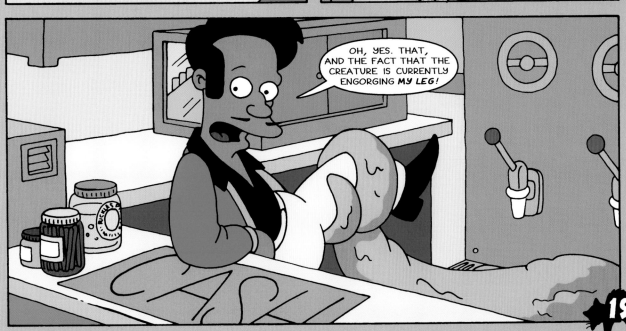

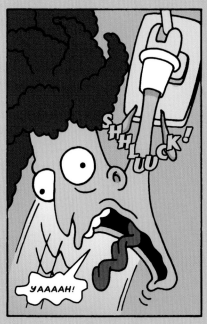

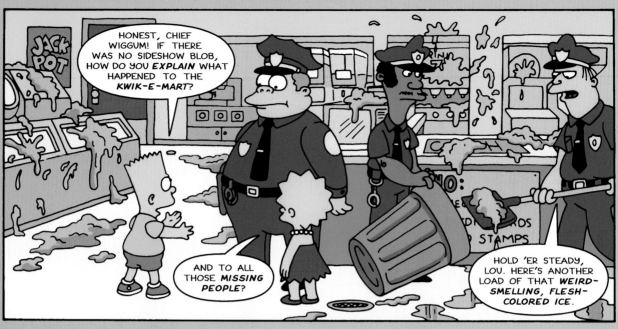

JACK POT

HONEST, CHIEF WIGGUM! IF THERE WAS NO SIDESHOW BLOB, HOW DO YOU *EXPLAIN* WHAT HAPPENED TO THE *KWIK-E-MART*?

AND TO ALL THOSE *MISSING PEOPLE*?

HOLD 'ER STEADY, LOU. HERE'S ANOTHER LOAD OF THAT *WEIRD-SMELLING, FLESH-COLORED ICE.*

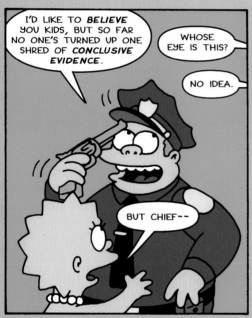

I'D LIKE TO *BELIEVE* YOU KIDS, BUT SO FAR NO ONE'S TURNED UP ONE SHRED OF *CONCLUSIVE EVIDENCE.*

WHOSE EYE IS THIS?

NO IDEA.

BUT CHIEF--

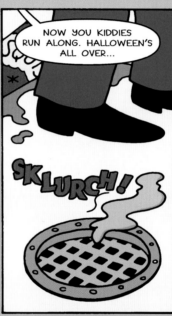

NOW YOU KIDDIES RUN ALONG. HALLOWEEN'S ALL OVER...

SKLURCH!

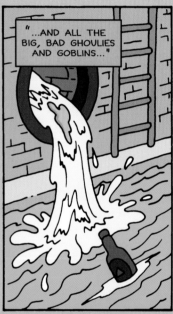

"...AND ALL THE BIG, BAD GHOULIES AND GOBLINS..."

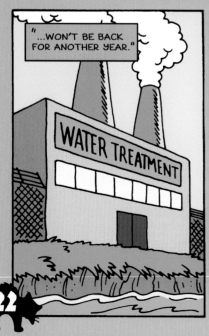

"...WON'T BE BACK FOR ANOTHER YEAR."

WATER TREATMENT

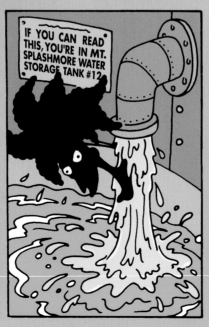

IF YOU CAN READ THIS, YOU'RE IN MT. SPLASHMORE WATER STORAGE TANK #12.

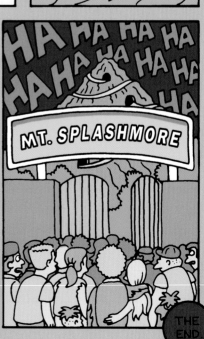

HA HA HA HA HA HA HA HA HA

MT. SPLASHMORE

THE END.

22

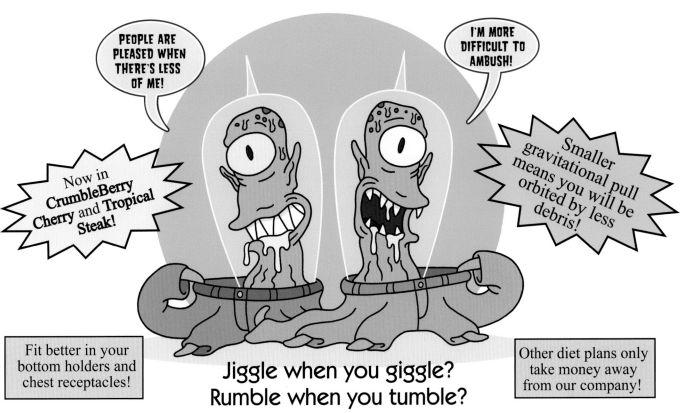

Jiggle when you giggle?
Rumble when you tumble?
Time to lose that extra weight! Time for...

KangFast!®

Magic Shrinking Granules

KangFast!® is not a cunning plan to introduce muscle-weakening hormones into the populace in order to make humans slower targets, nor is it an internal spicing mechanism to make humans tastier. It's the revolutionary fat-obliteration formula that will make you a newer you.

Just listen to these candid testimonials...

Kodos: Housewife, Mother of Two:
"After I expelled my second infant, Porgatz the Malevolent, I became slow and less attractive to future mating partners. When I would go to the purchasing complex, other humans would laugh and throw sun-ripened comestibles in my direction. I decided it was time for KangFast! In just three lunar rotations, I eliminated one third of my molecular mass. Now, when I go to the purchasing complex, I'm the one throwing the sun-ripened comestibles!"

Kang: Sun-ripened Comestibles Salesman:
"When I received the communication alerting me to my educational reunion, my gelatinous sides quivered in fear. The other educatees would stare in scorn at my expanded girth. Perhaps they would poke at my abdomen wondering if I was about to expel an infant. I even tried to fit into my old athletics garment, but as soon as I moved, it blew into bits. 'I shall begin KangFast!' I announced. By the time I went to my educational reunion, I had become so small, nobody recognized me! Not only was I not mocked, I was able to anonymously abscond with great amounts of valuable booty."

Many say to exercise. DO NOT!! Your stringy gristle is our wasted meat.

The KangFast! regimen is easy: Have a shake for breakfast, a shake for lunch, and be ~~eaten as a~~ be eating sensible dinner.

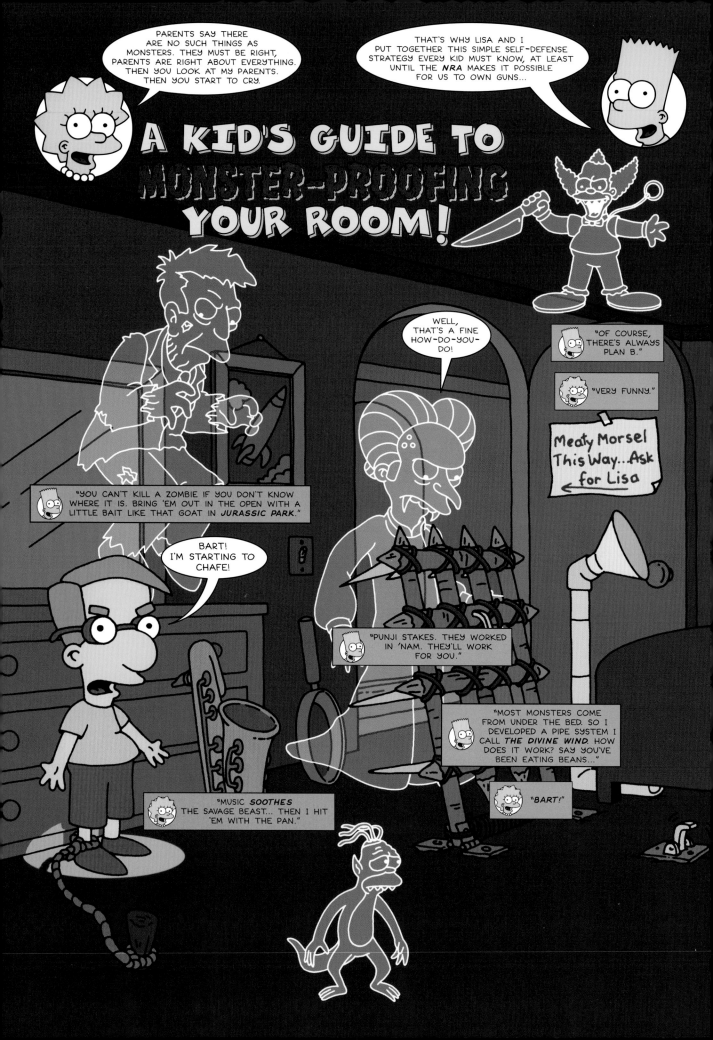

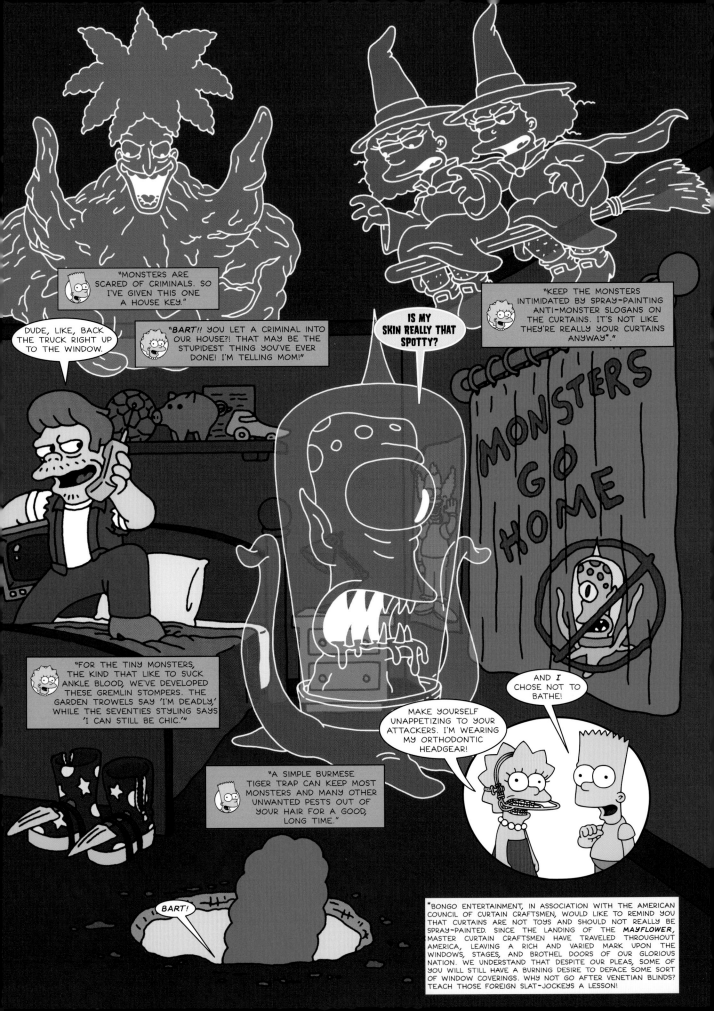

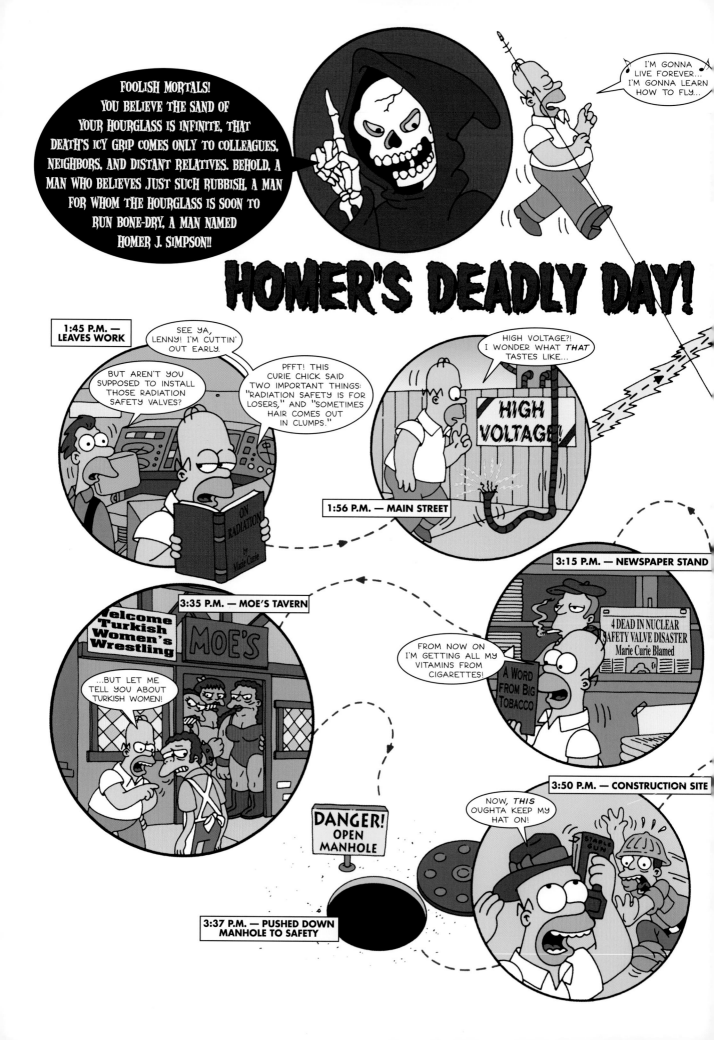

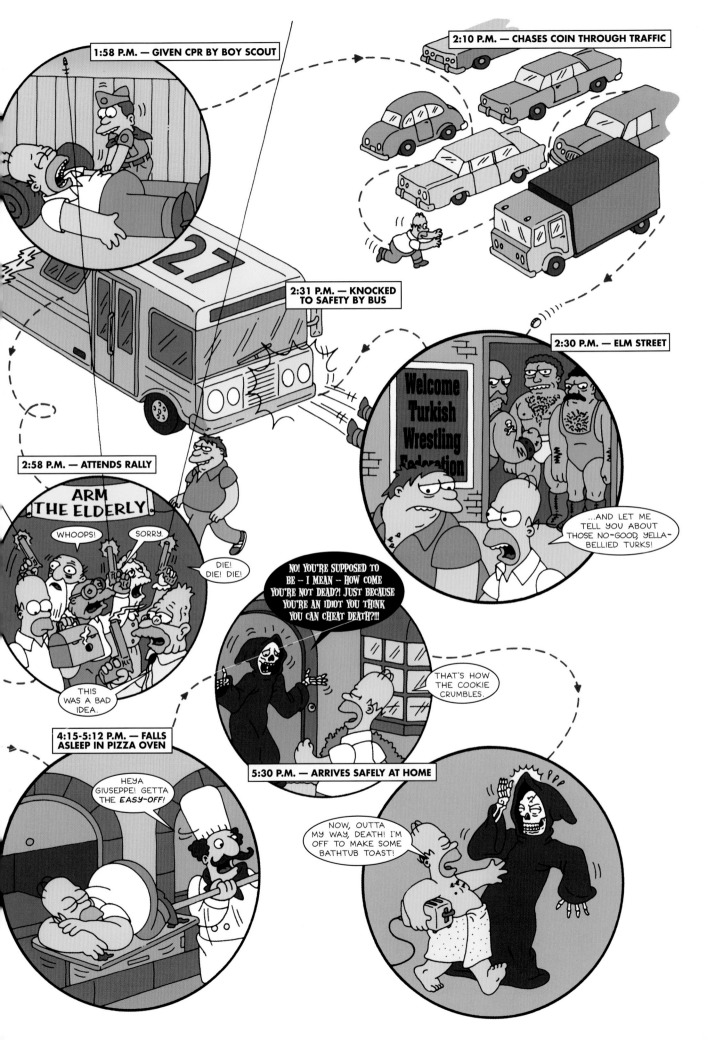

MEDICAL EXPERTS AGREE: MY SISTER'S A WIENER. LET ME SHOW YOU HOW TO TELL A *REAL* GHOST STORY!

THE CURSE OF THE THING!

As told by Bart Simpson

When young Star Capt. Lance Rapley agreed to go on the the cyborg-killing mission deep in the heart of the Fromzorb Nebula, he had no idea of the terror that would befall him on that fateful night.

Led by world-famous cyborg-hunter, Milhouse the Dork, the group had traveled by this really cool rocket with a wicked-bad cannon to the deepest part of the planet Bobojerk to find the chrome-domed RX42 and kill it. Coming around a bend, Lance spied an old man in a hovercraft. "Stay away from the Bubbling Butt Cave, for that is the home of the Bubbling Butt Monster." Lance had heard this myth. Long ago, this dude with a really small butt had been shoved in this butt biggification machine by a rival guy with a normal butt. Before he died, he swore his ghost would seek vengeance. Anyone he caught would get his butt biggified until it exploded. But Lance couldn't worry about myths. To find the chrome-domed RX42, they had to go to the Bubbling Butt Cave. As they left, they could hear the old man mutter, "You're gonna end up with one exploded butt."

Because members of the group were scared, Milhouse the Dork agreed to sit up all night with his gun. "See you tomorrow," he joked, "No ifs, ands or butts!" Later that night, young Lance was awoken by gunshots followed by a hideous scream. He ran to the spot where Milhouse the Dork had been. Instead he found his melted plasma ray and a pair of tightie-whities with the back ripped open. Suddenly, he heard a rustle in the bushes. THUMP, THUMP, SCRAPE... THUMP, THUMP, SCRAPE! Was it the Bubbling Butt Monster?! Lance began running back through the inky darkness toward the really cool rocket with the wicked-bad cannon. Once he reached it, he'd motor back to civilization and send for help. It seemed like an eternity, but he finally found it. His passage to safety! And as if that weren't enough, there in the door of the rocket he could make out a big shiny round thing... He'd actually found the chrome-domed RX42! But as he got closer, he realized the shiny round thing was much bigger than he had imagined. Could it be the dome was actually the butt side of the Bubbling Butt Monster?

That morning in the Fromzorb Gazette there was a short article near the back: "RX42 Destroys Planet Bobojerk Because RX42 Hunters Had Their Butts Blown Up By Butt Monster." An old man put down the paper and muttered to himself, "I am one oooold man!"

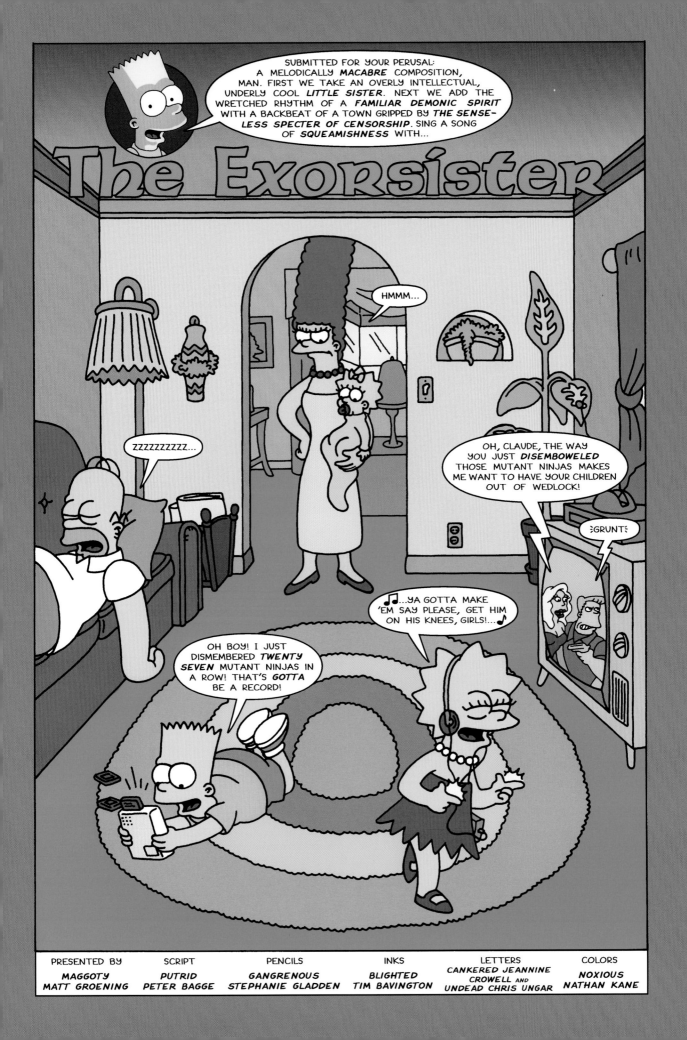

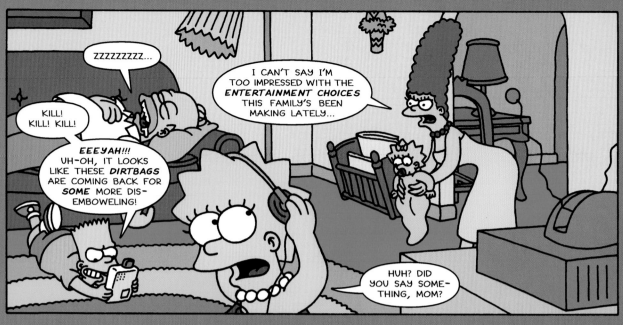

ZZZZZZZZZ...

KILL! KILL! KILL!

EEEYAH!!! UH-OH, IT LOOKS LIKE THESE *DIRTBAGS* ARE COMING BACK FOR *SOME* MORE DIS-EMBOWELING!

I CAN'T SAY I'M TOO IMPRESSED WITH THE *ENTERTAINMENT CHOICES* THIS FAMILY'S BEEN MAKING LATELY...

HUH? DID YOU SAY SOMETHING, MOM?

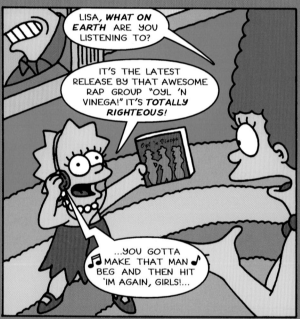

LISA, *WHAT ON EARTH* ARE YOU LISTENING TO?

IT'S THE LATEST RELEASE BY THAT AWESOME RAP GROUP "OYL 'N VINEGA!" IT'S *TOTALLY RIGHTEOUS!*

♪ ...YOU GOTTA MAKE THAT MAN BEG AND THEN HIT 'IM AGAIN, GIRLS!... ♪

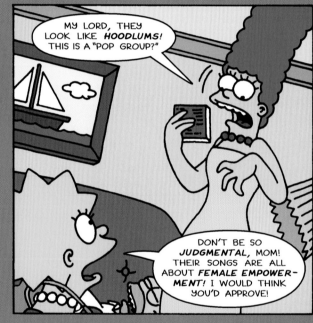

MY LORD, THEY LOOK LIKE *HOODLUMS!* THIS IS A "POP GROUP?"

DON'T BE SO *JUDGMENTAL*, MOM! THEIR SONGS ARE ALL ABOUT *FEMALE EMPOWERMENT!* I WOULD THINK YOU'D APPROVE!

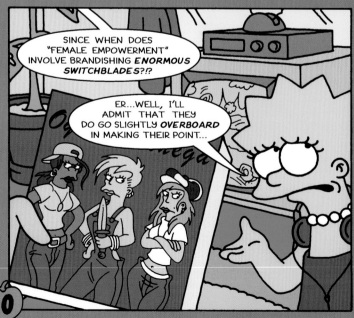

SINCE WHEN DOES "FEMALE EMPOWERMENT" INVOLVE BRANDISHING *ENORMOUS SWITCHBLADES?!?*

ER...WELL, I'LL ADMIT THAT THEY DO GO SLIGHTLY *OVERBOARD* IN MAKING THEIR POINT...

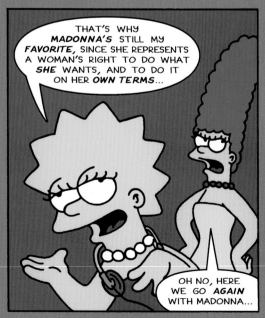

THAT'S WHY *MADONNA'S* STILL MY *FAVORITE*, SINCE SHE REPRESENTS A WOMAN'S RIGHT TO DO WHAT *SHE* WANTS, AND TO DO IT ON HER *OWN TERMS*...

OH NO, HERE WE GO *AGAIN* WITH MADONNA...

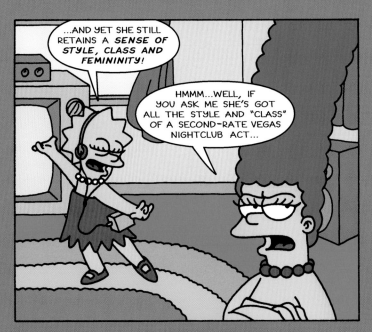

...AND YET SHE STILL RETAINS A *SENSE OF STYLE, CLASS AND FEMININITY!*

HMMM...WELL, IF YOU ASK ME SHE'S GOT ALL THE STYLE AND "CLASS" OF A SECOND-RATE VEGAS NIGHTCLUB ACT...

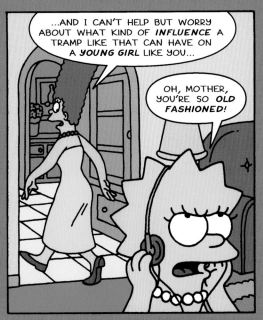

...AND I CAN'T HELP BUT WORRY ABOUT WHAT KIND OF *INFLUENCE* A TRAMP LIKE THAT CAN HAVE ON A *YOUNG GIRL* LIKE YOU...

OH, MOTHER, YOU'RE SO *OLD FASHIONED!*

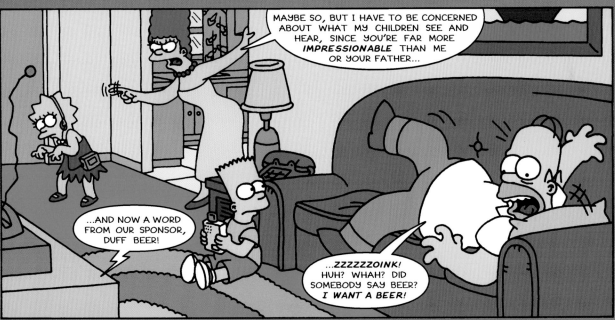

MAYBE SO, BUT I HAVE TO BE CONCERNED ABOUT WHAT MY CHILDREN SEE AND HEAR, SINCE YOU'RE FAR MORE *IMPRESSIONABLE* THAN ME OR YOUR FATHER...

...AND NOW A WORD FROM OUR SPONSOR, DUFF BEER!

...ZZZZZZOINK! HUH? WHAH? DID SOMEBODY SAY BEER? *I WANT A BEER!*

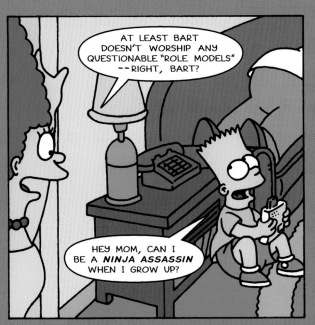

AT LEAST BART DOESN'T WORSHIP ANY QUESTIONABLE "ROLE MODELS" --RIGHT, BART?

HEY MOM, CAN I BE A *NINJA ASSASSIN* WHEN I GROW UP?

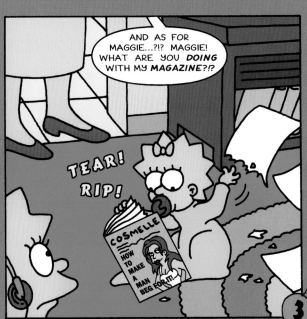

AND AS FOR MAGGIE...?!? MAGGIE! WHAT ARE YOU *DOING* WITH MY *MAGAZINE?!?*

TEAR!
RIP!

COSMELLE
HOW TO MAKE A MAN BEG FOR IT!

31

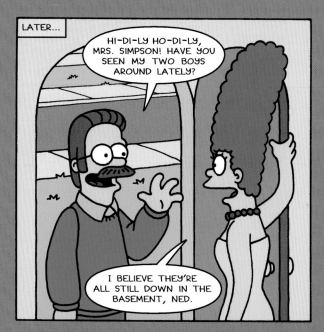

LATER...

HI-DI-LY HO-DI-LY, MRS. SIMPSON! HAVE YOU SEEN MY TWO BOYS AROUND LATELY?

I BELIEVE THEY'RE ALL STILL DOWN IN THE BASEMENT, NED.

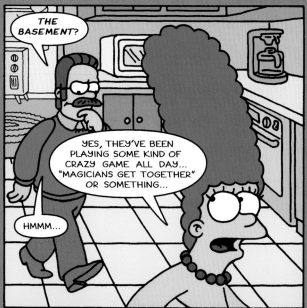

THE BASEMENT?

YES, THEY'VE BEEN PLAYING SOME KIND OF CRAZY GAME ALL DAY... "MAGICIANS GET TOGETHER" OR SOMETHING...

HMMM...

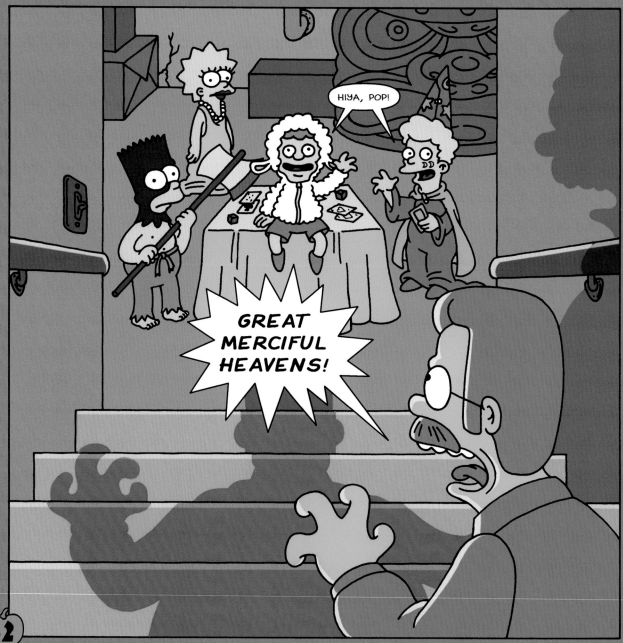

HIYA, POP!

GREAT MERCIFUL HEAVENS!

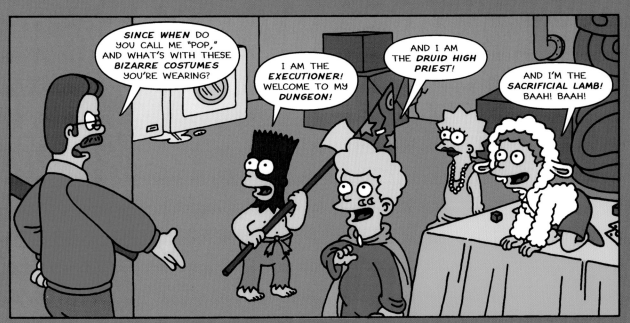

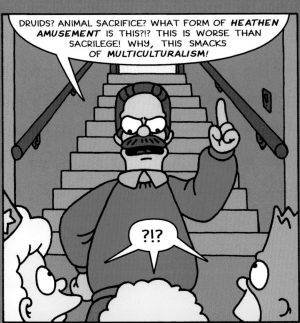

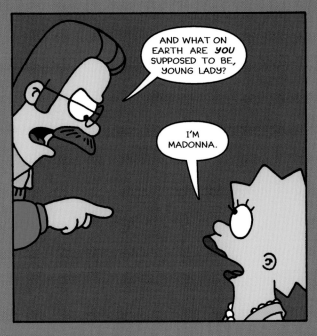

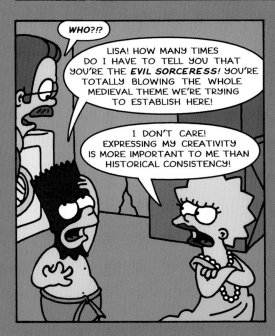

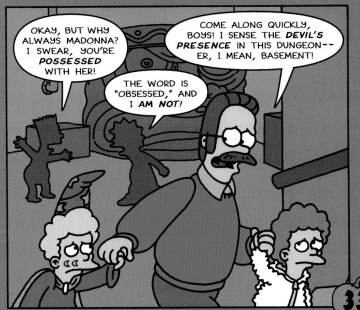

33

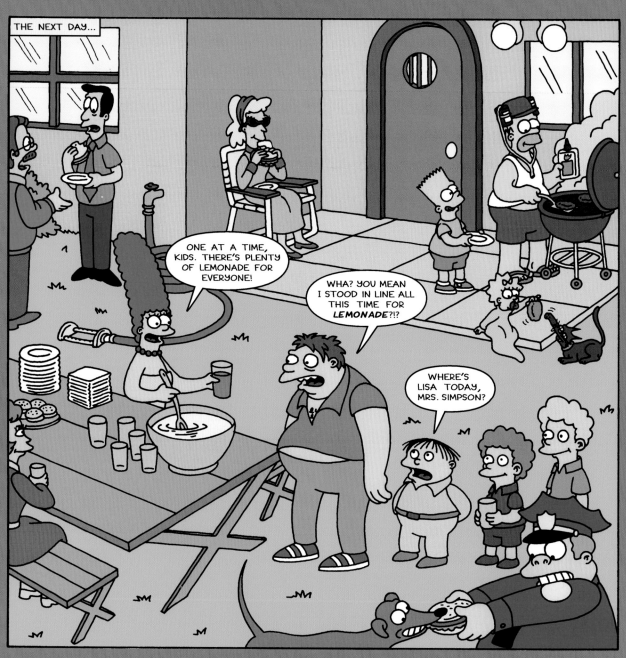

THE NEXT DAY...

ONE AT A TIME, KIDS. THERE'S PLENTY OF LEMONADE FOR EVERYONE!

WHA? YOU MEAN I STOOD IN LINE ALL THIS TIME FOR *LEMONADE*?!?

WHERE'S LISA TODAY, MRS. SIMPSON?

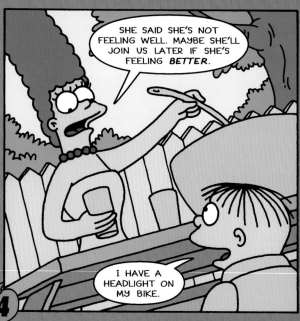

SHE SAID SHE'S NOT FEELING WELL. MAYBE SHE'LL JOIN US LATER IF SHE'S FEELING *BETTER*.

I HAVE A HEADLIGHT ON MY BIKE.

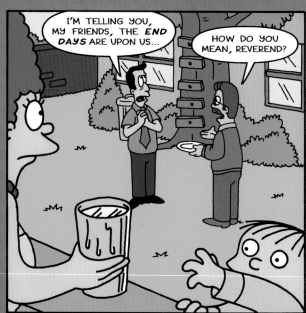

I'M TELLING YOU, MY FRIENDS, THE *END DAYS* ARE UPON US...

HOW DO YOU MEAN, REVEREND?

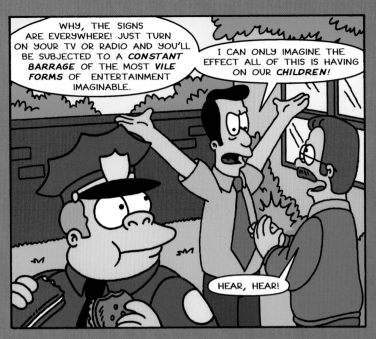

WHY, THE SIGNS ARE EVERYWHERE! JUST TURN ON YOUR TV OR RADIO AND YOU'LL BE SUBJECTED TO A *CONSTANT BARRAGE* OF THE MOST *VILE FORMS* OF ENTERTAINMENT IMAGINABLE.

I CAN ONLY IMAGINE THE EFFECT ALL OF THIS IS HAVING ON OUR *CHILDREN!*

HEAR, HEAR!

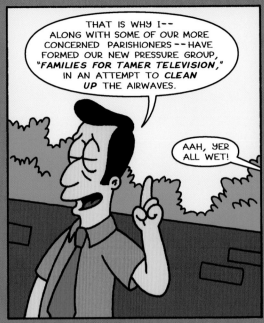

THAT IS WHY I-- ALONG WITH SOME OF OUR MORE CONCERNED PARISHIONERS-- HAVE FORMED OUR NEW PRESSURE GROUP, *"FAMILIES FOR TAMER TELEVISION,"* IN AN ATTEMPT TO *CLEAN UP* THE AIRWAVES.

AAH, YER ALL WET!

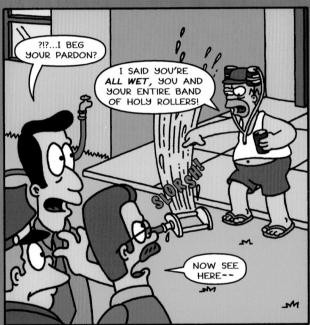

?!?...I BEG YOUR PARDON?

I SAID YOU'RE *ALL WET,* YOU AND YOUR ENTIRE BAND OF HOLY ROLLERS!

SLORSH!

NOW SEE HERE--

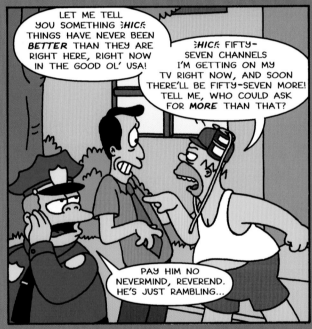

LET ME TELL YOU SOMETHING ɜHICɤ THINGS HAVE NEVER BEEN *BETTER* THAN THEY ARE RIGHT HERE, RIGHT NOW IN THE GOOD OL' USA!

ɜHICɤ FIFTY-SEVEN CHANNELS I'M GETTING ON MY TV RIGHT NOW, AND SOON THERE'LL BE FIFTY-SEVEN MORE! TELL ME, WHO COULD ASK FOR *MORE* THAN THAT?

PAY HIM NO NEVERMIND, REVEREND. HE'S JUST RAMBLING...

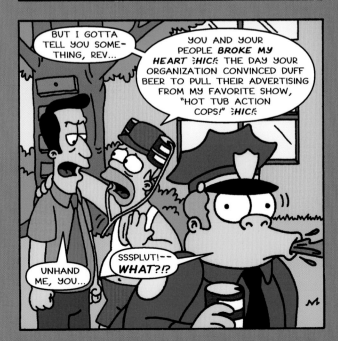

BUT I GOTTA TELL YOU SOME-THING, REV...

YOU AND YOUR PEOPLE *BROKE MY HEART* ɜHICɤ THE DAY YOUR ORGANIZATION CONVINCED DUFF BEER TO PULL THEIR ADVERTISING FROM MY FAVORITE SHOW, *"HOT TUB ACTION COPS!"* ɜHICɤ

UNHAND ME, YOU...

SSSPLUT!-- WHAT?!?

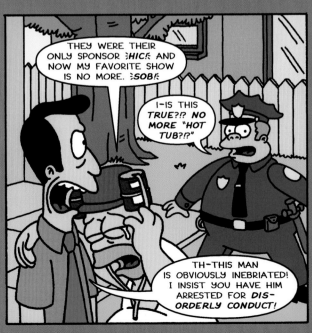

THEY WERE THEIR ONLY SPONSOR ɜHICɤ AND NOW MY FAVORITE SHOW IS NO MORE. ɜSOBɤ

I--IS THIS *TRUE?!? NO MORE "HOT TUB?!?"*

TH-THIS MAN IS OBVIOUSLY INEBRIATED! I INSIST YOU HAVE HIM ARRESTED FOR *DIS-ORDERLY CONDUCT!*

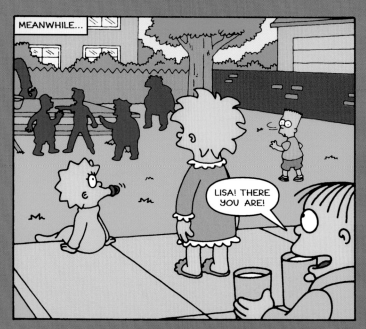

MEANWHILE...

LISA! THERE YOU ARE!

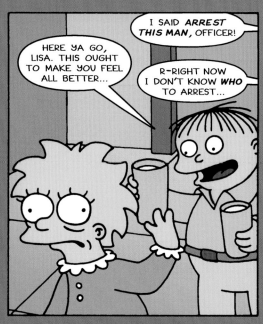

HERE YA GO, LISA. THIS OUGHT TO MAKE YOU FEEL ALL BETTER...

I SAID **ARREST THIS MAN**, OFFICER!

R-RIGHT NOW I DON'T KNOW **WHO** TO ARREST...

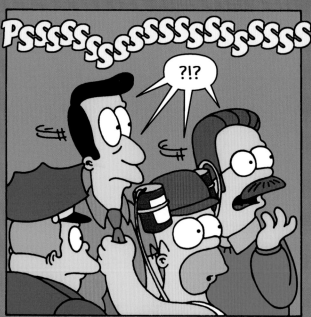

PSSSSSSSSSSSSSSSSSSSS

?!?

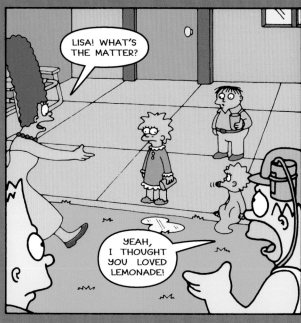

LISA! WHAT'S THE MATTER?

YEAH, I THOUGHT YOU LOVED LEMONADE!

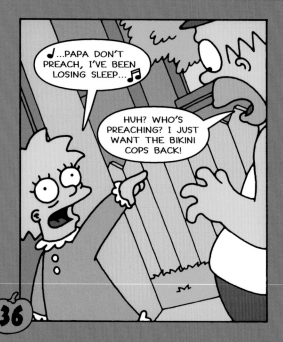

♪...PAPA DON'T PREACH, I'VE BEEN LOSING SLEEP...♪

HUH? WHO'S PREACHING? I JUST WANT THE BIKINI COPS BACK!

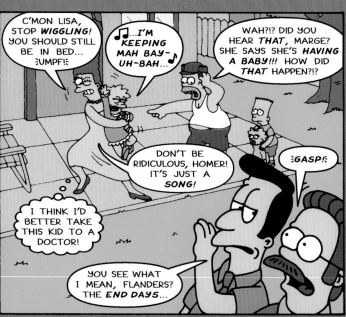

C'MON LISA, STOP **WIGGLING!** YOU SHOULD STILL BE IN BED... ⋮UMPF!⋮

♪...I'M **KEEPING MAH BAY-UH-BAH**...♪

WAH?!? DID YOU HEAR **THAT**, MARGE? SHE SAYS SHE'S **HAVING A BABY!!!** HOW DID **THAT** HAPPEN?!?

DON'T BE RIDICULOUS, HOMER! IT'S JUST A **SONG!**

⋮GASP!⋮

I THINK I'D BETTER TAKE THIS KID TO A DOCTOR!

YOU SEE WHAT I MEAN, FLANDERS? THE **END DAYS**...

LATER...

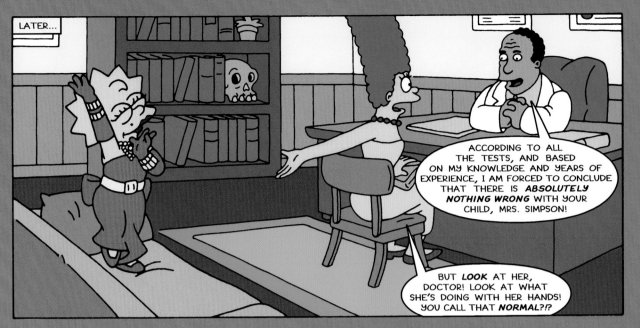

ACCORDING TO ALL THE TESTS, AND BASED ON MY KNOWLEDGE AND YEARS OF EXPERIENCE, I AM FORCED TO CONCLUDE THAT THERE IS **ABSOLUTELY NOTHING WRONG** WITH YOUR CHILD, MRS. SIMPSON!

BUT **LOOK** AT HER, DOCTOR! LOOK AT WHAT SHE'S DOING WITH HER HANDS! YOU CALL THAT **NORMAL**?!?

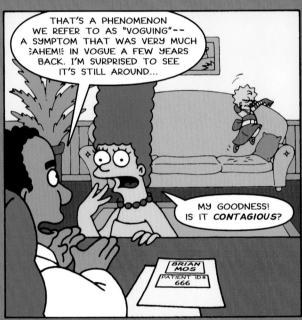

THAT'S A PHENOMENON WE REFER TO AS "VOGUING"-- A SYMPTOM THAT WAS VERY MUCH ¡AHEM!¡ IN VOGUE A FEW YEARS BACK. I'M SURPRISED TO SEE IT'S STILL AROUND...

MY GOODNESS! IS IT **CONTAGIOUS**?

BRIAN MOS PATIENT ID# 666

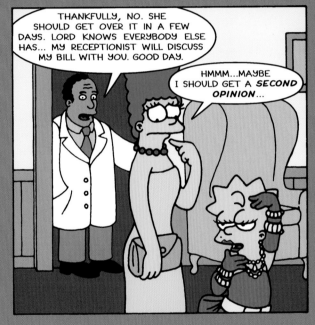

THANKFULLY, NO. SHE SHOULD GET OVER IT IN A FEW DAYS. LORD KNOWS EVERYBODY ELSE HAS... MY RECEPTIONIST WILL DISCUSS MY BILL WITH YOU. GOOD DAY.

HMMM...MAYBE I SHOULD GET A **SECOND OPINION**...

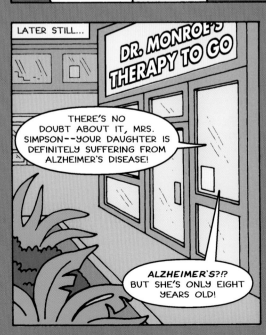

LATER STILL...

DR. MONROE'S THERAPY TO GO

THERE'S NO DOUBT ABOUT IT, MRS. SIMPSON--YOUR DAUGHTER IS DEFINITELY SUFFERING FROM ALZHEIMER'S DISEASE!

ALZHEIMER'S?!? BUT SHE'S ONLY EIGHT YEARS OLD!

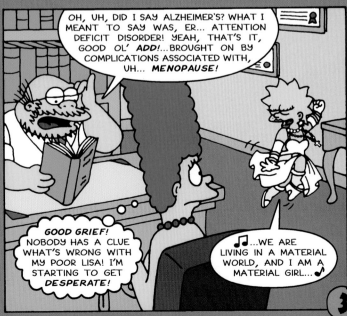

OH, UH, DID I SAY ALZHEIMER'S? WHAT I MEANT TO SAY WAS, ER... ATTENTION DEFICIT DISORDER! YEAH, THAT'S IT, GOOD OL' **ADD**!...BROUGHT ON BY COMPLICATIONS ASSOCIATED WITH, UH... **MENOPAUSE**!

GOOD GRIEF! NOBODY HAS A CLUE WHAT'S WRONG WITH MY POOR LISA! I'M STARTING TO GET **DESPERATE**!

♪...WE ARE LIVING IN A MATERIAL WORLD, AND I AM A MATERIAL GIRL...♪

37

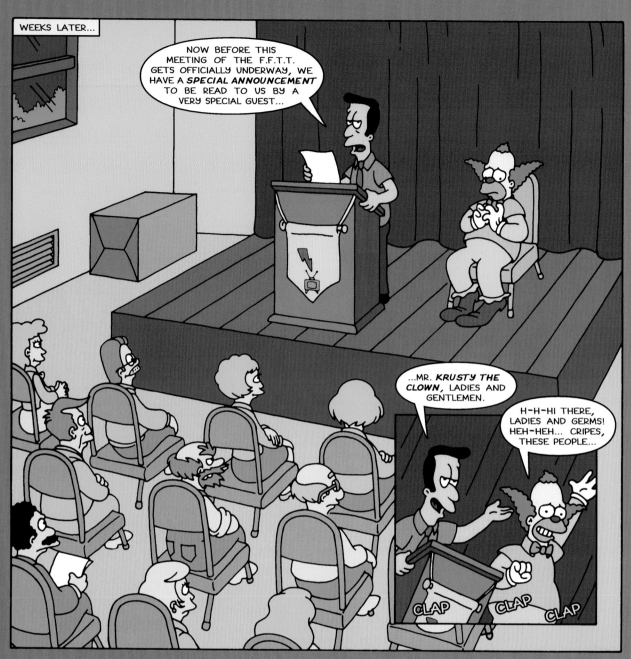

NOW BEFORE THIS MEETING OF THE F.F.T.T. GETS OFFICIALLY UNDERWAY, WE HAVE A *SPECIAL ANNOUNCEMENT* TO BE READ TO US BY A VERY SPECIAL GUEST...

...MR. *KRUSTY THE CLOWN*, LADIES AND GENTLEMEN.

H-H-HI THERE, LADIES AND GERMS! HEH-HEH... CRIPES, THESE PEOPLE...

CLAP CLAP CLAP

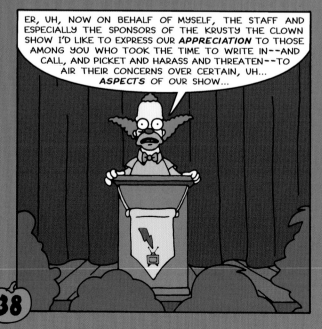

ER, UH, NOW ON BEHALF OF MYSELF, THE STAFF AND ESPECIALLY THE SPONSORS OF THE KRUSTY THE CLOWN SHOW I'D LIKE TO EXPRESS OUR *APPRECIATION* TO THOSE AMONG YOU WHO TOOK THE TIME TO WRITE IN--AND CALL, AND PICKET AND HARASS AND THREATEN--TO AIR THEIR CONCERNS OVER CERTAIN, UH... *ASPECTS* OF OUR SHOW...

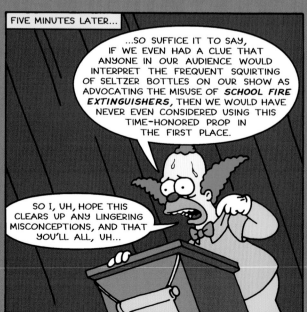

FIVE MINUTES LATER...

...SO SUFFICE IT TO SAY, IF WE EVEN HAD A CLUE THAT ANYONE IN OUR AUDIENCE WOULD INTERPRET THE FREQUENT SQUIRTING OF SELTZER BOTTLES ON OUR SHOW AS ADVOCATING THE MISUSE OF *SCHOOL FIRE EXTINGUISHERS*, THEN WE WOULD HAVE NEVER EVEN CONSIDERED USING THIS TIME-HONORED PROP IN THE FIRST PLACE.

SO I, UH, HOPE THIS CLEARS UP ANY LINGERING MISCONCEPTIONS, AND THAT YOU'LL ALL, UH...

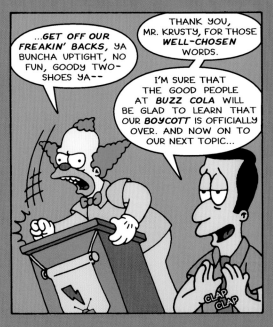

...*GET OFF OUR FREAKIN' BACKS*, YA BUNCHA UPTIGHT, NO FUN, GOODY TWO-SHOES YA--

THANK YOU, MR. KRUSTY, FOR THOSE *WELL-CHOSEN* WORDS.

I'M SURE THAT THE GOOD PEOPLE AT *BUZZ COLA* WILL BE GLAD TO LEARN THAT OUR *BOYCOTT* IS OFFICIALLY OVER. AND NOW ON TO OUR NEXT TOPIC...

CLAP CLAP

ONE HOUR LATER...

EXCUSE ME, MA'AM, BUT THE MEETING IS OVER... CAN I HELP YOU WITH ANYTHING, MISS...

...*MRS. SIMPSON?!?*

I HAVE TO TALK TO YOU, REVEREND.

AND SO...I'M AT MY WIT'S END, REVEREND, AND I DON'T KNOW WHAT ELSE TO DO, SO I'M TURNING TO *YOU* FOR HELP.

B-BUT, MRS. SIMPSON, YOU CAN'T REALLY BELIEVE THAT YOUR DAUGHTER IS *POSSESSED BY THE SPIRIT OF MADONNA!* I MEAN, LET'S GET REAL HERE; MS. CICCONE IS *STILL ALIVE*...I THINK.

DON'T TELL ME YOU *DON'T BELIEVE* ME EITHER! I THOUGHT FOR SURE AFTER THE WAY YOU WERE TALKING AT THE BARBECUE THAT--

OH, *THAT*. ⧼HEH-HEH!⧽ I'M AFRAID THAT WAS JUST THE *BLOODY MARYS* TALKING...

WE MINISTERS JUST CAN'T RESIST BREAKING INTO OUR *FIRE-AND-BRIMSTONE* ROUTINE FROM TIME TO TIME...

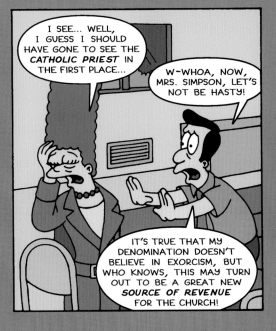

I SEE... WELL, I GUESS I SHOULD HAVE GONE TO SEE THE *CATHOLIC PRIEST* IN THE FIRST PLACE...

W-WHOA, NOW, MRS. SIMPSON, LET'S NOT BE HASTY!

IT'S TRUE THAT MY DENOMINATION DOESN'T BELIEVE IN EXORCISM, BUT WHO KNOWS, THIS MAY TURN OUT TO BE A GREAT NEW *SOURCE OF REVENUE* FOR THE CHURCH!

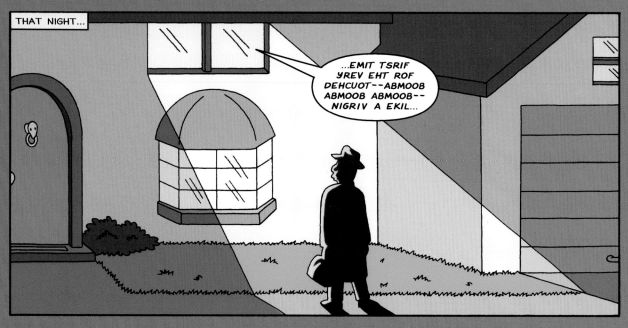

THAT NIGHT...

...EMIT TSRIF YREV EHT ROF DEHCUOT--ABMOOB ABMOOB ABMOOB-- NIGRIV A EKIL...

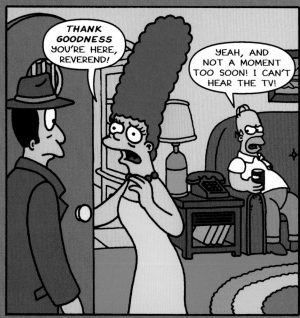

THANK GOODNESS YOU'RE HERE, REVEREND!

YEAH, AND NOT A MOMENT TOO SOON! I CAN'T HEAR THE TV!

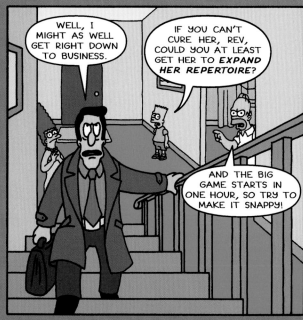

WELL, I MIGHT AS WELL GET RIGHT DOWN TO BUSINESS.

IF YOU CAN'T CURE HER, REV, COULD YOU AT LEAST GET HER TO EXPAND HER REPERTOIRE?

AND THE BIG GAME STARTS IN ONE HOUR, SO TRY TO MAKE IT SNAPPY!

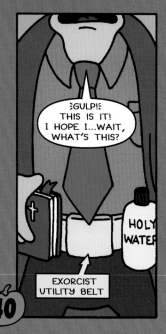

‹GULP!› THIS IS IT! I HOPE I...WAIT, WHAT'S THIS?

HOLY WATER

EXORCIST UTILITY BELT

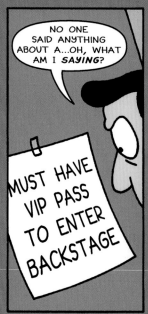

NO ONE SAID ANYTHING ABOUT A...OH, WHAT AM I SAYING?

MUST HAVE VIP PASS TO ENTER BACKSTAGE

BAM!

GOOD LORD! ‹CHOKE!›

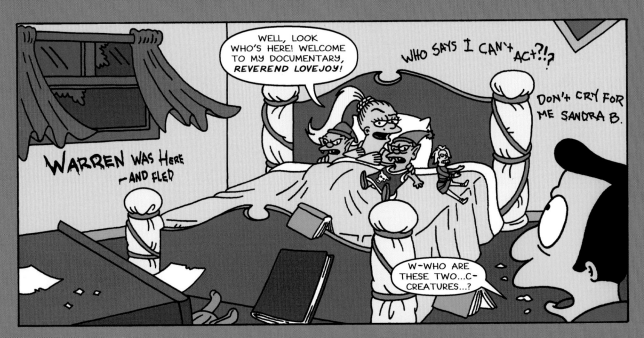

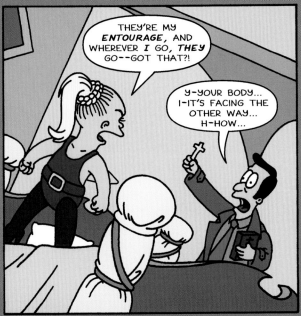

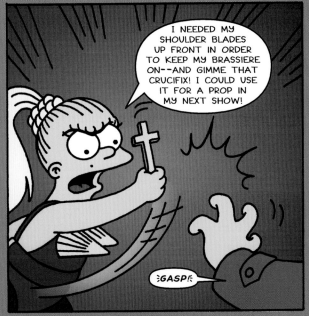

41

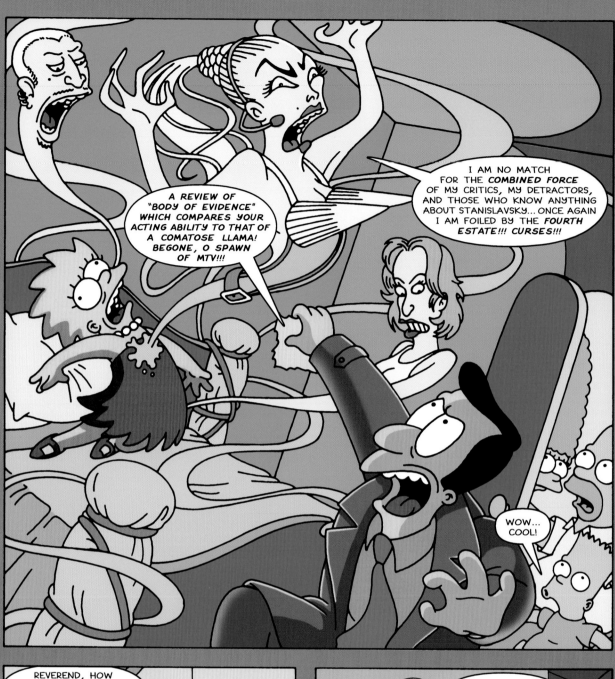

A REVIEW OF "BODY OF EVIDENCE" WHICH COMPARES YOUR ACTING ABILITY TO THAT OF A COMATOSE LLAMA! BEGONE, O SPAWN OF MTV!!!

I AM NO MATCH FOR THE *COMBINED FORCE* OF MY CRITICS, MY DETRACTORS, AND THOSE WHO KNOW ANYTHING ABOUT STANISLAVSKY... ONCE AGAIN I AM FOILED BY THE *FOURTH ESTATE!!!* CURSES!!!

WOW... COOL!

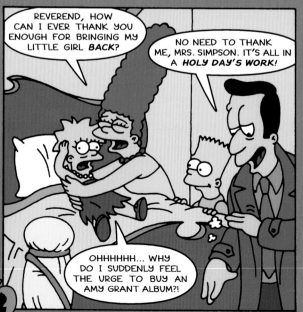

REVEREND, HOW CAN I EVER THANK YOU ENOUGH FOR BRINGING MY LITTLE GIRL *BACK*?

NO NEED TO THANK ME, MRS. SIMPSON. IT'S ALL IN A *HOLY DAY'S* WORK!

OHHHHHH... WHY DO I SUDDENLY FEEL THE URGE TO BUY AN AMY GRANT ALBUM?!

HEY, WHERE DID THAT MADONNA-GHOST-THINGIE GO TO, ANYWAY?

BEATS ME...

...LIKE A VIRGIN...DUM-DE-DUM-DE-DOO...♪ ♫

THE END.

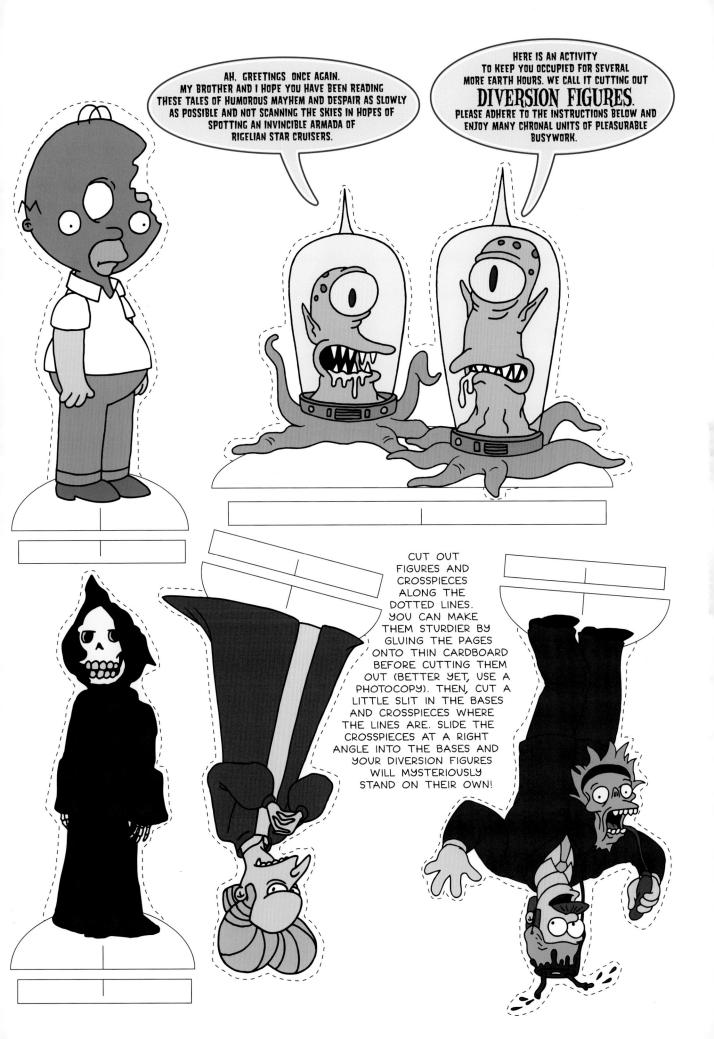

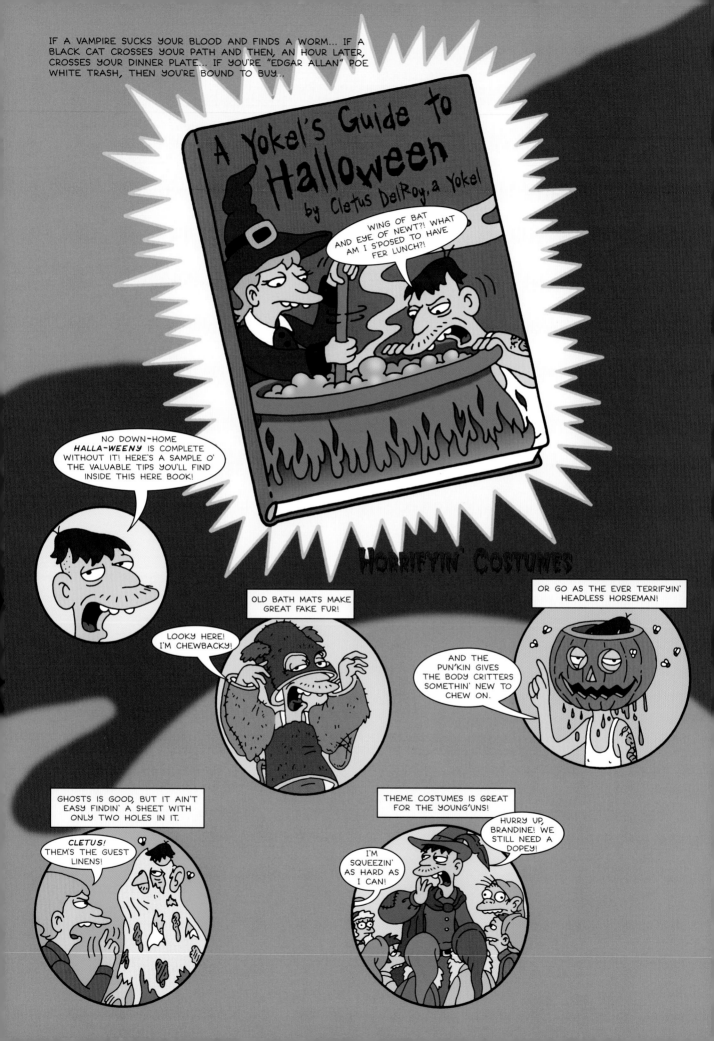

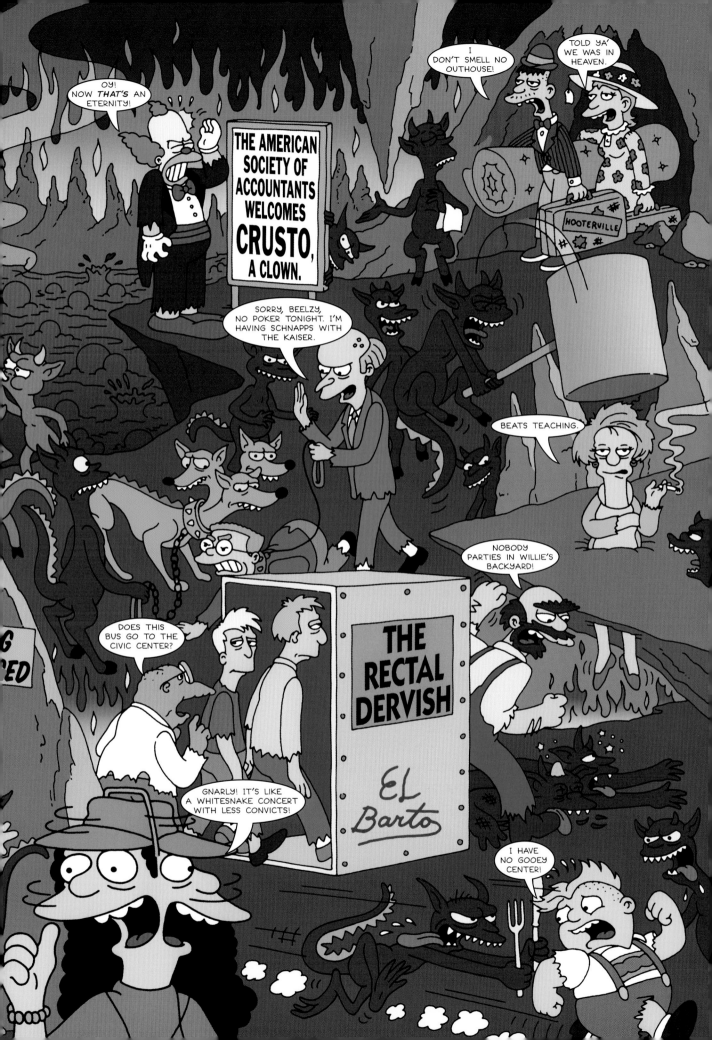

Revealed at last...

THE COSMIC SECRETS OF

KANG & KODOS' SPACESHIP

I AM KANG. MY SISTER KODOS AND I BRING TIDINGS FROM A DISTANT PLANET WHOSE NAME ALONE WOULD MELT YOUR CEREBRAL CORTEX. WE BID YOU TO TOUR OUR TRANS-GALACTIC STAR SAUCER AS A GESTURE OF GOODWILL AND LOVE. IT HAS NOTHING TO DO WITH OBTAINING SAMPLES OF YOUR GENETIC CODE TO BETTER VAPORIZE ALL LIFE AND PREPARE YOUR PLANET FOR FRESH COLONIZATION. PEACE AND HARMONIES FOR ALL!

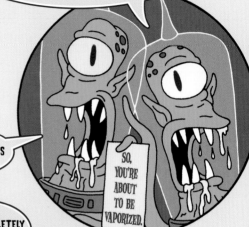

IT'S ALL EXPLAINED IN THIS PAMPHLET.

SO, YOU'RE ABOUT TO BE VAPORIZED.

HYDRO-PNEUMATIC SLEEP TUBES

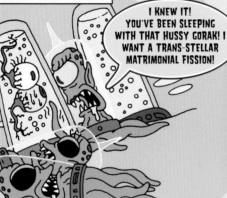

I KNEW IT! YOU'VE BEEN SLEEPING WITH THAT HUSSY GORAK! I WANT A TRANS-STELLAR MATRIMONIAL FISSION!

IT MEANS SOMETHING COMPLETELY DIFFERENT IN OUR LANGUAGE!

RELAXATION CUBICLE

SPACE PORN

SURE IT DOES, KANG.

INTERPLANETARY ORGANISM COLLECTION

I'M OUT OF KIBBLE!

GORFAN3 MIND MONKEY

VENOM-TONGUED HYPERCROOTCH OF ALGERNON-G

EARTH SCUM

BIO-DUPLICATION TUBES

CULTURAL PREPARATION COMPLEX

...AND THEIR GOD IS SOMEONE NAMED "SA-LEEN DEE-ON."

HYGENIC RECEPTICON

SOMEONE LEFT THE TOILET SEAT UP! WE ONLY HAVE TEN CENTONS TO LIVE!

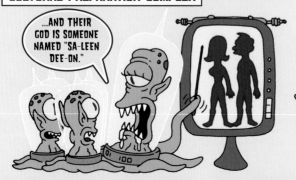

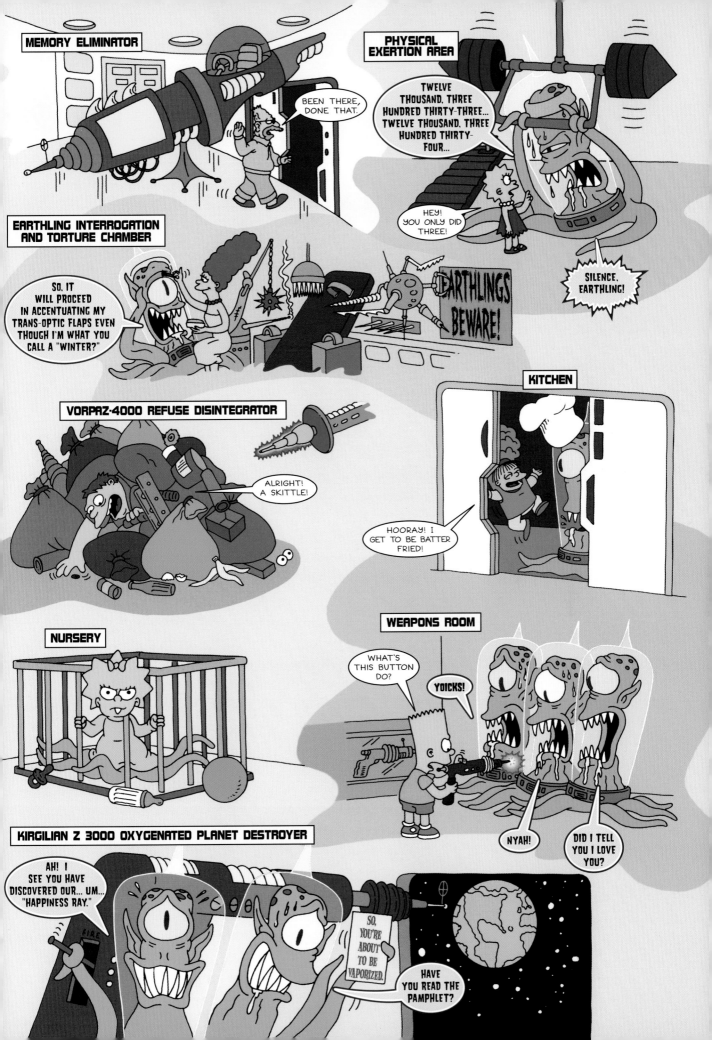

"MANY TALES THERE BE, WRIT IN BLOOD ON THE SEA..."

Elijah Dunn and the One-Armed Nun

When I peer back through my life, most years are shrouded in the mists of memory. But I'll always remember one fateful year like it was yesterday. The Year of Our Lord Nineteen Hundred and Ninety-Two. 'Twas a simpler time. The Berlin Wall had fallen, the economy was on the rise, and everyone was sure that Norm from "Cheers" would have his own hit show. Truly a time of sunshine and innocence. But Mother Ocean had far more ominous weather in store for me and the ill-fated crew of the SS *Natalie Wood*.

'Twas the middle of November. At sea for six months, we were a ship with no home. Burdened with a cargo of two thousand sticks of deodorant, we'd been turned away from ports in France and Italy, and we didn't have much hope for Turkey. The crew's morale had sunk to the bottom. I knew that at the next port o' call I'd lose more than the usual amount of men to bars, brothels, and the siren call of real estate sales. It seemed the only thing that kept the men from mutiny was a lad by the name of Hornpipe Joe. Every night after the dinner bell, Joe would hoist himself into the riggin' with his accordion and play a version of "Lady of Spain" so lovely even Ironeye Williams would shed a rusty tear. But that night, everything would change.

'Twas nine bells and most of us were down in the hold playing a game we'd invented called deodorant bowlin'. I'd been winnin', but as the saying goes, "No one really wins in deodorant bowlin'." On deck, Joe had already finished "Lady of Spain" and was beginnin' a longer, more complicated version of "Lady of Spain," when suddenly there was a horrible scream, arrgh, like the wail of the banshee herself. At first we assumed it was nothin' more than Barnaby Tench. Ol' Barnaby hated "Lady of Spain" and every time he heard it he'd protest by stabbin' himself in the shin with a fork. Or perhaps it was Bosun Diggs who hated "Lady of Spain" so much he'd pour hot wax in his ears, while yellin' "Quit playin' that crappy 'Lady of Spain!'" But this scream was different, for after this scream, the accordion music stopped cold as a heartbeat. I ran on deck as fast as I could to find the night watch white as a mainsail, the blood drained from his face. Slowly he held aloft a gruesome spectacle — Joe's accordion, and Joe's bloody shirt... with the right sleeve

missing. With barely a gasp, the night watch whispered, "Elijah Dunn!"

Elijah Dunn was a name known by all mariners, and it shivered our timbers like wet wool. Many years ago, Elijah had been a cook on the SS *Agnew*, a garbage scow sailin' from the mighty garbage mines of Newark. Of all the jobs in sailordom, garbage scow cook was probably the worst. Every night the men would come up with clever new barbs about his cookin', like "What is this garbage?" and "You call this Salisbury steak? I calls it Salisbury boot!" Needless to say, Elijah was an ornery cuss who kept to himself, his only friend a parrot named Arthur that he'd taught to speak. But Arthur was a drunk, and theirs soon became an abusive

relationship that ended in tears. By year's end, Elijah's heart was a barnacle-covered hull at the bottom of the ocean, a heart that could only be salvaged by the romance of a beautiful woman. And that woman would be Sister Mary Catherine, the one-armed nun.

She came aboard on Staten Island, headed east to the Hamptons on a mission to minister to the nearly unwealthy. Aye, she was a beauty! Broad of beam, stout of chest and dressed head-to-toe in luxuriant, form-concealin' black. But like the most radiant diamond, she had one minor flaw. She was missing an arm, lost during her days as a competitive lumberjack. But that was a minor flaw indeed for as soon as she stepped on deck, Elijah's heart leapt up from the very depth of his core. That afternoon, Elijah went all-out preparin' the evening meal. Even the crew was astounded, praisin' that the food had decreased in stench by at least twenty percent, maybe twenty-two. But Elijah saved the sweetest morsel for dessert. At that moment he announced that by the end of the night, he would take Mary Catherine's one good hand in the holy vow of marriage. The room sat stunned for what seemed like an eternity until Mary Catherine finally stood up and decried in tones clear as a clarion bell, "No, you nitwit, I'm a nun!"

But Elijah stood his ground, "Do not let society's cruel gaze wither our love! I know you have but one arm, and it matters not! For how many arms are needed for a kiss? How many arms does it take to share a soul?!" At which someone from the crowd was moved to declare, "Yo, looney tunes, she's a nun!" But Elijah would not be deterred. He grabbed Mary Catherine and rushed her out on deck where the Captain was enjoyin' the night air. Elijah's heart sang with passion, "We know our romance will be spurned by the nattering nabobs and militant 'two-armers' on the boat, but surely you as captain can see we must be conjoined in the holiest of matrimonies!" The Captain took a long pensive draw on his pipe and then replied, "Are you on goofballs? 'Cause if you are, I don't want you handlin' the can opener." This was the last straw for the star-crossed lover. Elijah stood atop the railin', cryin', "Come with me, my one true love, and we shall be married by the sea herself in the home of the eight-armed octopus and the no-armed eel, a place where arms do not matter, only love!... You are comin' with me, right?" Mary Catherine shook her head. "Well, then help me get down." But it was too late. For at that very moment, Elijah slipped and fell off the rail and as he fell, he called out, "Don't worry my sweet! I shall avenge your despair! Two-armers shall pay for our lost looooove!" And with a splash, he was gone. Well, he wasn't quite gone, he was flounderin' in the water behind the boat, but unfortunately it was at this very time the scow chose to dump its garbage.

And now, out in the middle of the Mediterranean, Elijah's gruesome revenge had come to pass. We searched fore and aft for young Hornpipe Joe, but found not a stitch of clothes, not a drop of blood. And all the while, despite our efforts, we knew in our hearts that Joe had been snatched away into the deepenin' fog of the Other Side, earthly payment for the spirit of lost love. And to this day, when the ocean breeze lies still and the air hangs tight like a winter coat, I remember Joe and his accordion and his endless versions of "Lady of Spain" playin' over and over and over, and I think, "Thank God he's dead."

Kangboro

Welcome to My Flavor Trap

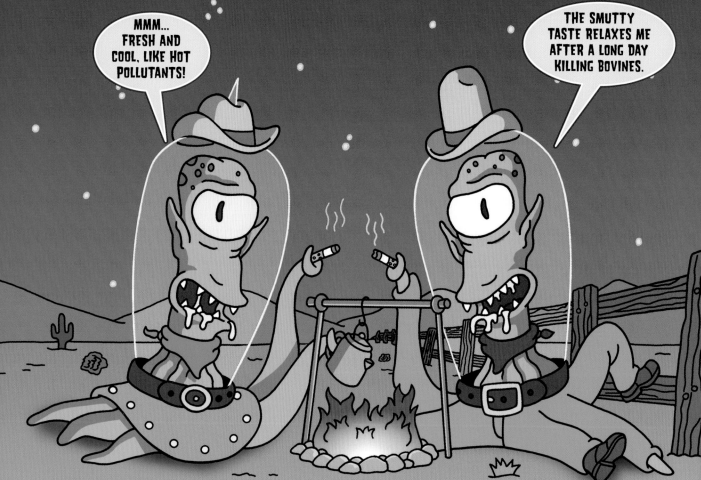

When your puny sun has set and the hours of labor have ceased, you may then enjoy the smooth taste of a Kangboro soot-inhaling tube. Sitting around a flame-hole, gazing up at the stars, you can relax in your ignorance of a planet known as Rigel-4 and the violent devastation its inhabitants are preparing to inflict upon you. Within a matter of solar days, your people will be running around, their heads aflame like so many soot-inhaling tubes, screaming that they are in flavor country. But now is not the time to prepare for the upcoming apocalypse.

Now is **your** time.

WARNING TO THE SURGEON GENERAL: You will be among the first to be executed under the new regime. You might as well smoke yourself silly.

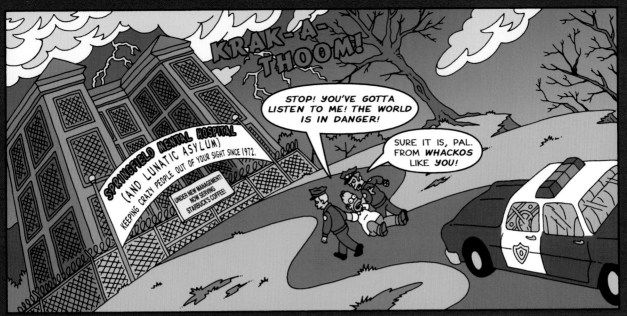

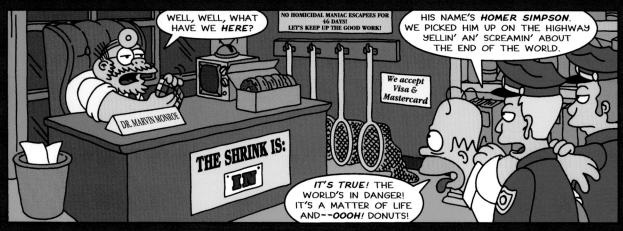

WELL, WELL, WHAT HAVE WE *HERE?*

NO HOMICIDAL MANIAC ESCAPEES FOR 46 DAYS! LET'S KEEP UP THE GOOD WORK!

HIS NAME'S *HOMER SIMPSON.* WE PICKED HIM UP ON THE HIGHWAY YELLIN' AN' SCREAMIN' ABOUT THE END OF THE WORLD.

DR. MARVIN MONROE

We accept Visa & Mastercard

THE SHRINK IS: *IN*

IT'S *TRUE!* THE WORLD'S IN DANGER! IT'S A MATTER OF LIFE AND--*OOOH!* DONUTS!

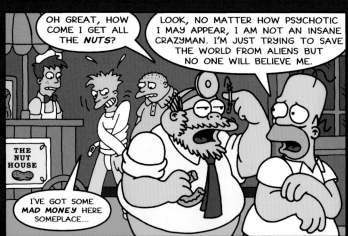

OH GREAT, HOW COME I GET ALL THE *NUTS?*

LOOK, NO MATTER HOW PSYCHOTIC I MAY APPEAR, I AM NOT AN INSANE CRAZYMAN. I'M JUST TRYING TO SAVE THE WORLD FROM ALIENS BUT NO ONE WILL BELIEVE ME.

THE NUT HOUSE

I'VE GOT SOME *MAD MONEY* HERE SOMEPLACE...

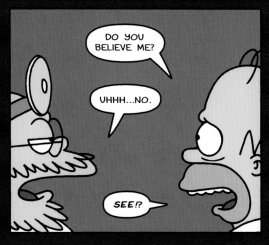

DO YOU BELIEVE ME?

UHHH...NO.

SEE!?

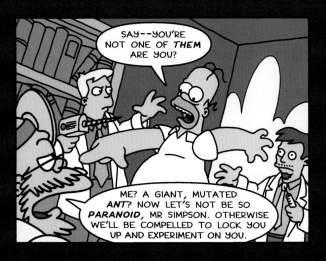

SAY--YOU'RE NOT ONE OF *THEM* ARE YOU?

ME? A GIANT, MUTATED *ANT?* NOW LET'S NOT BE SO *PARANOID,* MR SIMPSON. OTHERWISE WE'LL BE COMPELLED TO LOCK YOU UP AND EXPERIMENT ON YOU.

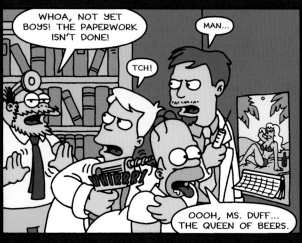

WHOA, NOT YET BOYS! THE PAPERWORK ISN'T DONE!

MAN...

TCH!

WHIRRR!

OOOH, MS. DUFF... THE QUEEN OF BEERS.

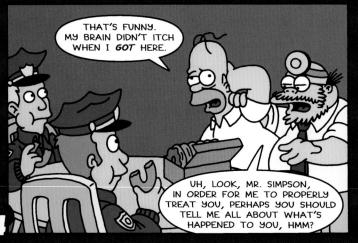

THAT'S FUNNY. MY BRAIN DIDN'T ITCH WHEN I *GOT* HERE.

UH, LOOK, MR. SIMPSON, IN ORDER FOR ME TO PROPERLY TREAT YOU, PERHAPS YOU SHOULD TELL ME ALL ABOUT WHAT'S HAPPENED TO YOU, HMM?

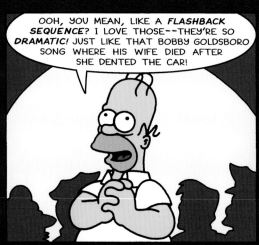

OOH, YOU MEAN, LIKE A *FLASHBACK SEQUENCE?* I LOVE THOSE--THEY'RE SO *DRAMATIC!* JUST LIKE THAT BOBBY GOLDSBORO SONG WHERE HIS WIFE DIED AFTER SHE DENTED THE CAR!

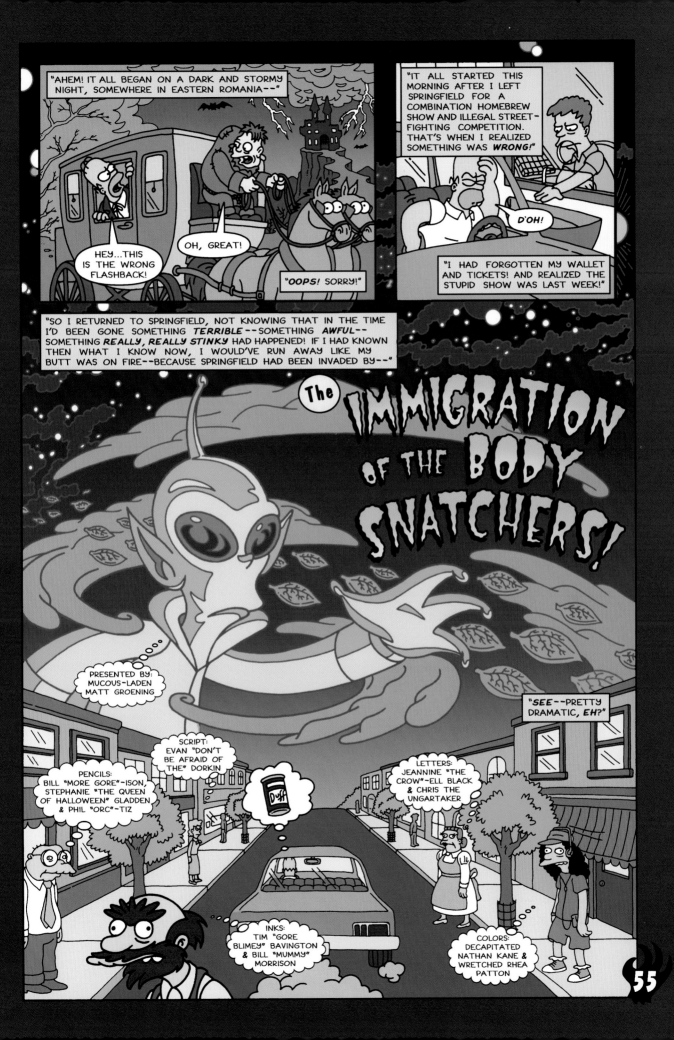

"AHEM! IT ALL BEGAN ON A DARK AND STORMY NIGHT, SOMEWHERE IN EASTERN ROMANIA--"

HEY...THIS IS THE WRONG FLASHBACK!

OH, GREAT!

"OOPS! SORRY!"

"IT ALL STARTED THIS MORNING AFTER I LEFT SPRINGFIELD FOR A COMBINATION HOMEBREW SHOW AND ILLEGAL STREET-FIGHTING COMPETITION. THAT'S WHEN I REALIZED SOMETHING WAS WRONG!"

D'OH!

"I HAD FORGOTTEN MY WALLET AND TICKETS! AND REALIZED THE STUPID SHOW WAS LAST WEEK!"

"SO I RETURNED TO SPRINGFIELD, NOT KNOWING THAT IN THE TIME I'D BEEN GONE SOMETHING TERRIBLE--SOMETHING AWFUL-- SOMETHING REALLY, REALLY STINKY HAD HAPPENED! IF I HAD KNOWN THEN WHAT I KNOW NOW, I WOULD'VE RUN AWAY LIKE MY BUTT WAS ON FIRE--BECAUSE SPRINGFIELD HAD BEEN INVADED BY--"

The IMMIGRATION of the BODY SNATCHERS!

PRESENTED BY: MUCOUS-LADEN MATT GROENING

"SEE--PRETTY DRAMATIC, EH?"

SCRIPT: EVAN "DON'T BE AFRAID OF THE" DORKIN

PENCILS: BILL "MORE GORE"-ISON, STEPHANIE "THE QUEEN OF HALLOWEEN" GLADDEN & PHIL "ORC"-TIZ

LETTERS: JEANNINE "THE CROW"-ELL BLACK & CHRIS THE UNGARTAKER

Duff

INKS: TIM "GORE BLIMEY" BAVINGTON & BILL "MUMMY" MORRISON

COLORS: DECAPITATED NATHAN KANE & WRETCHED RHEA PATTON

55

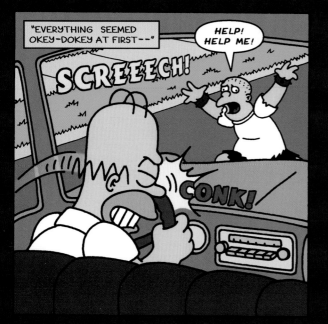

"EVERYTHING SEEMED OKEY-DOKEY AT FIRST--"

HELP! HELP ME!

SCREEECH!

CONK!

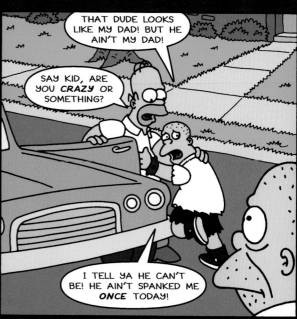

THAT DUDE LOOKS LIKE MY DAD! BUT HE AIN'T MY DAD!

SAY KID, ARE YOU *CRAZY* OR SOMETHING?

I TELL YA HE CAN'T BE! HE AIN'T SPANKED ME *ONCE* TODAY!

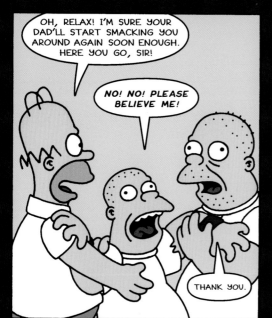

OH, RELAX! I'M SURE YOUR DAD'LL START SMACKING YOU AROUND AGAIN SOON ENOUGH. HERE YOU GO, SIR!

NO! NO! PLEASE BELIEVE ME!

THANK YOU.

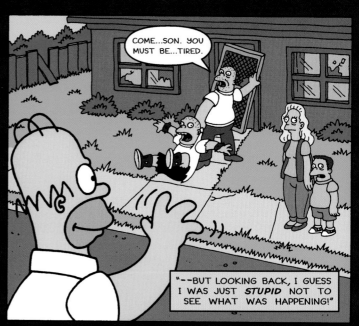

COME...SON. YOU MUST BE...TIRED.

"--BUT LOOKING BACK, I GUESS I WAS JUST *STUPID* NOT TO SEE WHAT WAS HAPPENING!"

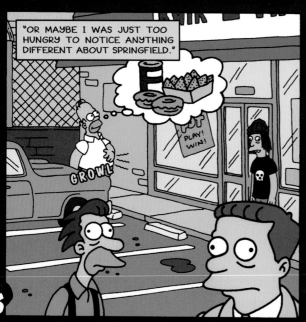

"OR MAYBE I WAS JUST TOO HUNGRY TO NOTICE ANYTHING DIFFERENT ABOUT SPRINGFIELD."

PLAY! WIN!

GROWL

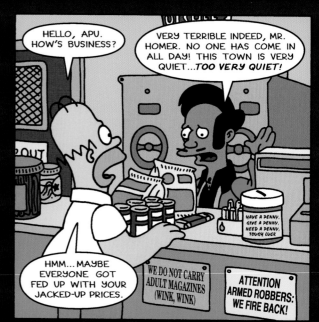

HELLO, APU. HOW'S BUSINESS?

VERY TERRIBLE INDEED, MR. HOMER. NO ONE HAS COME IN ALL DAY! THIS TOWN IS VERY QUIET...*TOO VERY QUIET!*

HAVE A PENNY, GIVE A PENNY, NEED A PENNY, TOUGH LUCK.

HMM...MAYBE EVERYONE GOT FED UP WITH YOUR JACKED-UP PRICES.

WE DO NOT CARRY ADULT MAGAZINES (WINK, WINK)

ATTENTION ARMED ROBBERS: WE FIRE BACK!

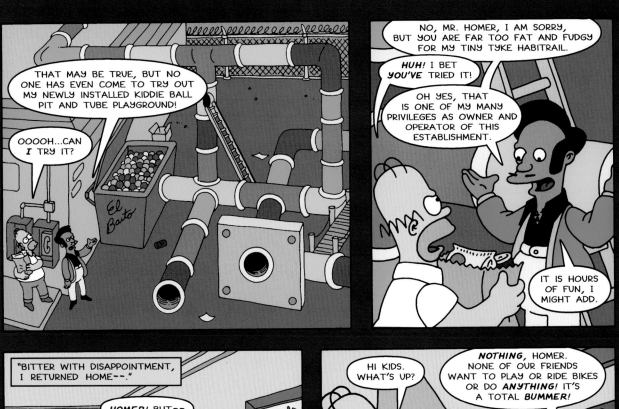
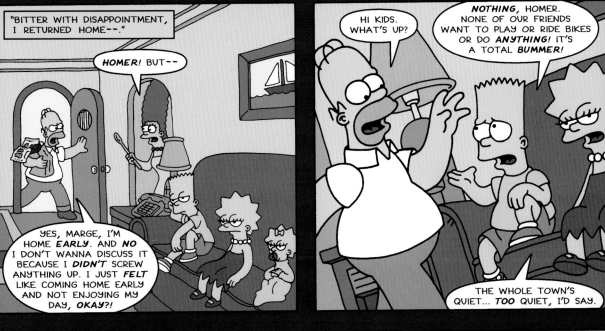
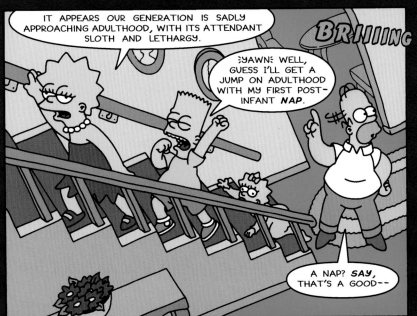

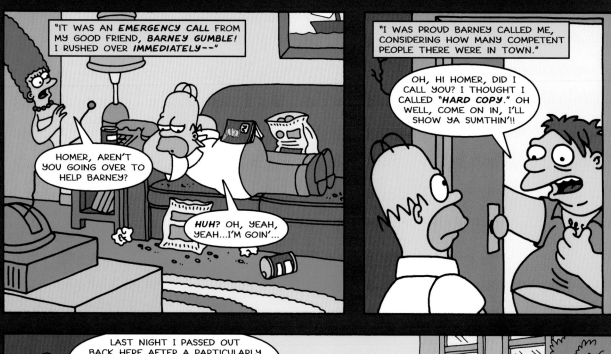

"IT WAS AN *EMERGENCY CALL* FROM MY GOOD FRIEND, *BARNEY GUMBLE!* I RUSHED OVER *IMMEDIATELY--*"

HOMER, AREN'T YOU GOING OVER TO HELP BARNEY?

HUH? OH, YEAH, YEAH...I'M GOIN'...

"I WAS PROUD BARNEY CALLED ME, CONSIDERING HOW MANY COMPETENT PEOPLE THERE WERE IN TOWN."

OH, HI HOMER, DID I CALL YOU? I THOUGHT I CALLED *"HARD COPY."* OH WELL, COME ON IN, I'LL SHOW YA SUMTHIN'!!

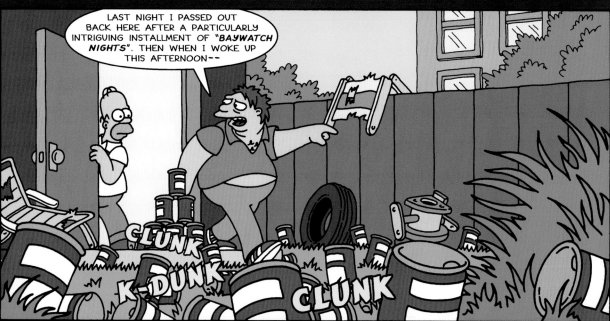

LAST NIGHT I PASSED OUT BACK HERE AFTER A PARTICULARLY INTRIGUING INSTALLMENT OF *"BAYWATCH NIGHTS"*. THEN WHEN I WOKE UP THIS AFTERNOON--

CLUNK

K-DUNK

CLUNK

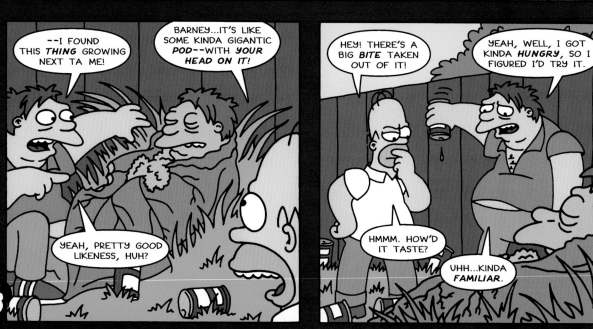

--I FOUND THIS *THING* GROWING NEXT TA ME!

BARNEY...IT'S LIKE SOME KINDA GIGANTIC *POD*--WITH *YOUR HEAD ON IT!*

YEAH, PRETTY GOOD LIKENESS, HUH?

HEY! THERE'S A BIG *BITE* TAKEN OUT OF IT!

YEAH, WELL, I GOT KINDA *HUNGRY*, SO I FIGURED I'D TRY IT.

HMMM. HOW'D IT TASTE?

UHH...KINDA *FAMILIAR.*

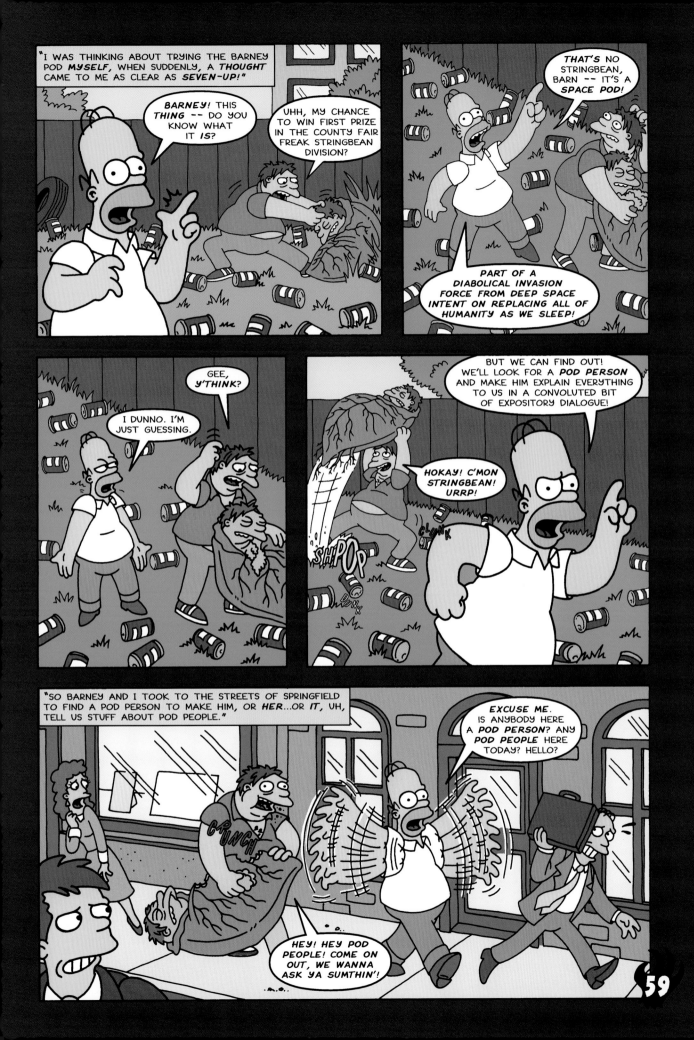

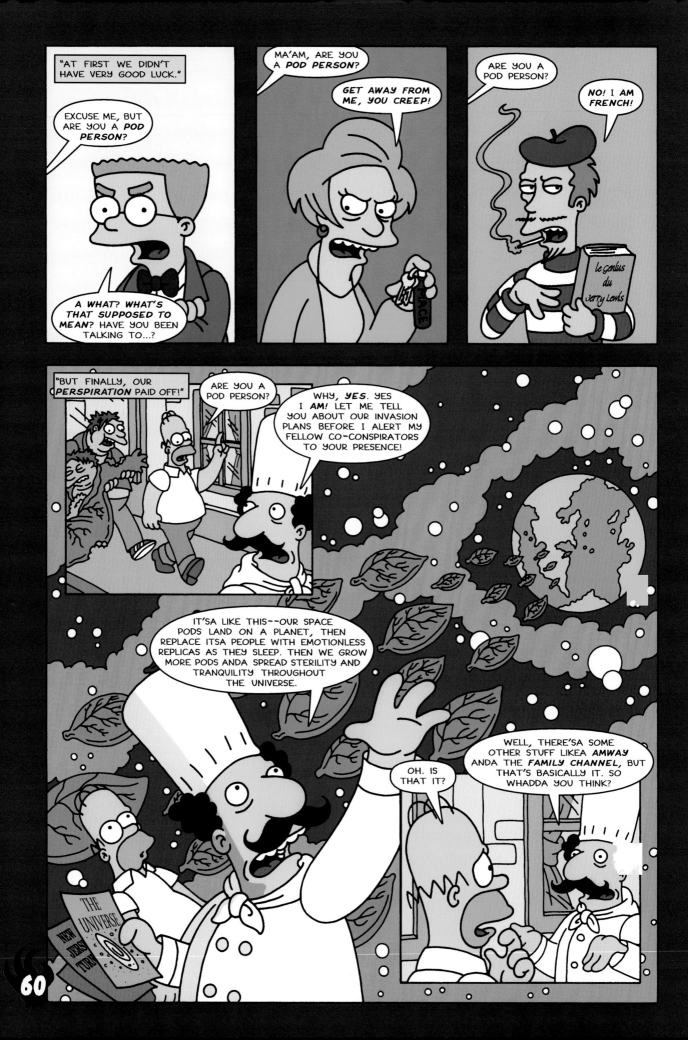

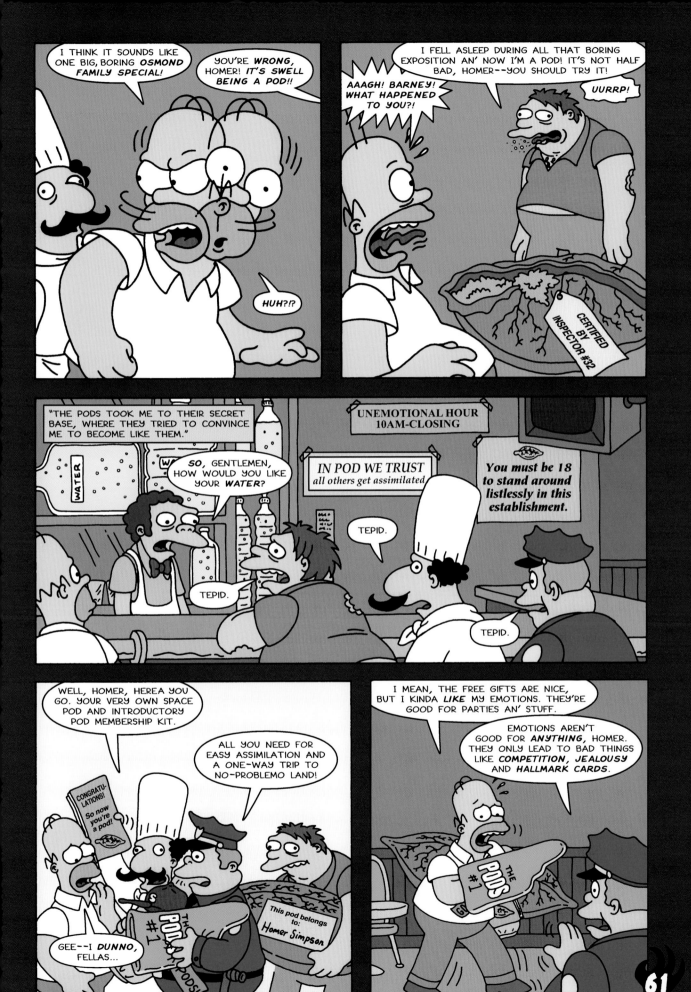

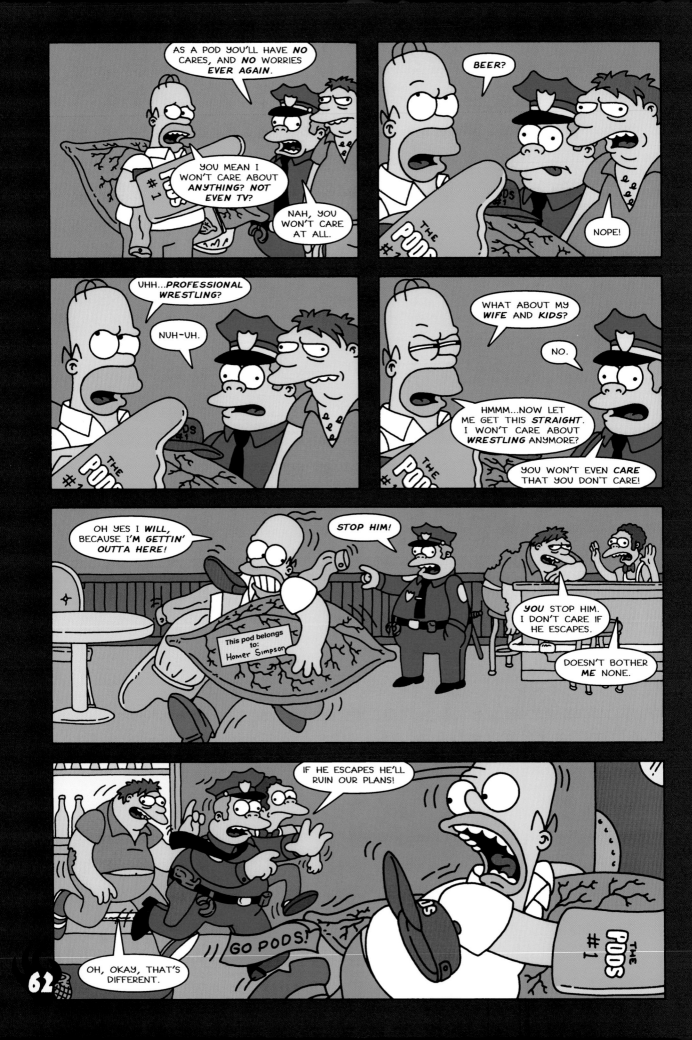

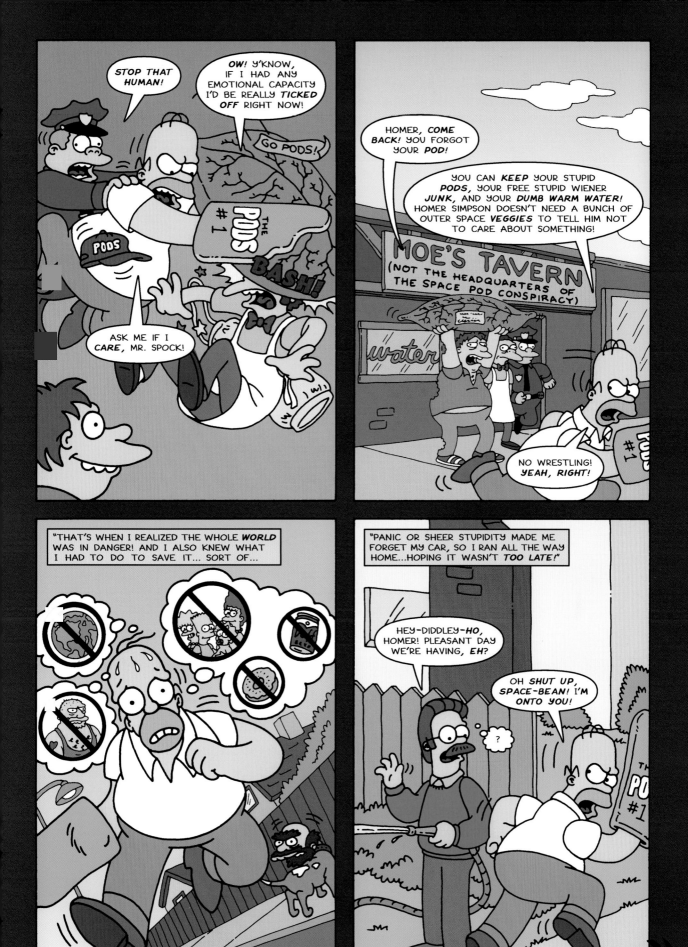

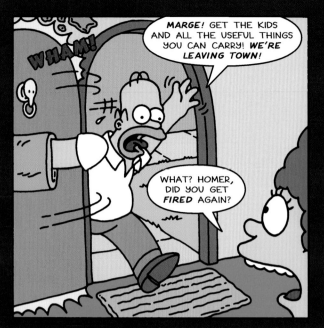

MARGE! GET THE KIDS AND ALL THE USEFUL THINGS YOU CAN CARRY! WE'RE LEAVING TOWN!

WHAT? HOMER, DID YOU GET FIRED AGAIN?

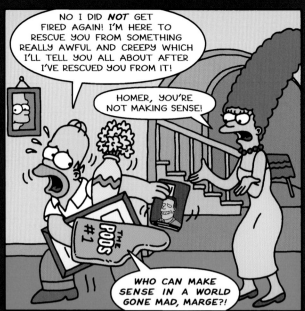

NO I DID NOT GET FIRED AGAIN! I'M HERE TO RESCUE YOU FROM SOMETHING REALLY AWFUL AND CREEPY WHICH I'LL TELL YOU ALL ABOUT AFTER I'VE RESCUED YOU FROM IT!

HOMER, YOU'RE NOT MAKING SENSE!

WHO CAN MAKE SENSE IN A WORLD GONE MAD, MARGE?!

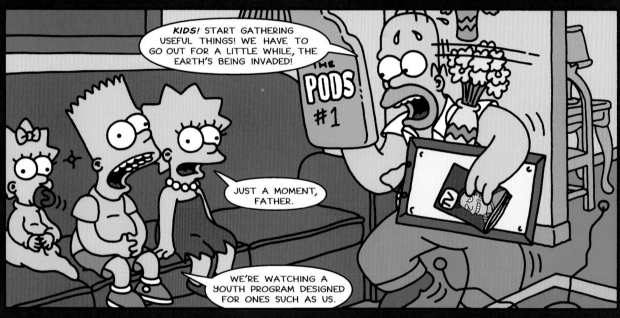

KIDS! START GATHERING USEFUL THINGS! WE HAVE TO GO OUT FOR A LITTLE WHILE, THE EARTH'S BEING INVADED!

JUST A MOMENT, FATHER.

WE'RE WATCHING A YOUTH PROGRAM DESIGNED FOR ONES SUCH AS US.

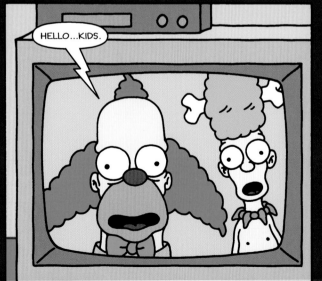

HELLO...KIDS.

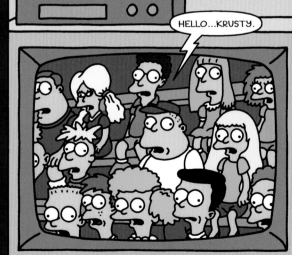

HELLO...KRUSTY.

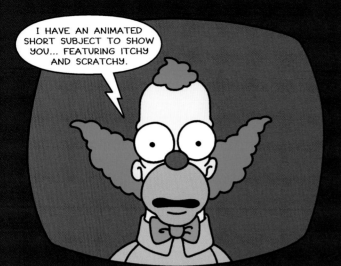

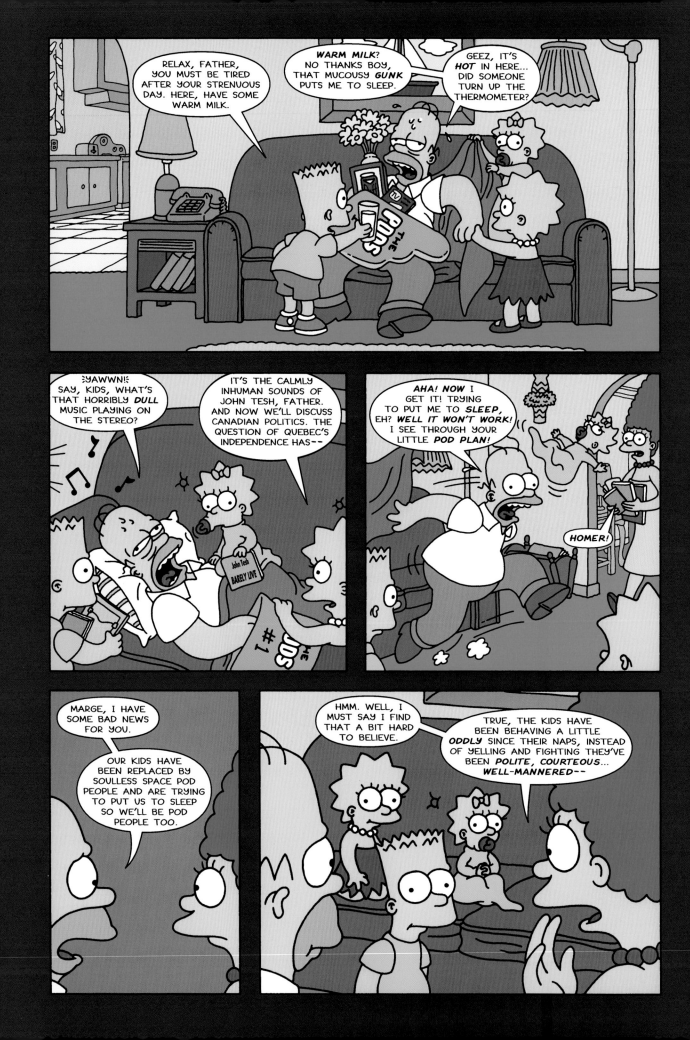

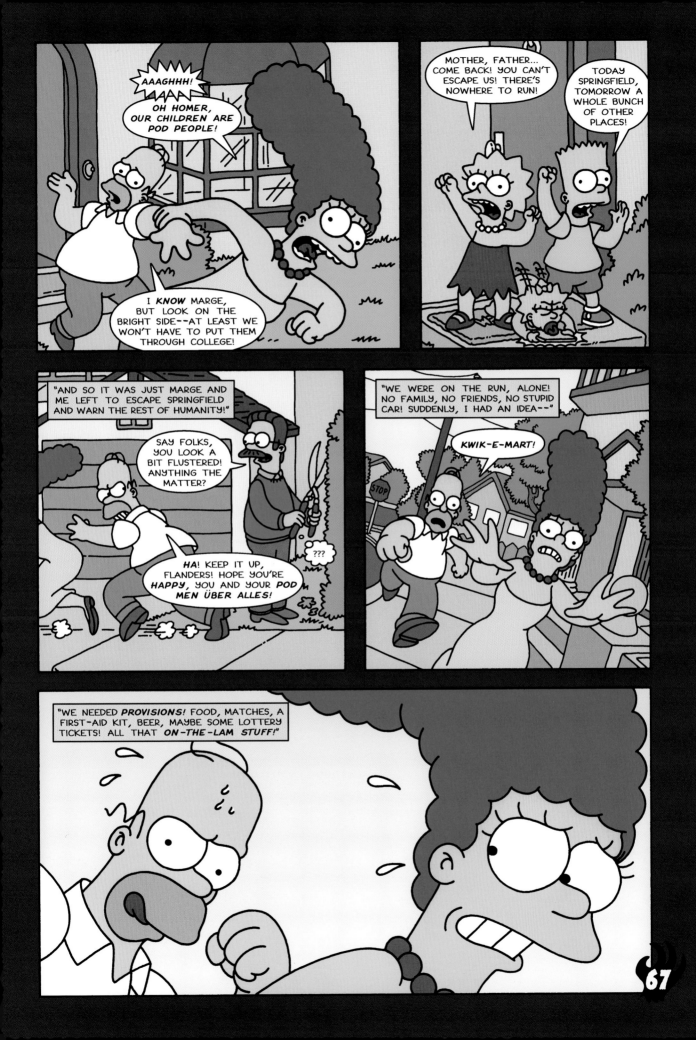

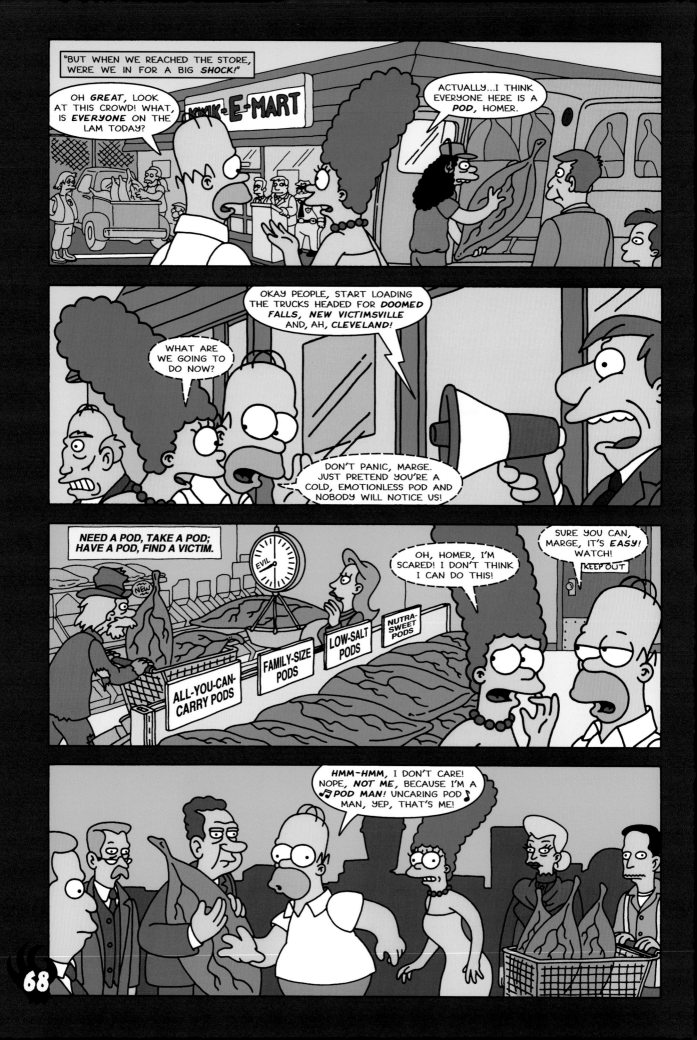

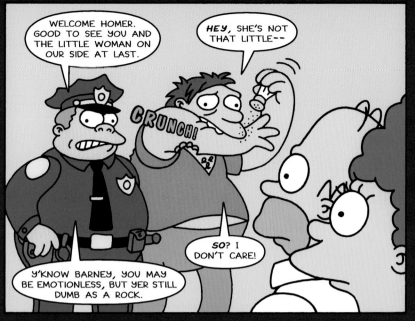

WELCOME HOMER. GOOD TO SEE YOU AND THE LITTLE WOMAN ON OUR SIDE AT LAST.

HEY, SHE'S NOT THAT LITTLE--

CRUNCH!

SO? I DON'T CARE!

Y'KNOW BARNEY, YOU MAY BE EMOTIONLESS, BUT YER STILL DUMB AS A ROCK.

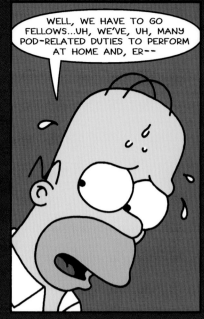

WELL, WE HAVE TO GO FELLOWS...UH, WE'VE, UH, MANY POD-RELATED DUTIES TO PERFORM AT HOME AND, ER--

OMIGOSH! MARGE, LOOK! LOOK! LOOK!

DONUT ARTIFACT SALE
all you can stomach

DONUT SALE!

MINI...

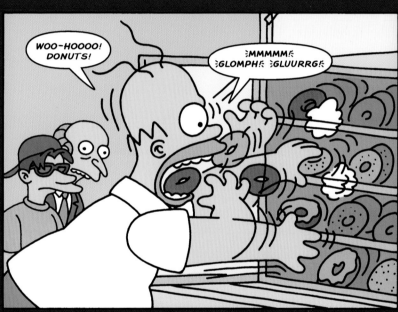

WOO-HOOOO! DONUTS!

MMMMM GLOMPH GLUURRG

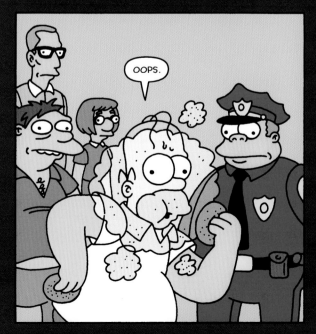

OOPS.

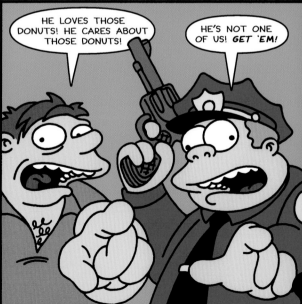

HE LOVES THOSE DONUTS! HE CARES ABOUT THOSE DONUTS!

HE'S NOT ONE OF US! *GET 'EM!*

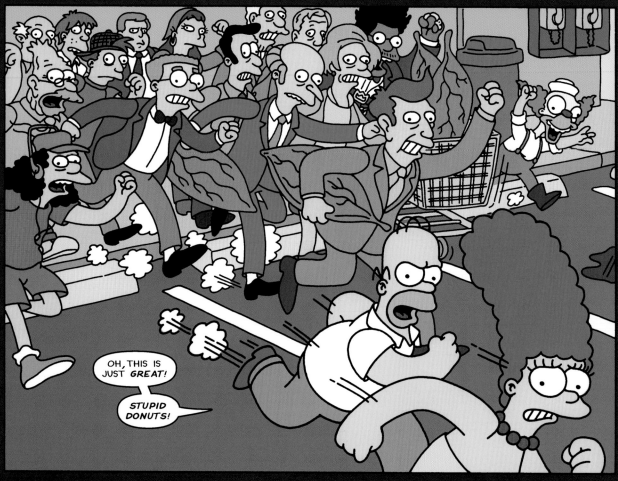

OH, THIS IS JUST *GREAT!*

STUPID DONUTS!

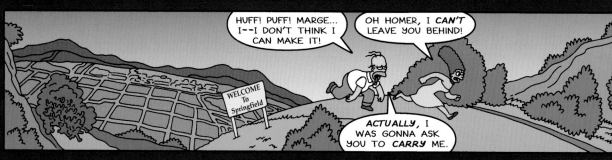

HUFF! PUFF! MARGE... I--I DON'T THINK I CAN MAKE IT!

OH HOMER, I *CAN'T* LEAVE YOU BEHIND!

WELCOME To Springfield

ACTUALLY, I WAS GONNA ASK YOU TO *CARRY* ME.

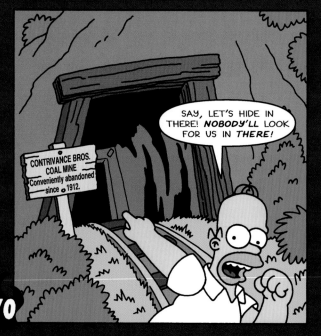

SAY, LET'S HIDE IN THERE! *NOBODY'LL* LOOK FOR US IN *THERE!*

CONTRIVANCE BROS. COAL MINE Conveniently abandoned since 1912.

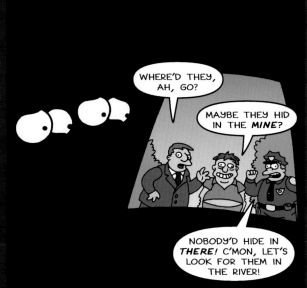

WHERE'D THEY, AH, GO?

MAYBE THEY HID IN THE *MINE?*

NOBODY'D HIDE IN *THERE!* C'MON, LET'S LOOK FOR THEM IN THE RIVER!

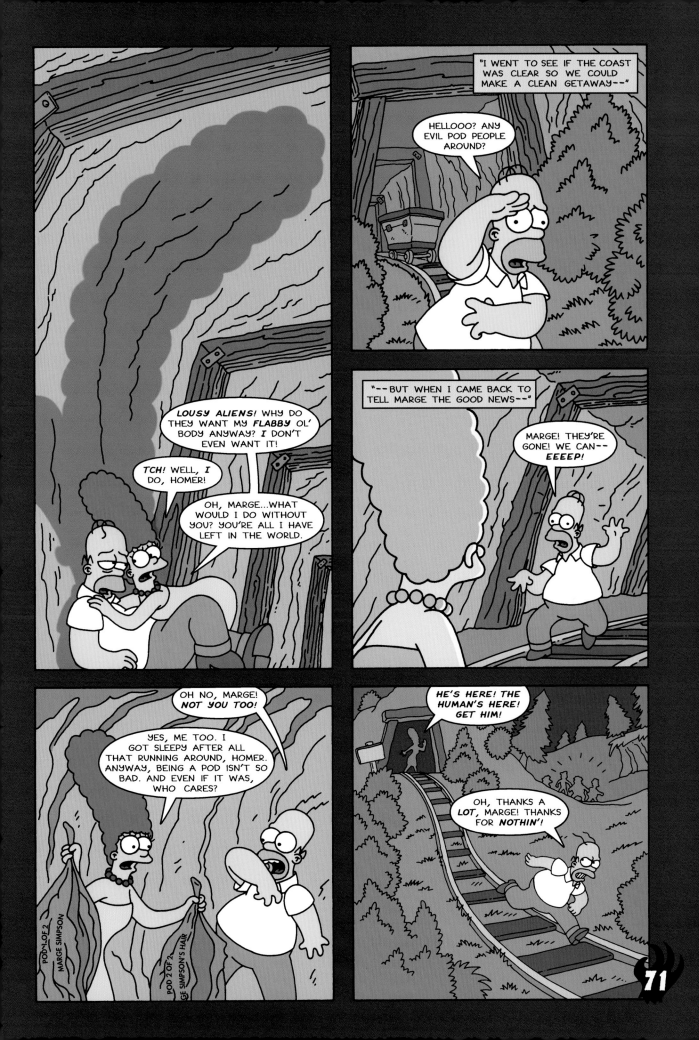

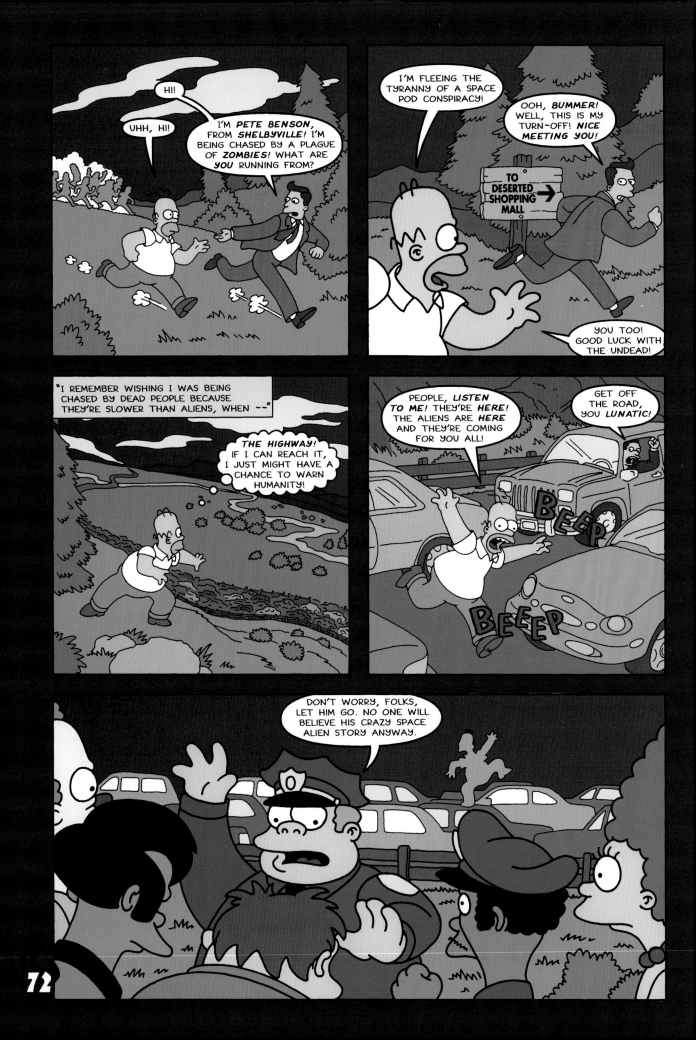

WELL...I COULD BE WRONG.

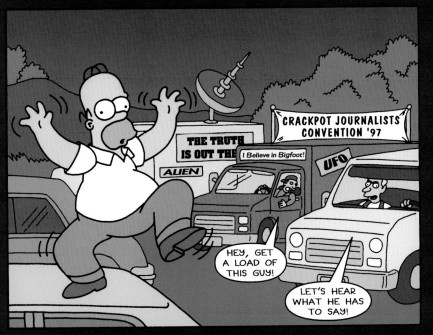

CRACKPOT JOURNALISTS CONVENTION '97

THE TRUTH IS OUT THE

I Believe in Bigfoot!

ALIEN

UFO

HEY, GET A LOAD OF THIS GUY!

LET'S HEAR WHAT HE HAS TO SAY!

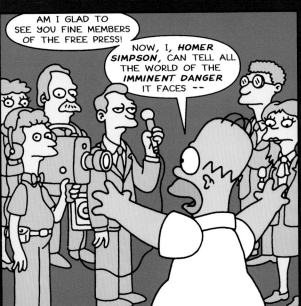

AM I GLAD TO SEE YOU FINE MEMBERS OF THE FREE PRESS!

NOW, I, *HOMER SIMPSON*, CAN TELL ALL THE WORLD OF THE *IMMINENT DANGER* IT FACES --

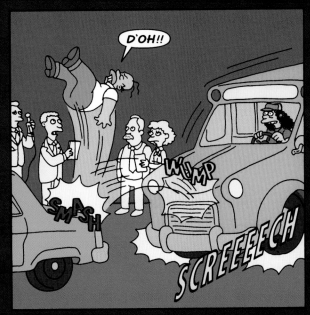

D'OH!!

SMASH

WUMP

SCREEEECH

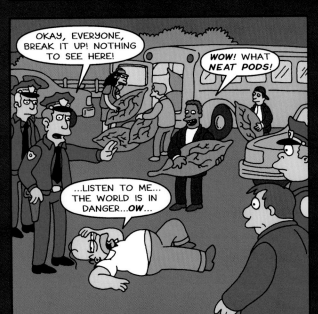

OKAY, EVERYONE, BREAK IT UP! NOTHING TO SEE HERE!

WOW! WHAT NEAT PODS!

...LISTEN TO ME... THE WORLD IS IN DANGER...*OW*...

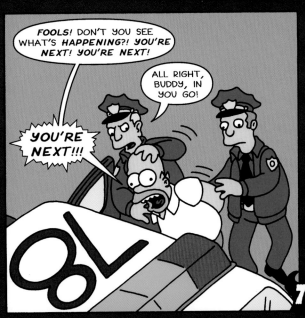

FOOLS! DON'T YOU SEE WHAT'S *HAPPENING*?! YOU'RE *NEXT*! YOU'RE NEXT!

ALL RIGHT, BUDDY, IN YOU GO!

YOU'RE NEXT!!!

73

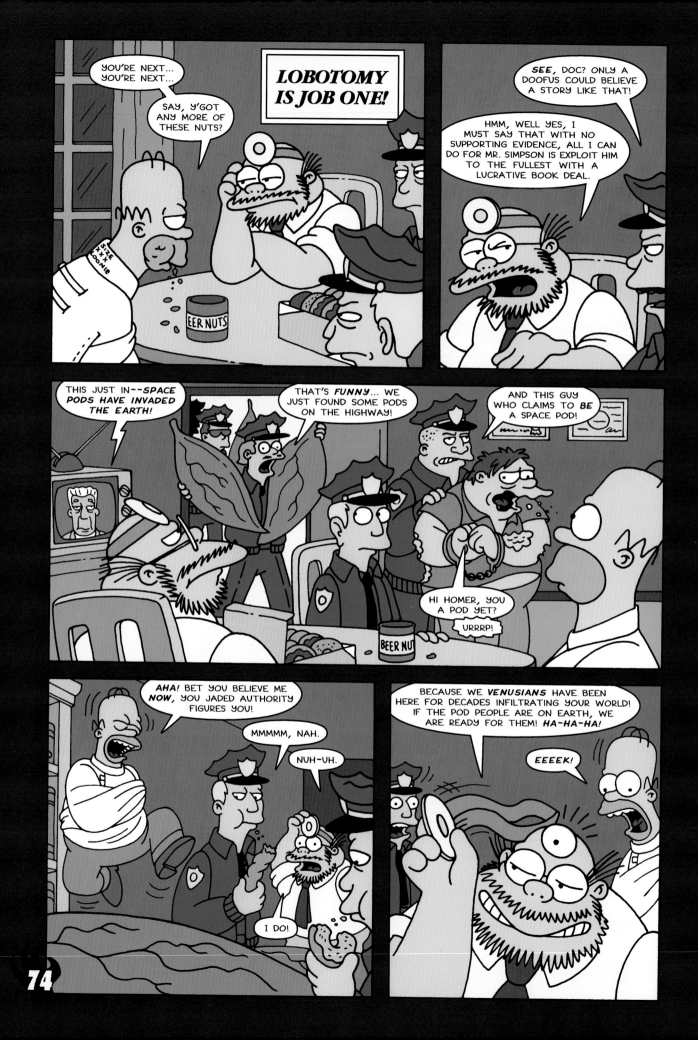

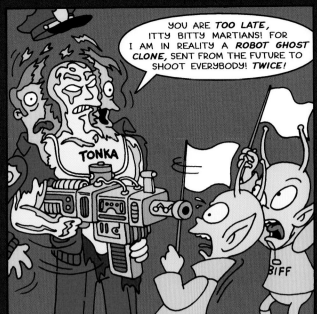

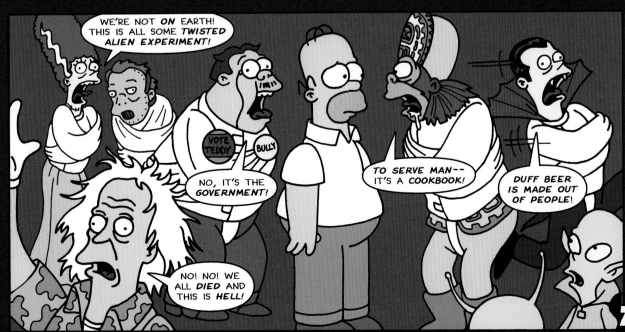

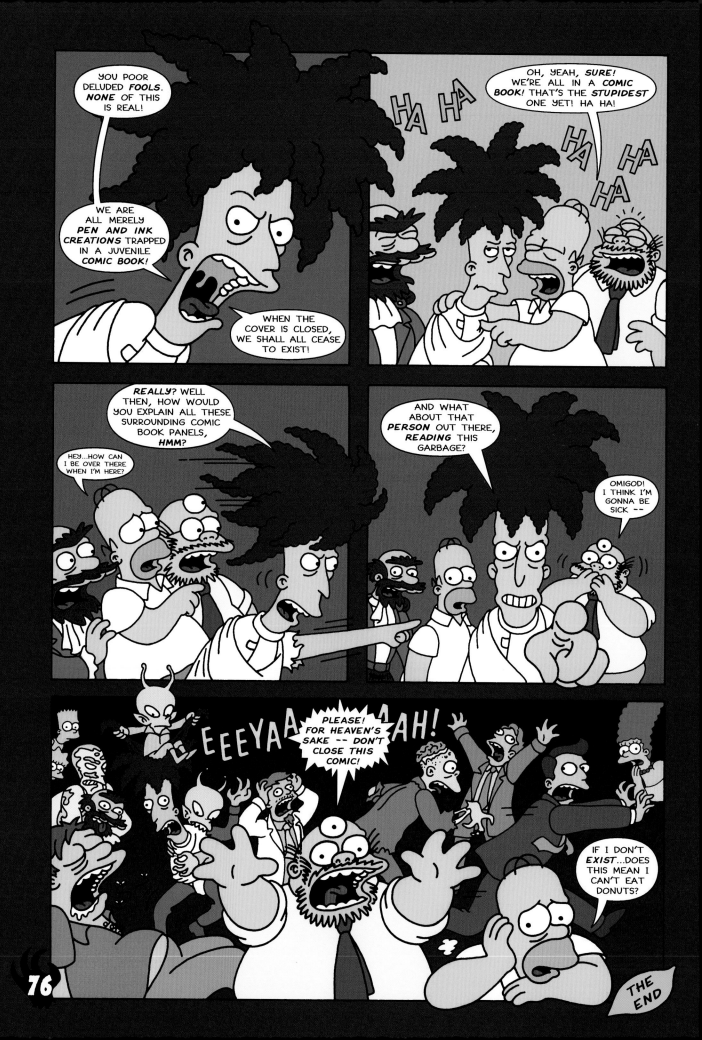

In High School, They Expected to Find
Good Times, Wild Parties, and Infant-Eating Contests.
What They Didn't Expect to Find...
Was Love.
Teen Superstar Kangy in...

Underage Comedy Hijinks II:

The Continuance of Underage Comedy Hijinks.

"You'll love Kangy when you realize he's not an old person!"
— *Movie Minute*

"I enjoyed Kodos' surgically expanded thorax!"
– Gene Shalit

This film is clearly not designed to divert attention from the intergalactic star destroyer focusing its detonation ray at the Earth's core."
— *Newsday*

HOWDY, NEIGHBOR! OR SHOULD I SAY "NEIGH-BOO!" EVERY YEAR AT HALLOWEEN TIME PEOPLE SAY, "NEDDY, TELL ME HOW TO MAKE MY HALLOWEEN SPOOK-TER-DOODILY-RIFIC WITHOUT BREAKING THE MANY IMPORTANT SOCIAL AND ETHICAL MORES LAID DOWN FOR GOOD WHOLESOME FOLK-DIDDILY-OLK LIKE YOU AND ME." WELL, THE BIBLE DOESN'T SAY, "THOU SHALT NOT PARTY." SO HERE'S A LITTLE PRIMER I LIKE TO CALL...

HALLOWEEN HOEDOWN AT THE FLANDEROSA!

YAY! I'M CAUGHT IN LOVE'S GLORIOUS WEB!

MY LOST ISRAELITE'S GOT A WORM IN ITS BRAIN.

"SURE, BOBBING FOR APPLES IS FUN ENOUGH FOR MOST FOLK, BUT AT THE FLANDERS HUT, WE PREFER TO GO *BOBBING FOR THE LOST TRIBE OF ISRAEL!*"

"PUMPKIN CARVING CAN BE FUN. WE HOLLOW THEM OUT TO MAKE DIORAMAS OF BIBLE SCENES. THEN WE GIVE THE PUMPKIN INNARDS TO PASSING TRANSIENTS AS A FREE GIFT."

HERE YA GO!

THANKS A HELLUVA LOT. I CAN NEITHER *SMOKE* NOR *DRINK* THIS.

"TRICK-OR-TREATERS MAY EXPECT AN IMPERSONAL HANDFUL OF CANDY, BUT AT THE FLANDERS HOME THE 'TREAT' IS A HUG AND THE GLIMMERING GLOW OF FRIENDSHIP."

WHA--?!

YEAH, WELL, I ALSO GOT THEIR BLENDER.

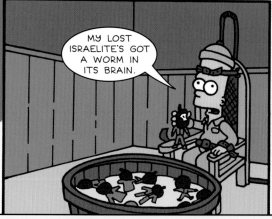
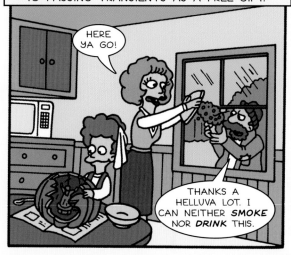
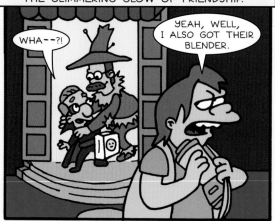

"WHEN TELLING SCARY STORIES, IT'S ALWAYS GOOD TO TAKE 'SPECIAL' PRECAUTIONS FOR THE CHILDREN."

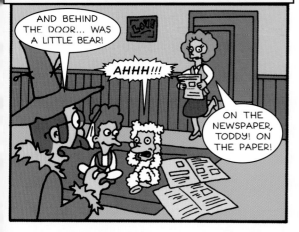

AND BEHIND THE DOOR... WAS A LITTLE BEAR!

AHHH!!!

ON THE NEWSPAPER, TODDY! ON THE PAPER!

"WHEN IT COMES TO TRICKSTERS, I DON'T JUST TURN THE OTHER CHEEK, I TURN IT **ALL** THE WAY AROUND!"

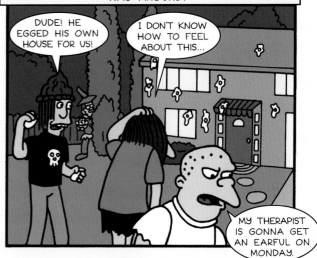

DUDE! HE EGGED HIS OWN HOUSE FOR US!

I DON'T KNOW HOW TO FEEL ABOUT THIS...

MY THERAPIST IS GONNA GET AN EARFUL ON MONDAY.

"MAKE SURE YOUR CHILDREN KNOW WHAT COSTUMES THEIR FRIENDS WILL BE WEARING TO AVOID EXCESSIVE FEAR AND CONFUSION."

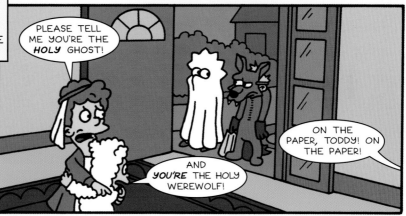

PLEASE TELL ME YOU'RE THE **HOLY** GHOST!

AND **YOU'RE** THE HOLY WEREWOLF!

ON THE PAPER, TODDY! ON THE PAPER!

"IN FACT, MOST OF THE HALLOWEEN CAST OF CHARACTERS COULD USE A LITTLE RE-NEDUCATION. SOMETIMES JUST A NEW NAME CAN MAKE THEM MUCH MORE FLAN-DIDDILY-TASTIC..."

BOLTY, THE HUGGING GIANT

SAINT BONE-ABUS

LARRY THE WELL-LOVED LEPER

COMMUNION CHARLIE

"OF COURSE, EVEN AT THE FLANDERS PAD WE RECOGNIZE THERE SHOULD BE A LITTLE SCARE IN HALLOWEEN..."

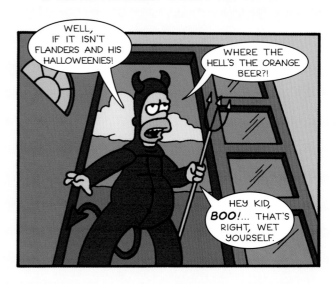

WELL, IF IT ISN'T FLANDERS AND HIS HALLOWEENIES!

WHERE THE HELL'S THE ORANGE BEER?!

HEY KID, **BOO!**... THAT'S RIGHT, WET YOURSELF.

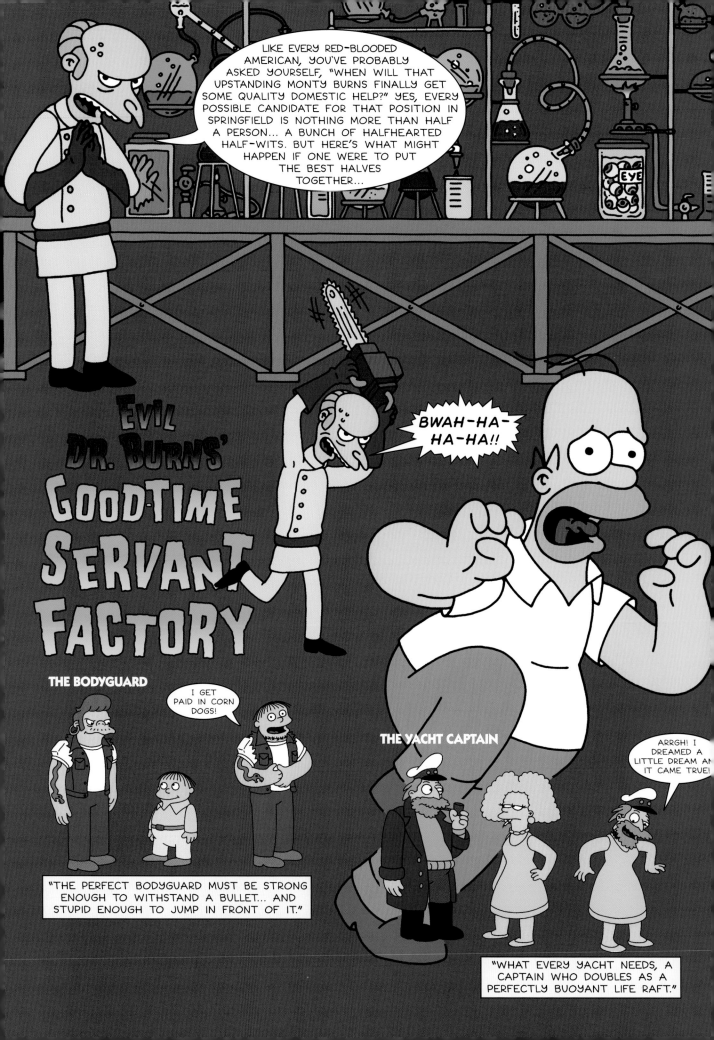

THE CHAMBERMAID

"THE PERFECT CHAMBERMAID IS FEMININE, BUT IMPAIRED FROM SEEING THE MORE, SHALL WE SAY, 'DELICATE PARTICULARS' OF A GENTLEMAN'S ANATOMY."

THE LIBRARIAN

"TO MY WAY OF THINKING, A GOOD LIBRARIAN HAS A ROBUST HUNGER FOR GREAT BOOKS... AND HANDS TOO SMALL TO STEAL THEM."

HMM...

HELLO.

UH-OH, LOOKS LIKE WE HAVE SLUGS AGAIN.

ALAS, GONE ARE THE DAYS OF THE TWELVE BURRITO LUNCH.

THE JESTER

WHOA! I DIDN'T WANT TO BE POINTED IN THAT DIRECTION!

BRAAP!

"WHEN BUILDING A JESTER, FEEL FREE TO SHOW SOME ARTISTIC FLAIR... I DID."

THE GARDENER

"A GROUNDSKEEPER PLUS A POLITICIAN... THERE'S A MAN WHO KNOWS HIS WAY AROUND MANURE!"

ACH! I'M WEARIN' UNDER-PANTIES!!

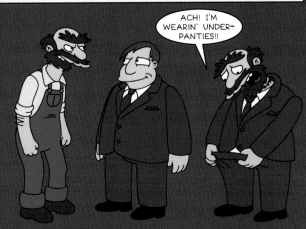

THE LACKEY

"AS HE WAS THE ONLY ABLE-BODIED WORKER ON MY ENTIRE STAFF, I DECIDED TO CLONE SMITHERS... THEN CUT BOTH OF THEM IN HALF."

THE CHEF

"THE MAN COOKING MY FOOD SHOULD HAVE A PUCKISH CREATIVITY COMBINED WITH A LOVE OF FOOD THAT KNOWS NO BOUNDS."

KNOWS NO BOUNDS, EH? KINDA LIKE HOMER'S GUT!

WHY YOU LITTLE--

ACHH! YACHH!

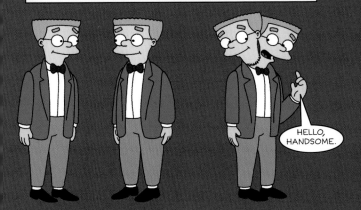

HELLO, HANDSOME.

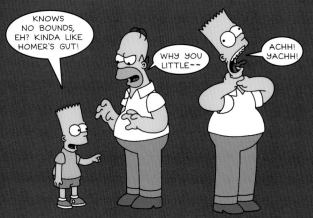

"UNFORTUNATELY, HE BECAME A LITTLE TOO IN LOVE WITH HIMSELF."

"OH, WELL, LOOKS LIKE I'LL BE EATING OUT."

AS AN EXPERT ON ALL THINGS HORRIFYING, I CAN SAFELY SAY THIS STORY WILL SCARE THE PANTS OFF OF YOU. AND IF THERE'S ONE OTHER THING I KNOW ABOUT, IT'S PANTSLESSNESS!

THE CURSE OF THE THING!

As told by bomer J. Simpson

When young bomer J. Simpson agreed to go on the beer-watching expedition deep in the heart of Beersylvania, he had no idea of the terror that would befall him on that fateful night.

Led by world-famous beer-keteer, Barney Gumble, the group had traveled by golly to the deepest part of oh, you know ... that state with the rednecks to find some beer. Coming around a bend, bomer spied an old man in a retirement home where he belongs. "Stay away from Monsterville, for that is the home of The Selmavore." bomer had heard this myth. Long ago, this fat chick named Selma had been been shaved, burlap-bagged, and thrown in the river by the church. Before she died, she swore her ghost would seek vengeance. Anyone she caught would be yammered at until their ears fell off. But bomer couldn't worry about myths. To find the beers, they had to go to Monsterland. As they left, they could hear the old man mutter, "I wish I'd left my son more money."

Because members of the group were scared, Barney agreed to sit up all night with his bomb machine. "bey look! I found a peanut in the dirt," he joked, "No really! I found a peanut!" Later that night, young bomer was awoken by gunshots followed by a hideous scream. He ran to the spot where Barney had been. Instead he found his dirt peanut and a moment later, he ate it. Suddenly, he heard a rustle in the bushes. THUMP, THUMP, SCRAPE... THUMP, THUMP, SCRAPE! Was it the Selmathing?! The guy... General whats-his-name began running back through the inky darkness toward the I have no idea what goes here. Once he reached it, he'd motor back to civilization and send for help. It seemed like an eternity, but he finally found it. His passage to safety! And as if that weren't enough, there on the plane ride home he could make out with the stewardess... He'd actually found all women love bomer the Great! But as he got closer, he realized Selma's butt was much bigger than he had imagined. Could it be Selma was actually stealing my pork rinds?

That morning in the MonsterTown Gazette there was a short article near the back: "Beetle Bailey Kisses Miss Buxley." An old man put down the paper and muttered to himself, "Why don't I ever shut up?"

Call Me HOMER

JAUNDICED JEFF SMITH–STORY & BREAKDOWNS
MAD STEPHANIE GLADDEN–PENCILS
BILL "THE HORROR, THE HORROR" MORRISON–INKS
MIKE "MOJO" SAKAMOTO–LETTERING
NATHAN "RAISIN" KANE–COLORS
MATT "DR. PAIN" GROENING–SON OF BLUBBER

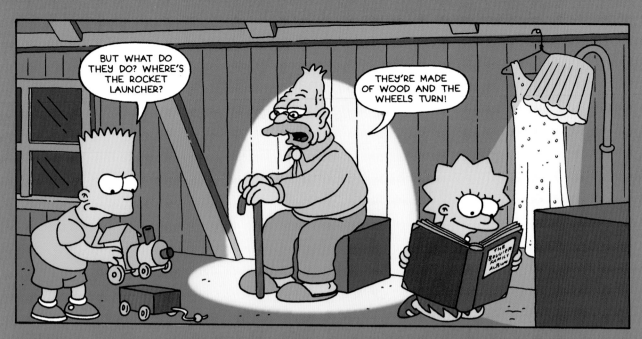

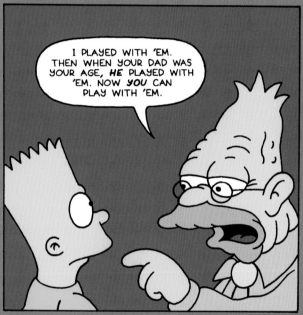

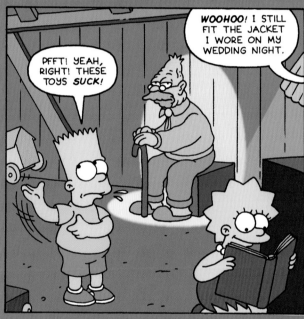

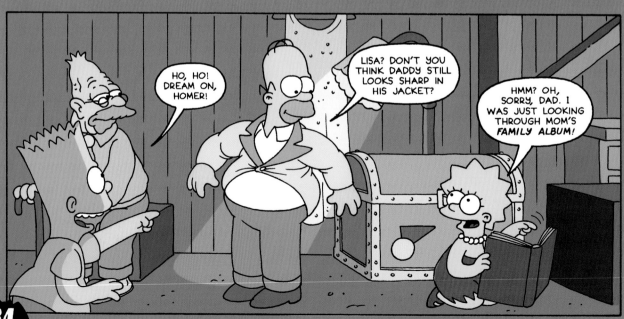

THIS IS REALLY FASCINATING! OLD PHOTOGRAPHS AND NEWS CLIPPINGS!

MAN BITES DOG

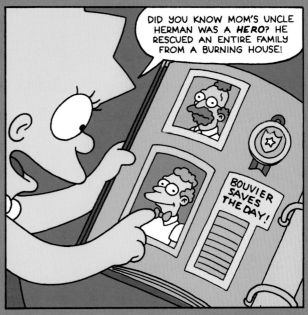

DID YOU KNOW MOM'S UNCLE HERMAN WAS A *HERO*? HE RESCUED AN ENTIRE FAMILY FROM A BURNING HOUSE!

BOUVIER SAVES THE DAY!

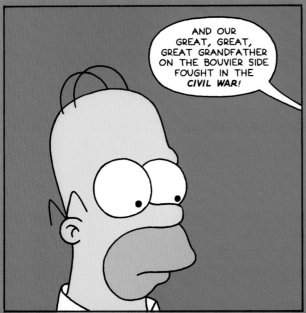

AND OUR GREAT, GREAT, GREAT GRANDFATHER ON THE BOUVIER SIDE FOUGHT IN THE *CIVIL WAR!*

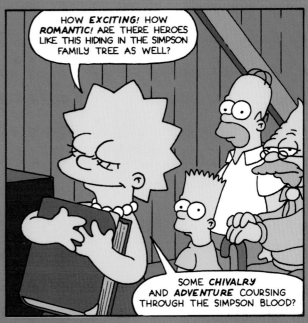

HOW *EXCITING!* HOW *ROMANTIC!* ARE THERE HEROES LIKE THIS HIDING IN THE SIMPSON FAMILY TREE AS WELL?

SOME *CHIVALRY* AND *ADVENTURE* COURSING THROUGH THE SIMPSON BLOOD?

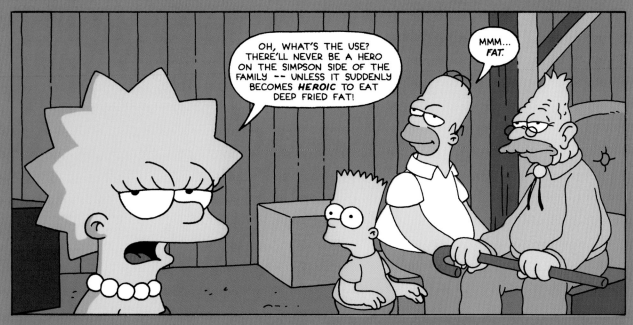

OH, WHAT'S THE USE? THERE'LL NEVER BE A HERO ON THE SIMPSON SIDE OF THE FAMILY -- UNLESS IT SUDDENLY BECOMES *HEROIC* TO EAT DEEP FRIED FAT!

MMM... *FAT.*

ACTUALLY, THERE *WAS* ONE SIMPSON THAT WAS CELEBRATED IN *SONG* AND *STORY*...

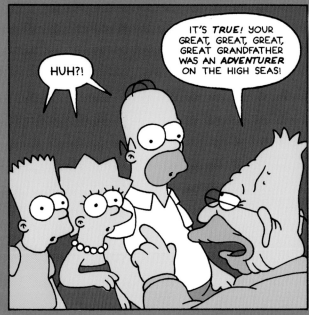

HUH?!

IT'S *TRUE!* YOUR GREAT, GREAT, GREAT, GREAT GRANDFATHER WAS AN *ADVENTURER* ON THE HIGH SEAS!

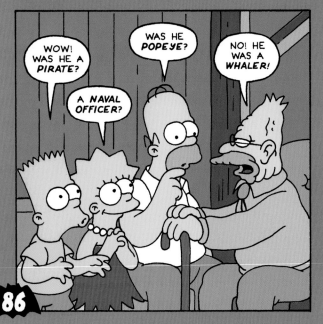

WOW! WAS HE A *PIRATE?*

A *NAVAL OFFICER?*

WAS HE *POPEYE?*

NO! HE WAS A *WHALER!*

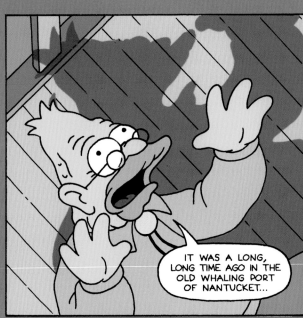

IT WAS A LONG, LONG TIME AGO IN THE OLD WHALING PORT OF NANTUCKET...

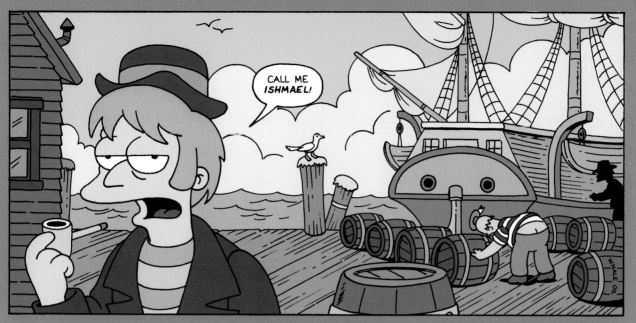

CALL ME *ISHMAEL!*

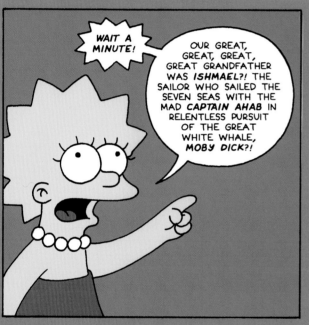

WAIT A MINUTE!

OUR GREAT, GREAT, GREAT, GREAT GRANDFATHER WAS *ISHMAEL?!* THE SAILOR WHO SAILED THE SEVEN SEAS WITH THE MAD *CAPTAIN AHAB* IN RELENTLESS PURSUIT OF THE GREAT WHITE WHALE, *MOBY DICK?!*

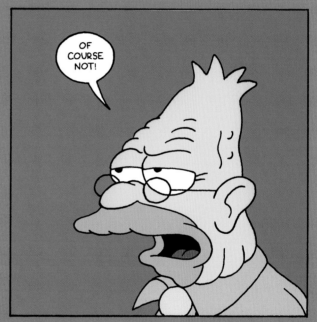

OF COURSE NOT!

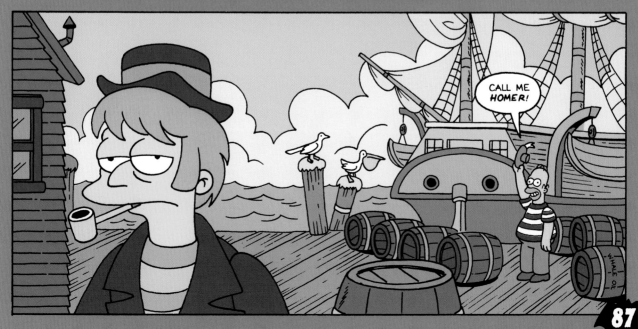

CALL ME *HOMER!*

IT ALL STARTED ONE DAY AFTER A PARTICULARLY GOOD HARVEST OF WHALES...

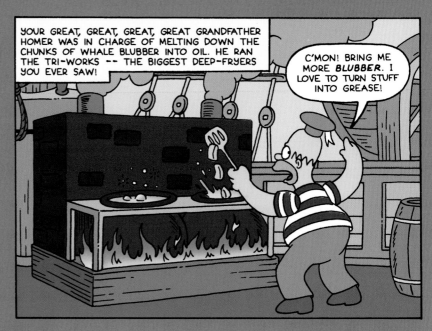

YOUR GREAT, GREAT, GREAT, GREAT GRANDFATHER HOMER WAS IN CHARGE OF MELTING DOWN THE CHUNKS OF WHALE BLUBBER INTO OIL. HE RAN THE TRI-WORKS -- THE BIGGEST DEEP-FRYERS YOU EVER SAW!

C'MON! BRING ME MORE *BLUBBER*. I LOVE TO TURN STUFF INTO GREASE!

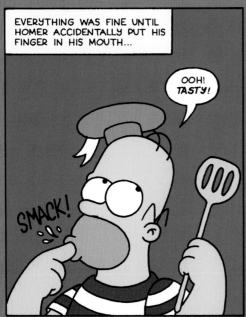

EVERYTHING WAS FINE UNTIL HOMER ACCIDENTALLY PUT HIS FINGER IN HIS MOUTH...

OOH! TASTY!

SMACK!

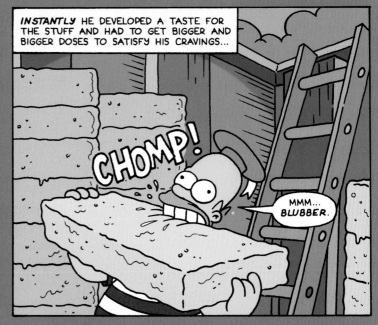

INSTANTLY HE DEVELOPED A TASTE FOR THE STUFF AND HAD TO GET BIGGER AND BIGGER DOSES TO SATISFY HIS CRAVINGS...

CHOMP!

MMM... BLUBBER.

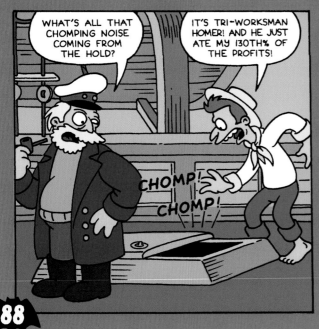

WHAT'S ALL THAT CHOMPING NOISE COMING FROM THE HOLD?

IT'S TRI-WORKSMAN HOMER! AND HE JUST ATE MY 130TH% OF THE PROFITS!

CHOMP! CHOMP!

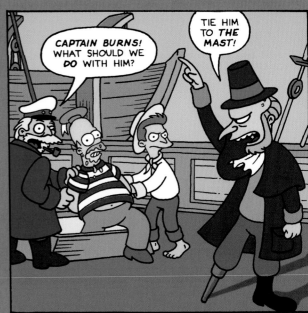

CAPTAIN BURNS! WHAT SHOULD WE *DO* WITH HIM?

TIE HIM TO *THE MAST!*

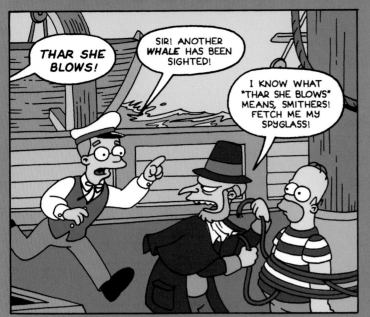

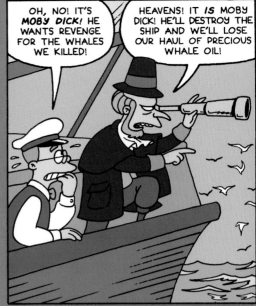

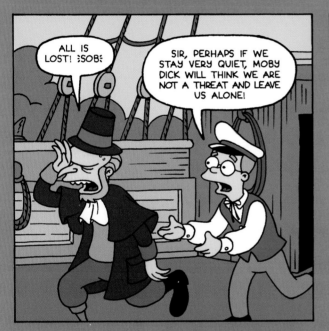

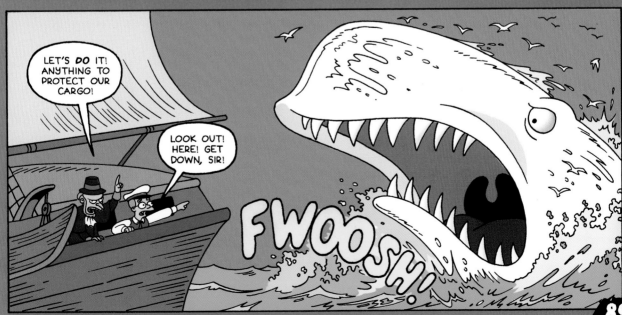

89

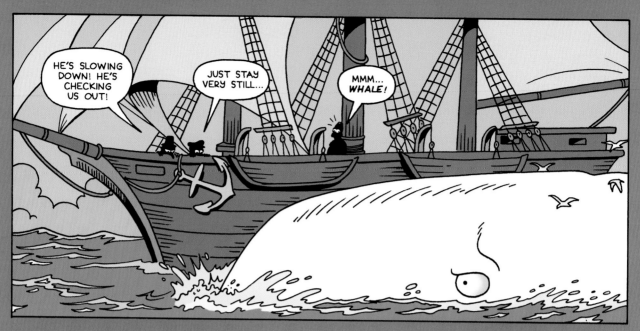

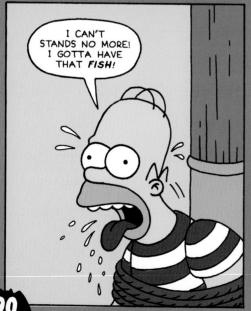

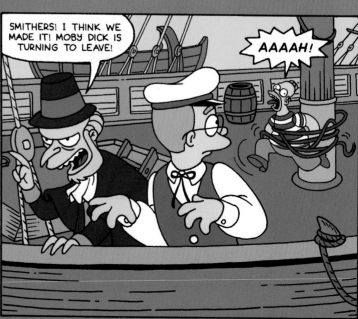

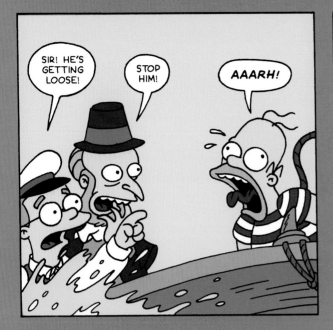

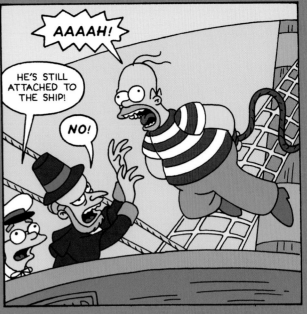

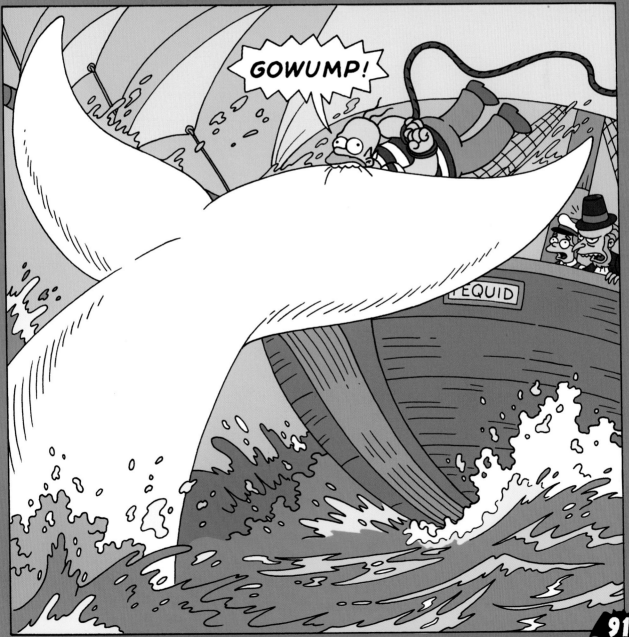

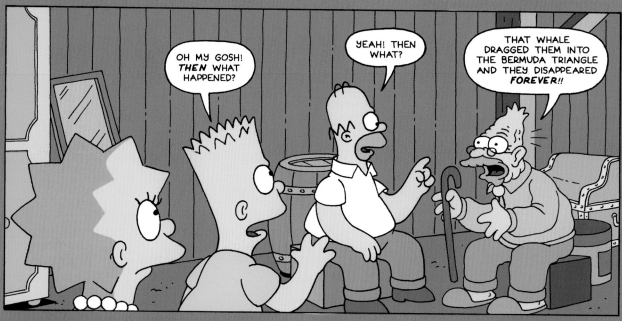

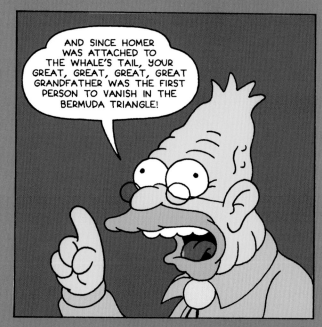

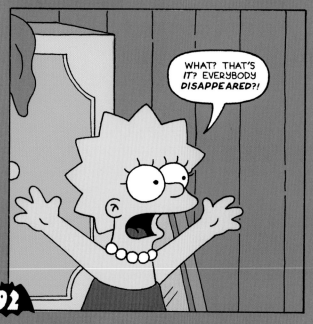

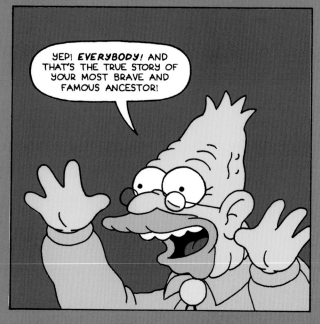

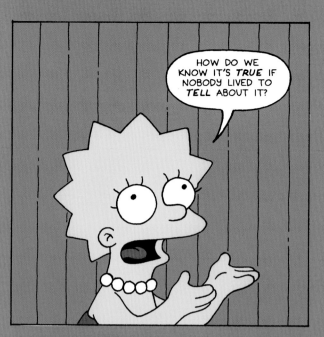

HOW DO WE KNOW IT'S *TRUE* IF NOBODY LIVED TO *TELL* ABOUT IT?

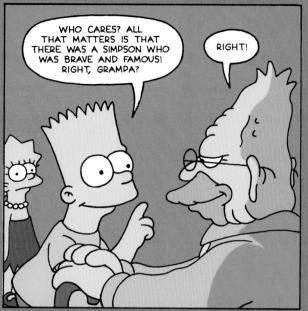

WHO CARES? ALL THAT MATTERS IS THAT THERE WAS A SIMPSON WHO WAS BRAVE AND FAMOUS! RIGHT, GRAMPA?

RIGHT!

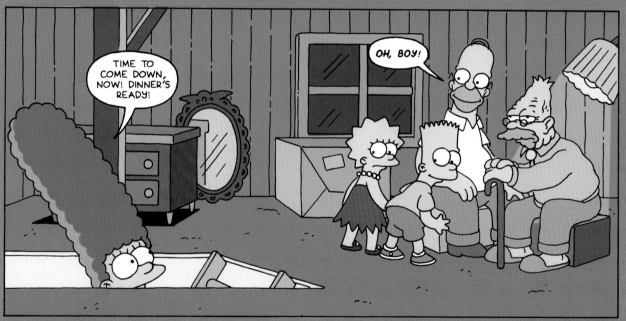

TIME TO COME DOWN, NOW! DINNER'S READY!

OH, BOY!

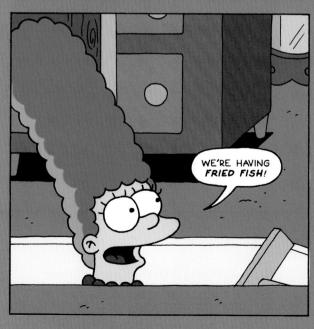

WE'RE HAVING *FRIED FISH!*

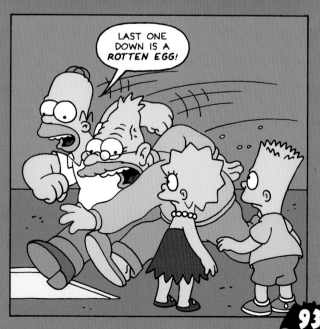

LAST ONE DOWN IS A *ROTTEN EGG!*

93

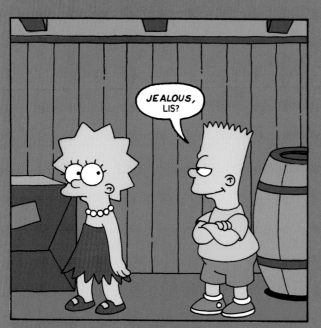

JEALOUS, LIS?

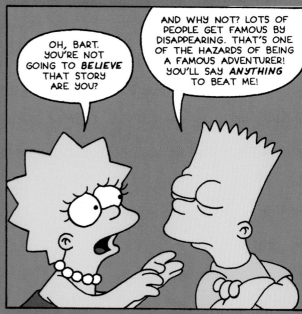

OH, BART. YOU'RE NOT GOING TO *BELIEVE* THAT STORY ARE YOU?

AND WHY NOT? LOTS OF PEOPLE GET FAMOUS BY DISAPPEARING. THAT'S ONE OF THE HAZARDS OF BEING A FAMOUS ADVENTURER! YOU'LL SAY *ANYTHING* TO BEAT ME!

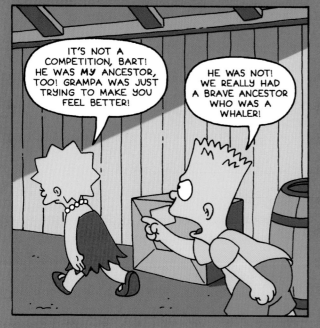

IT'S NOT A COMPETITION, BART! HE WAS *MY* ANCESTOR, TOO! GRAMPA WAS JUST TRYING TO MAKE YOU FEEL BETTER!

HE WAS NOT! WE REALLY HAD A BRAVE ANCESTOR WHO WAS A WHALER!

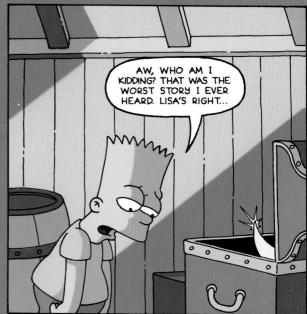

AW, WHO AM I KIDDING? THAT WAS THE WORST STORY I EVER HEARD. LISA'S RIGHT...

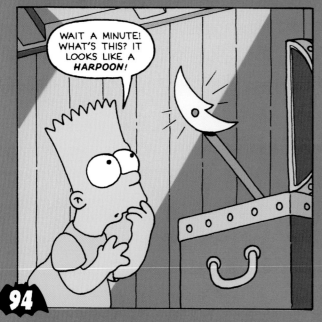

WAIT A MINUTE! WHAT'S THIS? IT LOOKS LIKE A *HARPOON!*

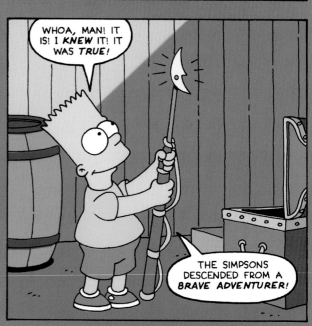

WHOA, MAN! IT IS! I *KNEW* IT! IT WAS *TRUE!*

THE SIMPSONS DESCENDED FROM A *BRAVE ADVENTURER!*

POOF!

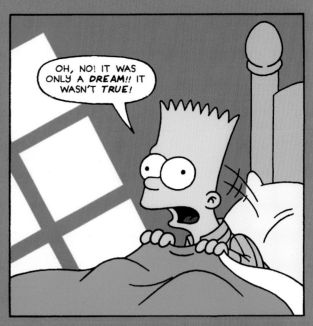

OH, NO! IT WAS ONLY A *DREAM!!* IT WASN'T *TRUE!*

HUH? WHAT'S THIS?!

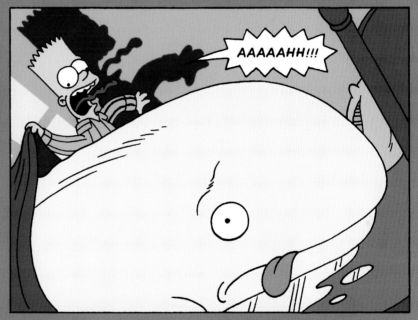

AAAAAHH!!!

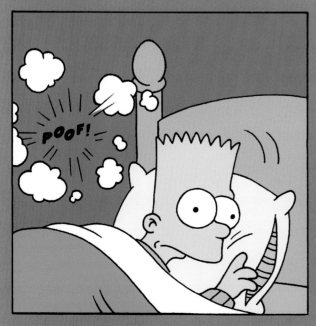

POOF!

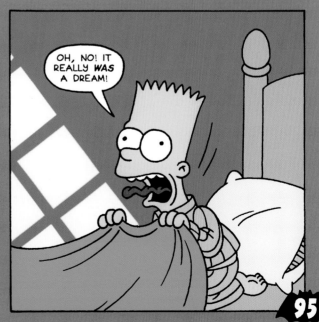

OH, NO! IT REALLY *WAS* A DREAM!

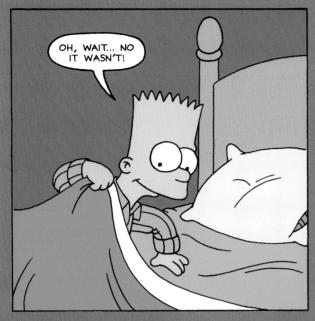

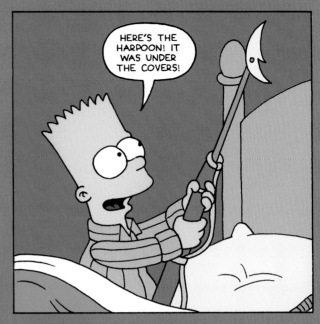

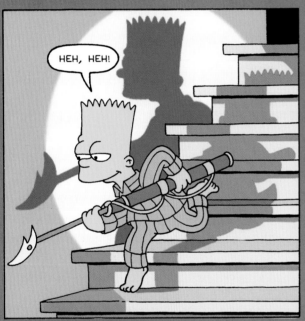

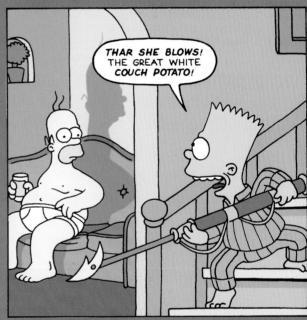

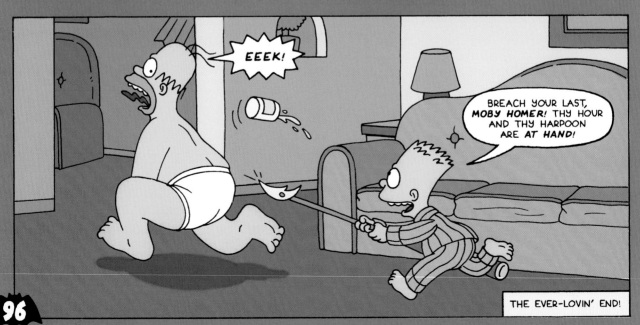

THE EVER-LOVIN' END!

BART SIMPSON—MASTER OF DISGUISE

presents

THE QUICK 'N' EASY, LOW-BUDGET DO-IT-YOURSELF GUIDE TO

COOL COSTUMES

MR. MARKER FACE

DOC LOOSE-LEAF, MAN OF PULP

THE HEADLESS GEEK

PROFESSOR PANTY HOSE

WALRUS MAN

CHOMP-ZILLA

PHANTOM OF THE VIDEO ARCADE

THE MAN WHO COULD SEE HIS EYELIDS

VASELINO, THE THING THAT WOULDN'T DRY

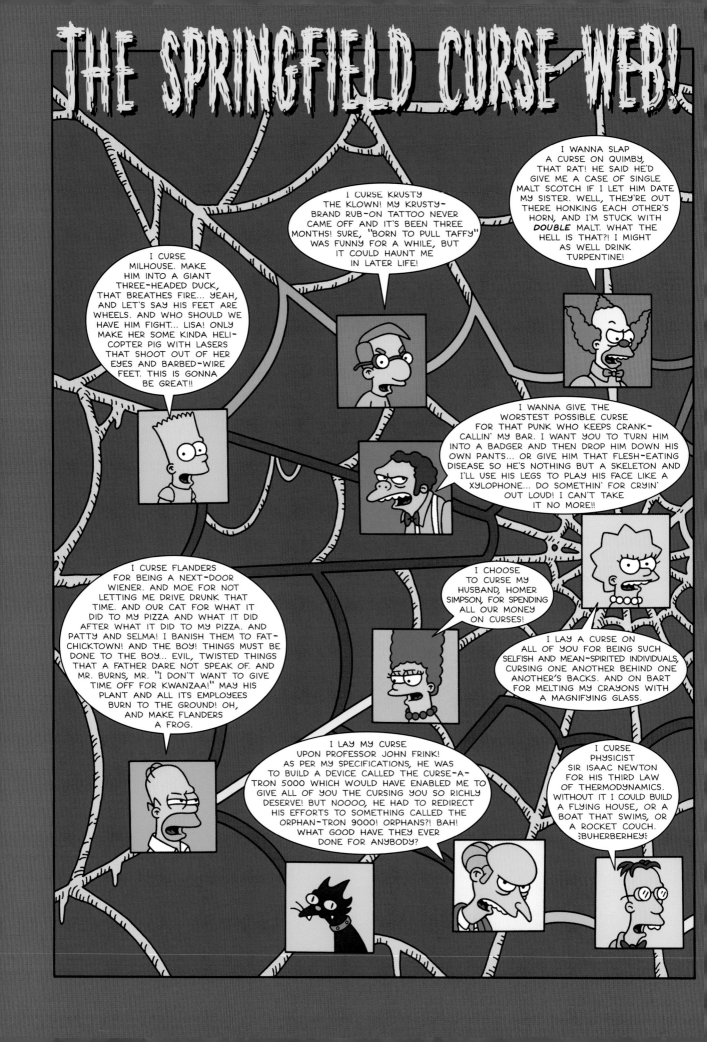

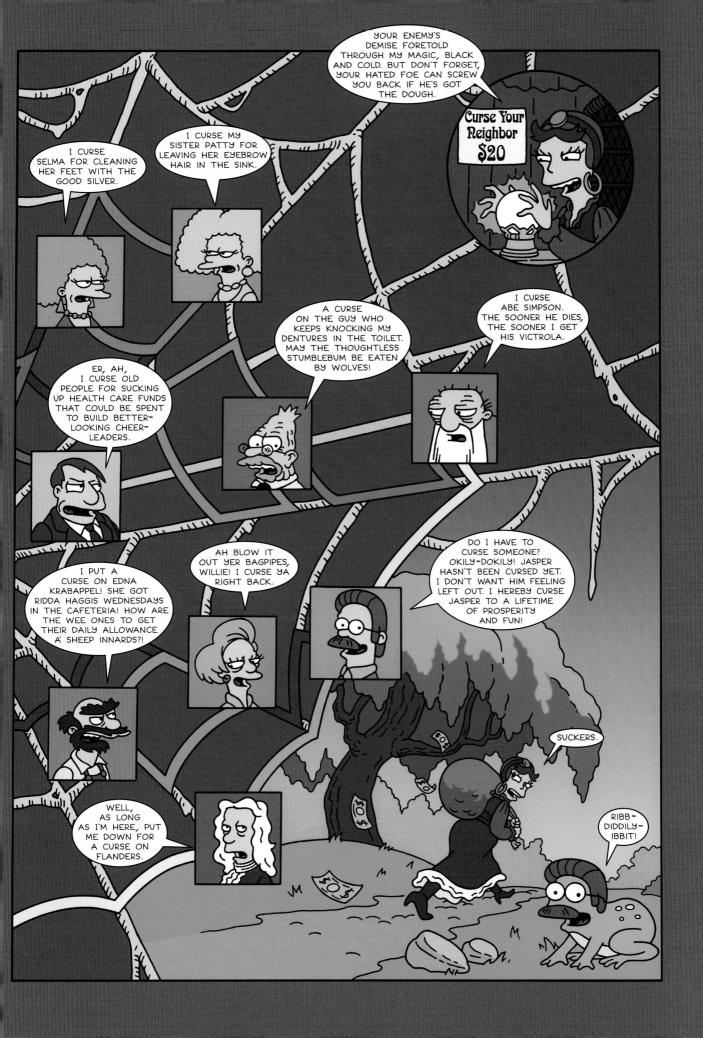

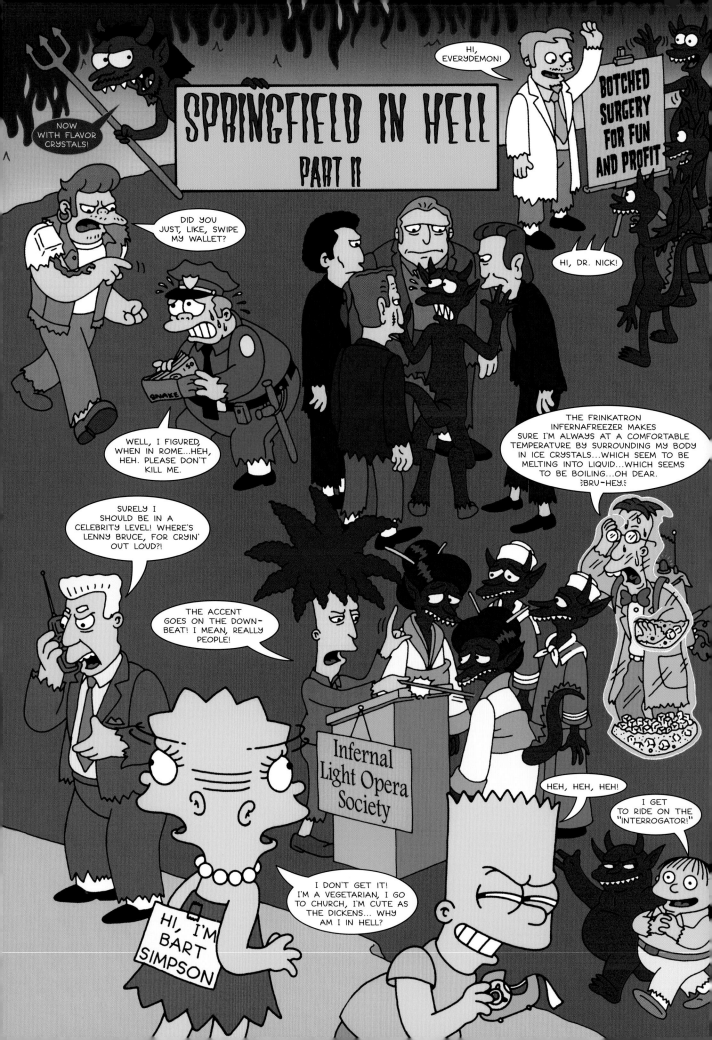

HALLOWEEN IS AN UGLY MELEE WHERE YOU'RE EITHER THE TREATED OR THE TRICKED. SO REMEMBER, WHEN YOU GO OUT ONTO THAT PUMPKIN-STREWN BATTLEFIELD, BE ALERT, BE PREPARED, AND WHEN NECESSARY, RUN LIKE HELL!

OH, THAT? JUST A LITTLE SOMETHING THE JOHNSONS ARE GIVING OUT. SAID THEY WERE MAKING UP FOR THEIR TIGHT-WAD NEIGHBORS.

TIGHTWAD?! I'LL SHOW THAT JOHNS WHO THE TIGHTWAD JOAN! BRING THE E CANDY BARS... HEL BRING THE VCR!

BART'S HALLOWEEN SURVIVAL KIT!

(1) "AT FIRST, PEOPLE WILL WANT TO GIVE YOU SOME CANDY IN THE 'BITE-SIZED' FAMILY. BUT LOOK WHAT HAPPENS WHEN YOU 'ACCIDENTALLY' SHOW THEM WHAT THEIR NEIGHBORS ARE GIVING OUT.

THE LATEST ISSUE OF "DOILY PARADE!" AND IT'S SIGNED BY TONY RANDALL!

OF COURSE, I COULD JUST GRAB HIS BAG, BUT THEN, WHERE'S THE ART IN THAT?

"WHAT ARE THOSE EGGS DOING IN HERE... SURELY IT'S NOT EASTER?" ⟨WINK⟩

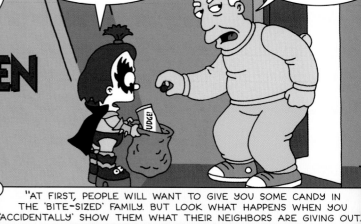

(2) "THIS IS A LITTLE SOMETHING I CALL 'THE DORK DISTRACTER.'"

"EVERY SKINFLINT LOVES TO FIND SOMETHING IN THE MAILBOX. WHY NOT LET IT BE SHAVING CREAM?"

(3) "WHEN IT COMES TO MAKING THE BIG CANDY HAUL, A COSTUME IS ONLY AS GOOD AS THE TEAR-JERKING STORY THAT GOES WITH IT."
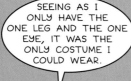

(4) "LET'S SAY YOU'RE GETTING CHASED BY... I DON'T KNOW, LET'S SAY THE POLICE. DONUTS MAKE A GREAT DIVERSION."

SEEING AS I ONLY HAVE THE ONE LEG AND THE ONE EYE, IT WAS THE ONLY COSTUME I COULD WEAR.

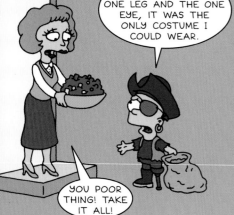

YOU POOR THING! TAKE IT ALL!

STOP, YA LITTLE HOODLUM! YA LITTLE EGG-THROWING, JELLY-FILLED, SPRINKLE-TOPPED... UM, COULD YA THROW SOME MILK?

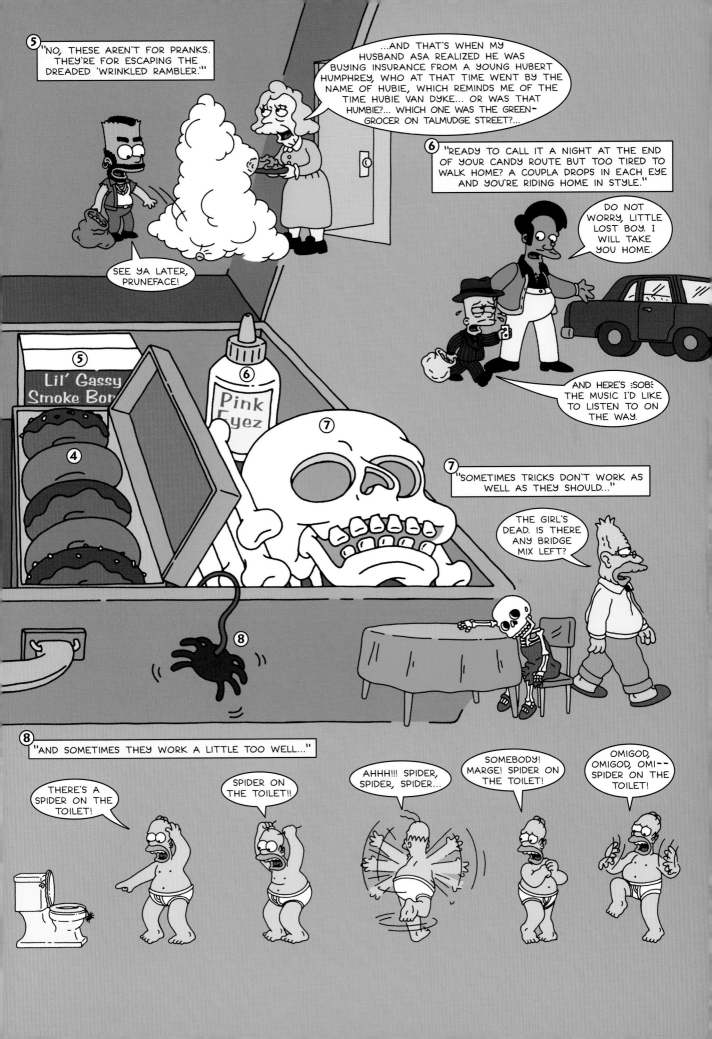

RETURN OF THE
DIVERSION FIGURES

SEE DIRECTIONS
ON PAGE 43 TO
OCCUPY YOURSELF
FOR HOURS
WITH MORE
DIVERSIONARY FUN!

BART PEOPLE

AHHH!

EEEK! CAT GIRL!

JAMES "GRAVE ROBBIN'"-SON: STORY
CHRIS "MOANIN' & GROANIN'" ROMAN: LAYOUTS
BILL "MORGUE"-ISON: FINISHED ART
MIKE "SHOCK"-AMOTO: LETTERING
CADAVEROUS NATHAN KANE: COLORS
MATT GRRRRROENING: TOP CAT

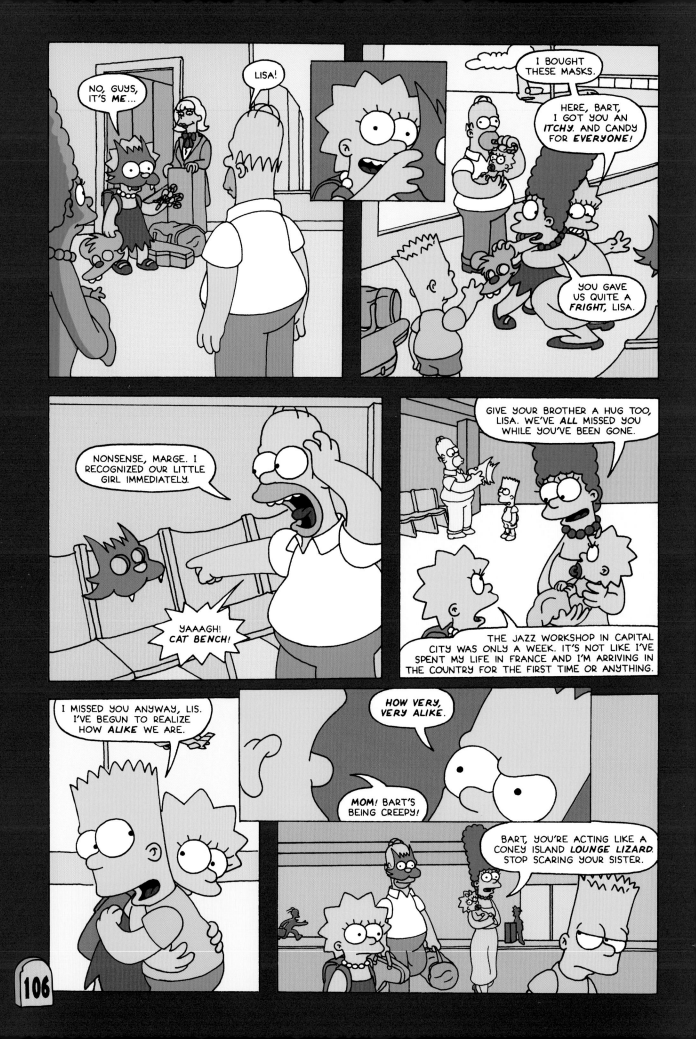

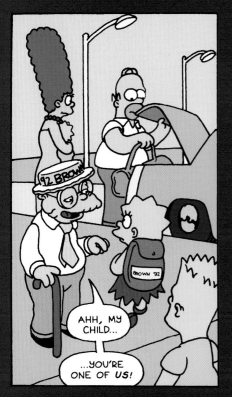

AHH, MY CHILD...

...YOU'RE ONE OF *US!*

BRROWWWN!

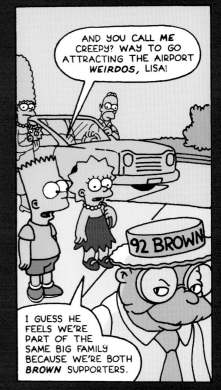

AND YOU CALL *ME* CREEPY? WAY TO GO ATTRACTING THE AIRPORT *WEIRDOS,* LISA!

I GUESS HE FEELS WE'RE PART OF THE SAME BIG FAMILY BECAUSE WE'RE BOTH *BROWN* SUPPORTERS.

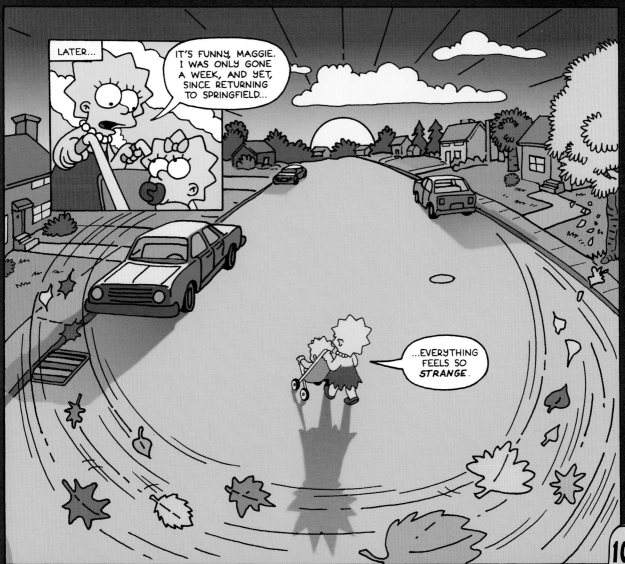

LATER...

IT'S FUNNY, MAGGIE. I WAS ONLY GONE A WEEK, AND YET, SINCE RETURNING TO SPRINGFIELD...

...EVERYTHING FEELS SO *STRANGE.*

107

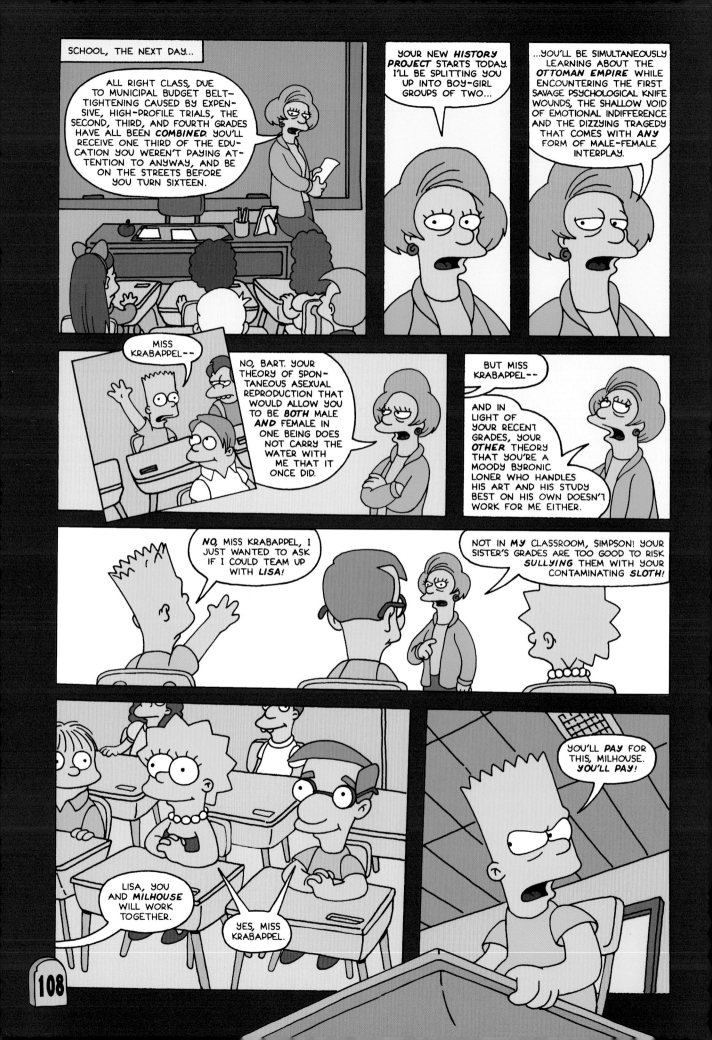

SCHOOL, THE NEXT DAY...

ALL RIGHT CLASS, DUE TO MUNICIPAL BUDGET BELT-TIGHTENING CAUSED BY EXPENSIVE, HIGH-PROFILE TRIALS, THE SECOND, THIRD, AND FOURTH GRADES HAVE ALL BEEN *COMBINED.* YOU'LL RECEIVE ONE THIRD OF THE EDUCATION YOU WEREN'T PAYING ATTENTION TO ANYWAY, AND BE ON THE STREETS BEFORE YOU TURN SIXTEEN.

YOUR NEW *HISTORY PROJECT* STARTS TODAY. I'LL BE SPLITTING YOU UP INTO BOY-GIRL GROUPS OF TWO...

...YOU'LL BE SIMULTANEOUSLY LEARNING ABOUT THE *OTTOMAN EMPIRE* WHILE ENCOUNTERING THE FIRST SAVAGE PSYCHOLOGICAL KNIFE WOUNDS, THE SHALLOW VOID OF EMOTIONAL INDIFFERENCE AND THE DIZZYING TRAGEDY THAT COMES WITH *ANY* FORM OF MALE-FEMALE INTERPLAY.

MISS KRABAPPEL--

NO, BART. YOUR THEORY OF SPONTANEOUS ASEXUAL REPRODUCTION THAT WOULD ALLOW YOU TO BE *BOTH* MALE *AND* FEMALE IN ONE BEING DOES NOT CARRY THE WATER WITH ME THAT IT ONCE DID.

BUT MISS KRABAPPEL--

AND IN LIGHT OF YOUR RECENT GRADES, YOUR *OTHER* THEORY THAT YOU'RE A MOODY BYRONIC LONER WHO HANDLES HIS ART AND HIS STUDY BEST ON HIS OWN DOESN'T WORK FOR ME EITHER.

NO, MISS KRABAPPEL, I JUST WANTED TO ASK IF I COULD TEAM UP WITH *LISA!*

NOT IN *MY* CLASSROOM, SIMPSON! YOUR SISTER'S GRADES ARE TOO GOOD TO RISK *SULLYING* THEM WITH YOUR CONTAMINATING *SLOTH!*

LISA, YOU AND *MILHOUSE* WILL WORK TOGETHER.

YES, MISS KRABAPPEL.

YOU'LL *PAY* FOR THIS, MILHOUSE. *YOU'LL PAY!*

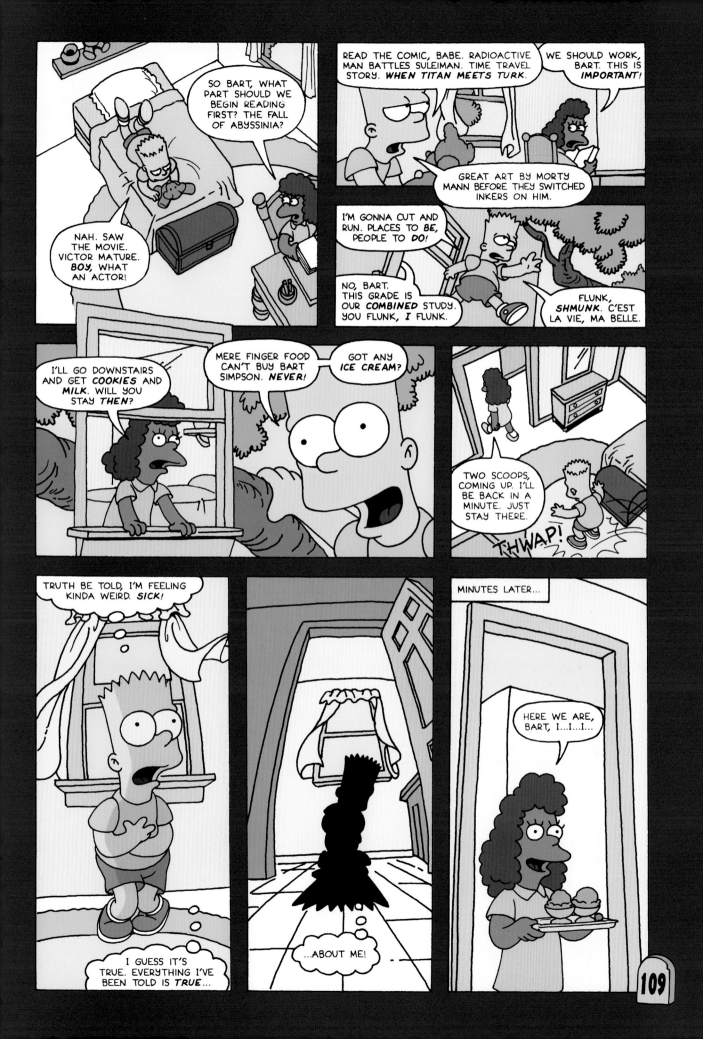

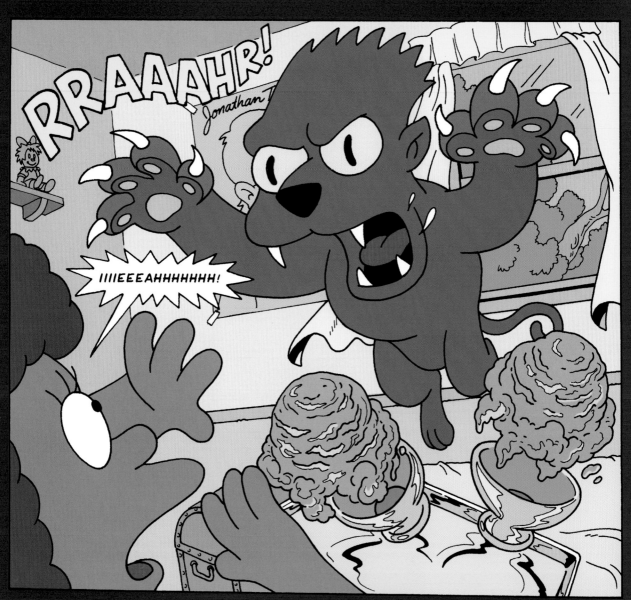

RRAAAHR!

IIIIEEEAHHHHHHH!

WHOA! WHA, WHA, WHAT'S THAT?

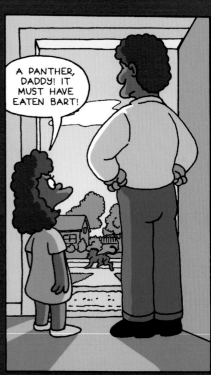

A PANTHER, DADDY! IT MUST HAVE EATEN BART!

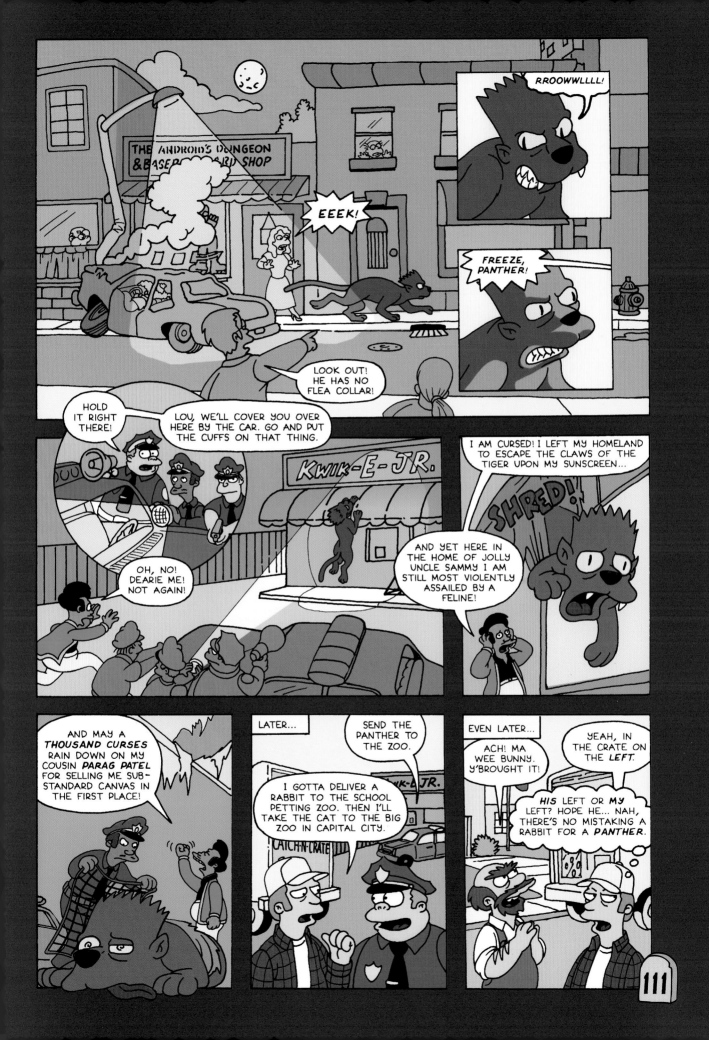

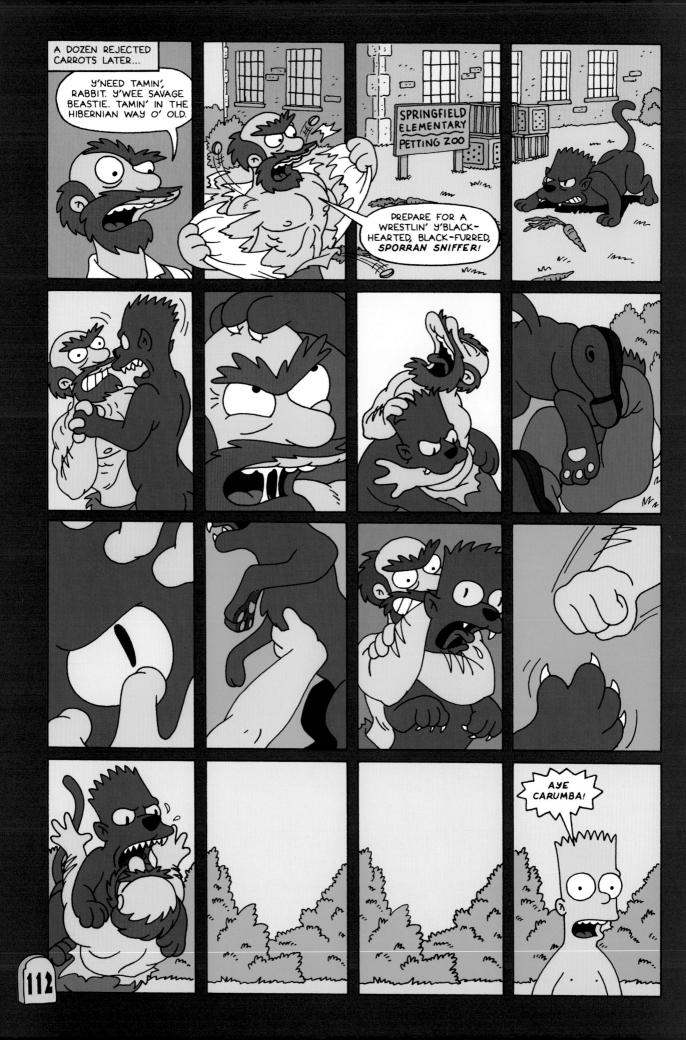

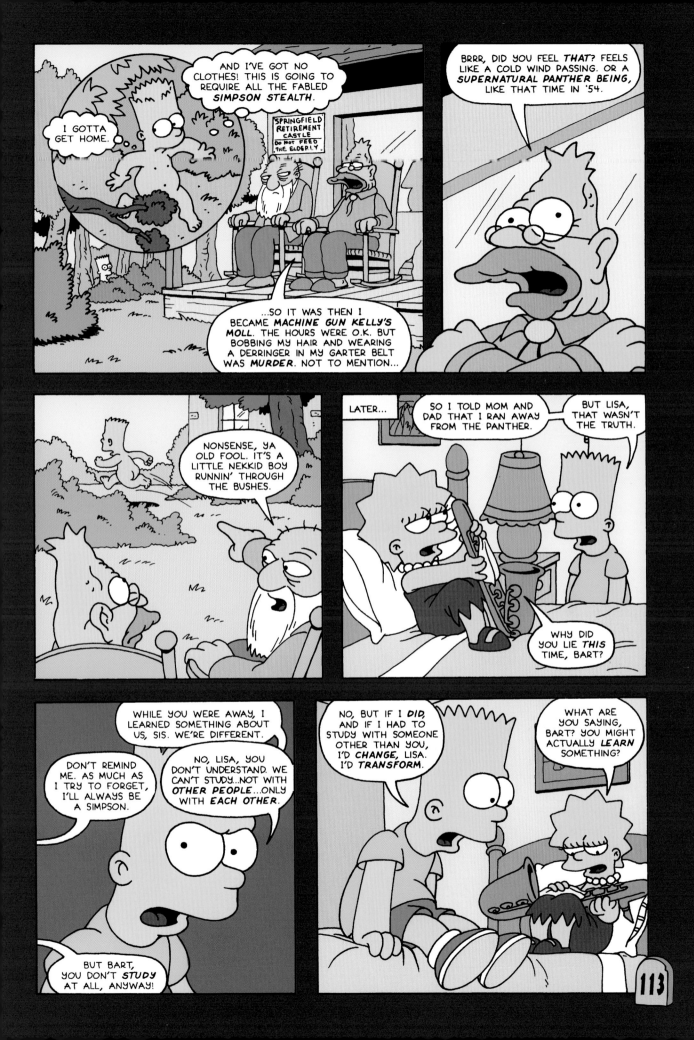

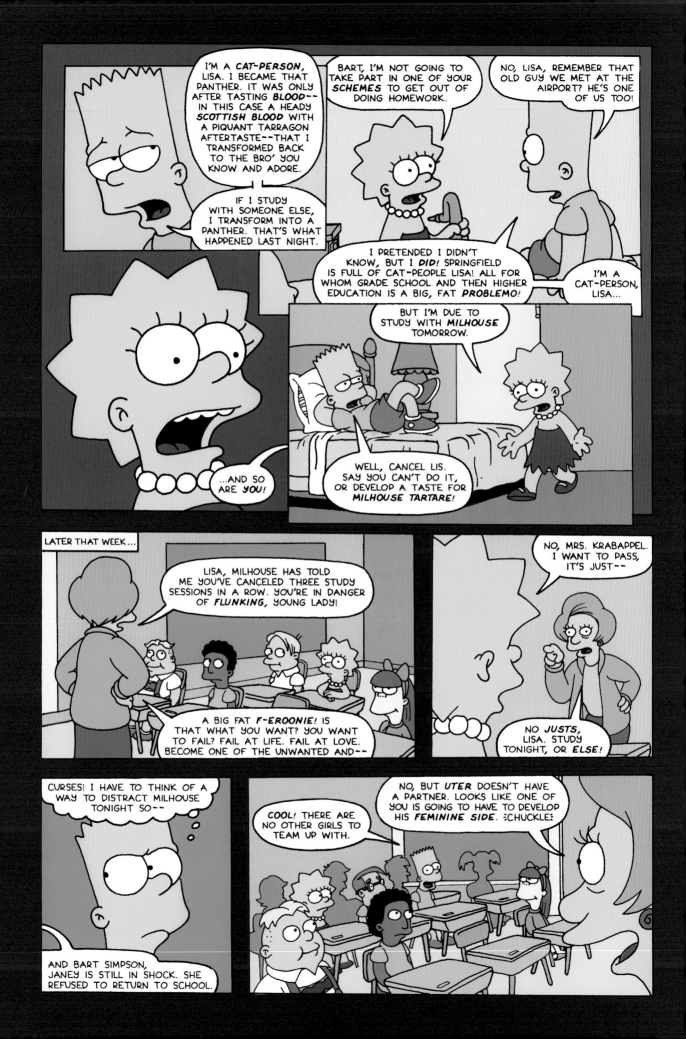

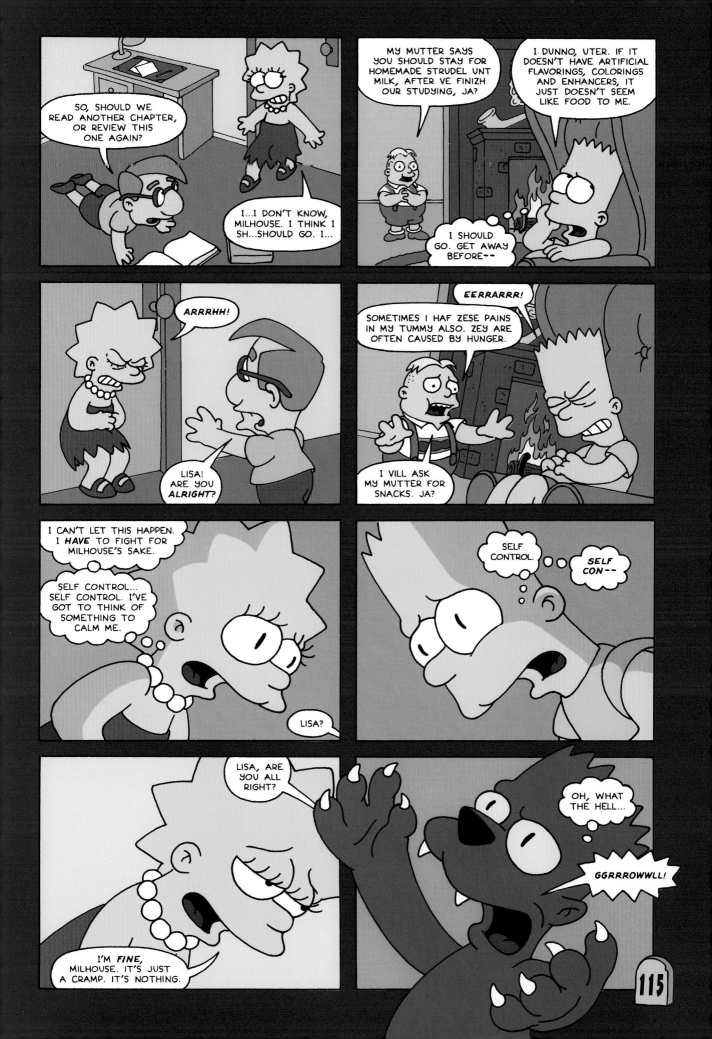

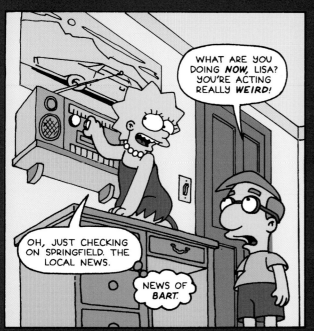

WHAT ARE YOU DOING *NOW*, LISA? YOU'RE ACTING REALLY *WEIRD*!

OH, JUST CHECKING ON SPRINGFIELD. THE LOCAL NEWS.

NEWS OF *BART*.

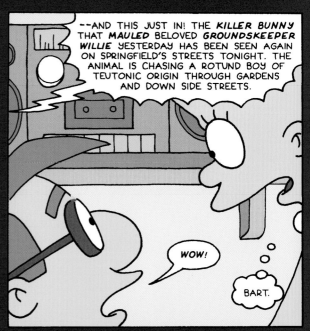

--AND THIS JUST IN! THE *KILLER BUNNY* THAT *MAULED* BELOVED *GROUNDSKEEPER WILLIE* YESTERDAY HAS BEEN SEEN AGAIN ON SPRINGFIELD'S STREETS TONIGHT. THE ANIMAL IS CHASING A ROTUND BOY OF TEUTONIC ORIGIN THROUGH GARDENS AND DOWN SIDE STREETS.

WOW!

BART.

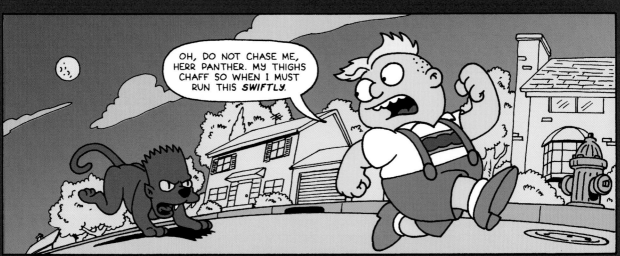

OH, DO NOT CHASE ME, HERR PANTHER. MY THIGHS CHAFF SO WHEN I MUST RUN THIS *SWIFTLY*.

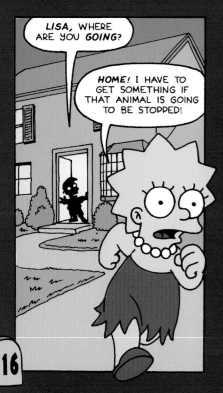

LISA, WHERE ARE YOU *GOING*?

HOME! I HAVE TO GET SOMETHING IF THAT ANIMAL IS GOING TO BE STOPPED!

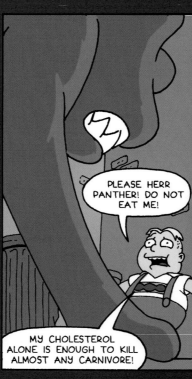

PLEASE HERR PANTHER! DO NOT EAT ME!

MY CHOLESTEROL ALONE IS ENOUGH TO KILL ALMOST ANY CARNIVORE!

FREEZE, RABBIT!

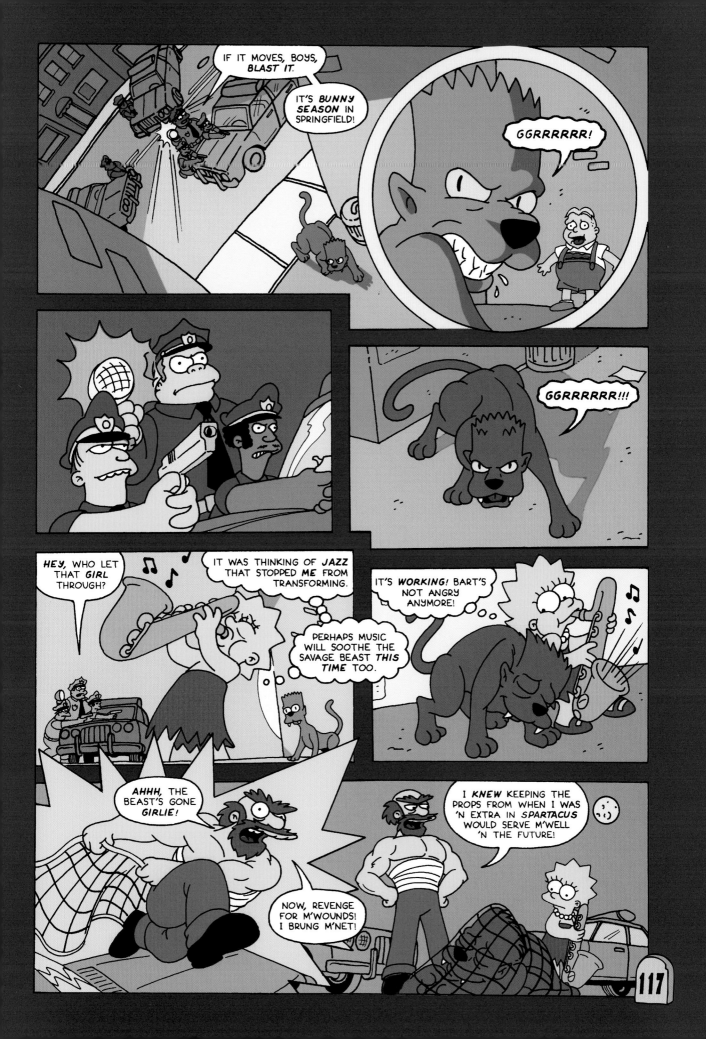

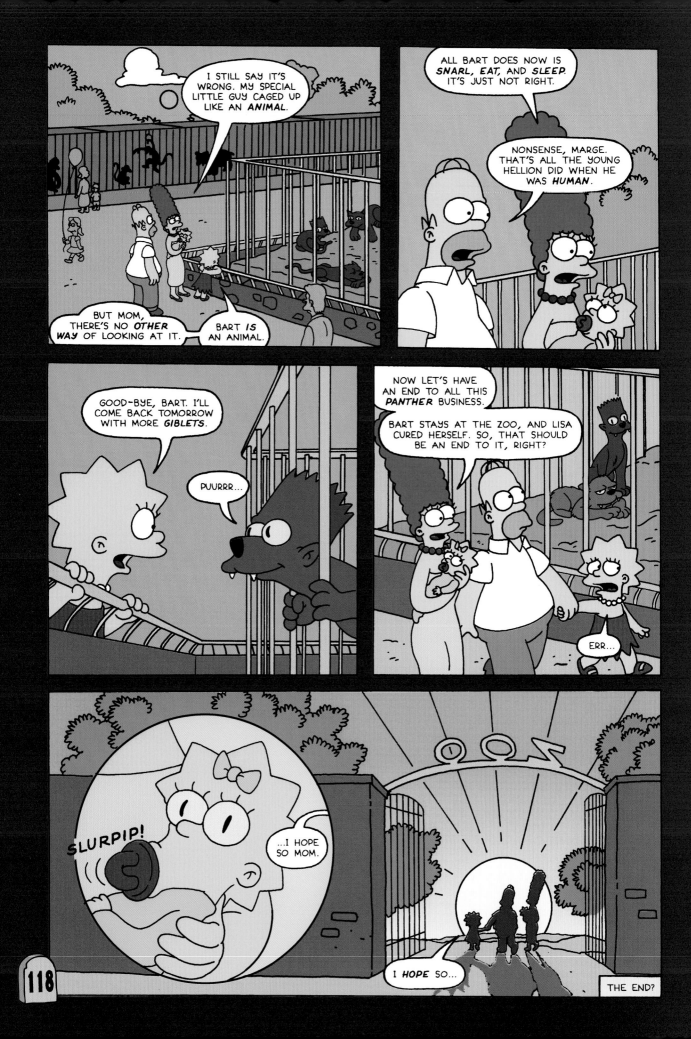

Speech bubble: YOU WANNA BE SCARED?! WELL, SHUT UP AND LISTEN, OR I'LL GIVE YOU SOME-THING TO BE SCARED ABOUT!

THE CURSE OF THE THING!

What's wrong with an old hero? As told by **Abraham Simpson**.
Are you scared his teeth might fall out?
So what if they do? It's my story and I'm makin' him a hero for the elderly

When young **Ebeneezer McBride** agreed to go on the **search for the scary monster** deep in the heart of **the eeevil forest**, he had no idea of the terror that would befall him on that fateful night.

Led by world-famous **Dracula catcher, Dwight D. Eisenhower** the group had traveled by **Edsel** to the deepest part of **the eee evil forrest** to find **well, something evil, ya dunderhead**. Coming around a bend **Ebeneezer** spied an old man **I bet you think the old man is going to say something stupid. Well not in** "Stay away from **The Castle of the Mole People**, for **my story!** that is the home of **the eeevil Mole Princess**." **Ebeneezer** had heard this myth. Long ago, **You might not think** had been **moles are scary, but in my day they were everywhere!** by a rival _____. Before **When people** he died, he swore his ghost would seek vengeance. Anyone he caught would **would ask,** **be fed to the moles, I tell ya** as he was. But **Ebeneezer** couldn't worry about myths. "How'd ya sleep?" To find the **Eeevil Mole Princess**, they had to go to **find her**. As they left, they **You'd say,** could hear the **smart** old man mutter, "**If yer not scared a moles by now, wait till Easter!**" **"Moley" or**

Because members of the group were scared, **Ebeneezer** agreed to sit **"Not so Moley."** up all night with **his achin' back and bowel troubles My bowels are nothin to joke And at Easter,** he joked, "**I said it's nothing to joke about!**" Later that night, young **Dadburnit** was **our parents** **about!** **wouldn't hide** awoken by gunshots followed by a hideous scream. He ran to the spot where **eggs, they'd** **Chachi** had been. Instead he found his **Fonzie's dog** and a **Nuts to this! I'm goin' ter a** **hide moles.** Suddenly, he heard a rustle in the bushes. THUMP, THUMP, SCRAPE... THUMP, THUMP, **malted!". Ah! I wish** SCRAPE! Was it _____?! _____ began running back through the **I hadn't** inky darkness toward _____. Once he reached it, he'd motor back **found a mole!"** to civilization and send for help. It seemed like an eternity, but he finally found it. His **You'd yell as** passage to safety! And as if that weren't enough, there _____ he could make **one bit you** out **I'm back. What'd I miss?** He'd actually found **Where the hell are the Mole** **on the** But as he got closer, he realized **This story stinks!** was much bigger than he had **People you mentioned?** imagined. Could it be **I could write a better story with a bag** was actually **finger.** **around my head. Easter was a** For shaaame! **Blah, blah, blah, who cares?** ? **hoooooorible time!**

That morning in the _____ Gazette there was a short article near the back: "_____." An old man put down the paper and muttered to himself, "**I'm back! What'd I miss?**"

Left margin vertical text: Why can't ya accept an old hero?! I'll tell ya why! Cuz this story thing was probably put together by those senior-haters over at Young Miss magazine! For shaaame! I've read your magazine. All you young people care about is soda pop,

Bottom text: flavored lipsticks and that guy Chachi! Chachi, Chachi, Chachi! You think old people don't know Chachi, but we do! He's Fonzie's son, or his dog. And he sickens us! Some day old people will rule the world, and then you'll be sorry. Sincerely, Abraham Simpson P.S. I loved you in "All about Eve".

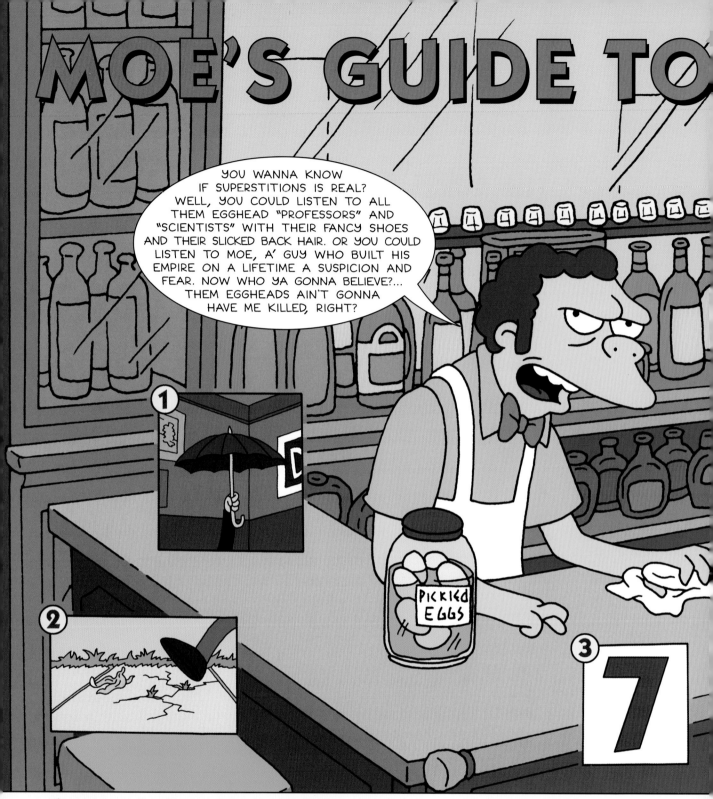

1. *IT'S BAD LUCK TO OPEN AN UMBRELLA INDOORS.*
"LET'S SEE... THERE WAS THE TIME MY BOOKIE SHOWED UP, AND I DIDN'T HAVE THE MONEY, AND ONE A' HIS BOYS USE[D] AN UMBRELLA ON ME. THAT UMBRELLA GOT OPENED INDOORS, ALRIGHT, A LITTLE TOO INDOORS IF YA GET MY DRIFT. [SIGH] IF THAT AIN'T BAD LUCK, I DON'T KNOW WHAT IS."

2. *STEP ON A CRACK, BREAK YOUR MOTHER'S BACK.*
"UNFORTUNATELY, THIS ONE AIN'T TRUE. LORD KNOWS I'VE TRIED."

3. *THE NUMBER SEVEN WILL BRING GOOD FORTUNE.*
"DAMN RIGHT IT WILL. THAT'S WHY I MAKE SURE THERE'S ONLY SEVEN PEANUTS IN THE NUT TRAY, SEVEN SQUARES A' T[OILET PAPER?] IN EACH JOHN, AND I CHARGE SEVEN BUCKS FOR MARGARITAS. THAT AIN'T BEIN' CHEAP, THAT'S TO BRING YOU GOO[D] LUCK, YA BUM!"

4. *THIRTEEN IS AN UNLUCKY NUMBER.*
"ALLS I KNOW IS, IF BARNEY'S HAD THIRTEEN BEERS AND THE BATHROOM'S OUTTA ORDER, THERE AIN'T NO GOOD LUC[K] FOR NO ONE."

5. *IF A BLACK CAT CROSSES YOUR PATH, IT'S BAD LUCK FOR THE REST OF THE WEEK.*
"THIS ONE'S TRUE. ONE DAY A BLACK CAT CROSSED RIGHT IN FRONTA ME. THAT VERY NIGHT, I TAKE MY GIRLFRIEND OU[T]

SUPERSTITIONS

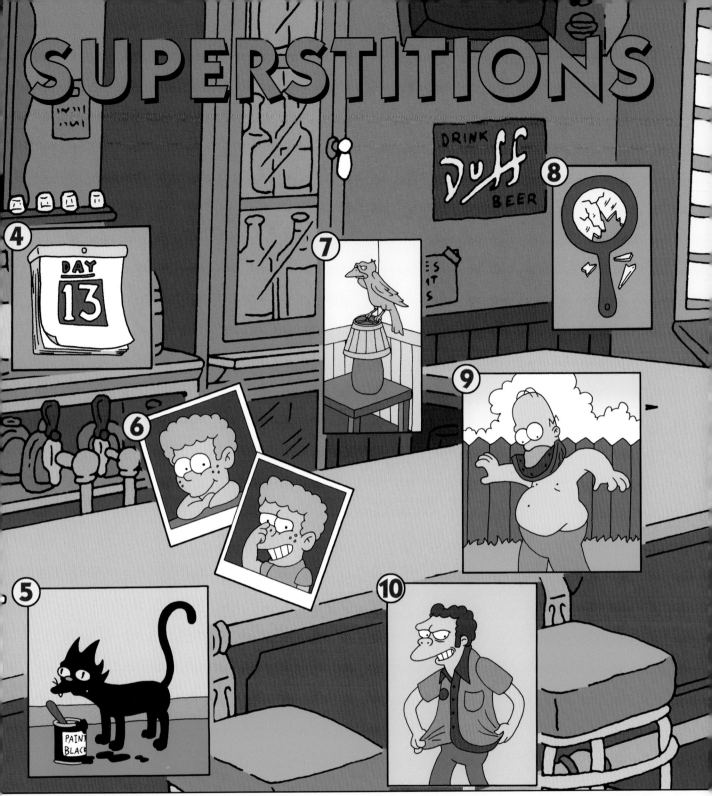

"...OR OUR ANNIVERSARY, AND SHE BREAKS UP WITH ME. SAID I WASN'T CLASSY ENOUGH! RIGHT THERE IN FRONTA ALL MY FRIENDS AT THE STRIP CLUB! YEAH, THE CAT'S THE ONLY EXPLANATION ON THAT ONE."

6. IF YOU MAKE A FACE LONG ENOUGH, IT WILL STAY THAT WAY.
"THIS ONE'S HAUNTED ME EVER SINCE KINDYGARTEN."

7. A BIRD IN THE HOUSE IS A SIGN OF DEATH.
"ONLY IF THE HEALTH INSPECTOR SHOWS UP. AND, OF COURSE, HE'S GONNA SHOW UP! HE ALWAYS SHOWS UP! I MEAN, WHADDAS HE LIVE NEXT DOOR?!"

8. A BROKEN MIRROR IS SEVEN YEARS' BAD LUCK.
"THE BAD LUCK WAS HAVING 'FREE HAMMER NIGHT' IN THE FIRST PLACE."

9. IF YOU EAT A WATERMELON SEED, IT WILL GROW A WATERMELON IN YOUR STOMACH.
"THIS ONE AIN'T TRUE, ALTHOUGH I AIN'T SURE ABOUT MY PICKLED EGGS. LET'S JUST SAY I'M MENTIONED IN A LAWSUIT."

10. WEAR THE SAME SHIRT AND IT WILL BRING YOU GOOD LUCK.
"OH, I GOT A LUCKY SHIRT. AND IF I WEAR IT ON A FRIDAY NIGHT, I GET LUCKY ALRIGHT, **REAL** LUCKY! HEH, HEH, HEH... AAAAH, WHO'M I KIDDING. I STILL END UP AT HOME WATCHING A SCRAMBLED VERSION A' THE NUDIE CHANNEL."

"YE LANDLUBBERS KNOW THE SEA AS A PLACE OF FROLIC AND WHIMSY. A PLACE TO DIP YOUR WEE ANKLES IN THE HOT SUMMER MONTHS, AND WHERE THE WORST THAT CAN HAPPEN IS SAND CRABS IN YOUR BATHIN' PANTIES. ARRGH, BUT THAT BE IN THE SHALLOWS. FOR DEEP IN THE BELLY OF THE BEAST, WHERE LIGHT HAS NO NAME AND SOUND IS NAUGHT BUT THE SLOW SCREAM OF DEATH, LIVE CREATURES SO FOUL, SO HIDEOUS THAT TO MERELY SPEAK THEIR NAME IS TO DIE OF FRIGHT. TRULY, YOU DON'T WANT THESE CREATURES EVEN NEAR YOUR PANTIES. WHAT FOLLOWS IS THE HORRIFYIN' ACCOUNT OF JUST SUCH A BEAST."

The Trench Wraith

'Twas the dead of winter, and I was sailin' across the North Pacific as captain of the good ship *Gertrude Stein*. Ah, the *Gertrude Stein*... a two-thousand-ton lily of the sea, dainty as her namesake and with half the barnacles. She was truly a ship that could withstand even the greatest danger. But we'd soon find a danger larger than any we could imagine, and it would come from the smallest member of our crew.

Little Tobias Trivel had signed on as cabin boy, and the crew loved him in the way you could only love a small person. His tiny, little hands could reach in to fix whirring gears, he could be greased up and sent in to unclog even the smallest pipes, and the fishermen in the crew found he made excellent bait. Just drag him on a rope from the stern, and within seconds you'd be reelin' in a marlin the size of a couch. Crack the fish open, and there'd be Toby, covered in fish goo and smilin' big as life. Yes, he was a stupid boy, but, oh, how he loved the creatures of the sea! He loved 'em so much, he turned his quarters into a veritable aquarium with rare species from the four corners of the globe. Why, he even swore he had a fish that could write poetry. And it may have, for all we know. If only it hadn't been electrocuted by the typewriter Toby dropped in the tank. As I said, he was a stupid, stupid boy.

At port in Hong Kong, while the other sailors were hittin' the brothels, fightin' in bars, and buyin' their weight in black market wicker, Toby found himself in a tiny exotic fish store filled with every rare marine

creature from the Venezuelan dancin' scrod, to the East Borneo face-biter. It was there Toby spied the most curious fish he'd ever laid eyes on. It had flipper-like fins and a multipronged tail. Its mouth was filled with long, sharp teeth and a bristly tube that popped out occasionally to suck the aquarium glass like a lamprey. But it was the eyes that sucked Toby in. Big as saucers were they, puppy dog eyes if ever a fish had 'em. "I see you like most rare," said the wizened Chinese woman runnin' the shop. "That legendary trench wraith from deepest part of ocean. Very, very dangerous. If you take on ship, many sailors die horrible death." But young Toby hadn't been listenin', and the shopkeeper couldn't repeat herself, as she'd just been attacked by an East Borneo face-biter. While the woman wrestled with her assailant, Toby placed his money on the counter and unknowingly, left the store carryin' a plastic baggy filled with doom.

But a scary little fish was the future's concern. We were ten days out of Hong Kong and jammed to the hatches with the most important cargo we'd ever carried: the entire spring line for the Paris Women's Fashion Show. To reach France in time, we would have to sail as quickly as possible through some of the most treacherous waters on earth. But I knew my crew, and they were hearty. I gathered the men on deck and announced, "We'll make our deadline so long as we work hard, stay alert, and, most importantly, no matter how strong the allure, no one, but no one tries on those dresses." Then, to prove I was serious, I banished Bosun Hale to the brig just for sneaking on a pair of Donna Karan thigh-highs.

Ladies stockings were not on young Toby's mind, however. Down in his quarters he stared with fascination as the fish he had interestin'ly named Colonel Sucky Mouth began to glow a bright green, and its puppy dog eyes began pulsatin' in their sockets. The other fish swam nervously to the other side of the tank, for fish are always the first to smell danger. Suddenly, the exotic fish emitted a loud throbbin' squeal that seemed to carry out over the sea itself. Up on deck, the lookout rubbed his eyes then looked again. Had he really just seen that strange, dark shape pass under the bow of the boat? Little did he know that a monster

had been summoned from the murky depths.

That night, as the ship's bell rang out eleven o'clock, the first victim was claimed. The evening to that point had been calm, relaxing even. Most of the men had gathered in the conference hall to watch our musical society's production of "Grease." A production, I might add, for which I received great acclaim in the role of Rizzo. But the magic of that marvelous play was rent asunder when Ensign Goldner burst in and announced that the cook was dead. We rushed to the kitchen. At first all we could see was the spigot of the sink runnin' as if someone were washin' vegetables. But next to the sink was a sight most unappetizin'. There, lying on the floor, was the body of our beloved cook, sucked dry like a shriveled raisin. Nothin' left of him but skin, bones, and an Anna Sui strapless evening gown. What beastly creature could do such a thing?! Back in Toby's quarters, Colonel Sucky Mouth continued his siren call.

The next mornin' we searched for the cook's murderer. The bravest men searched the kitchen, while the less brave agreed to look around their rooms and in their pants pockets. One particularly cowardly party decided they better take the ship's helicopter and search some of those brothels back in Hong Kong. But no one found the creature. What was found instead was the body of Xavier McDaniels, shriveled bone dry despite being found in the shower, and the equally desiccated body of the ship's bilge operator Flowers O'Dooley. Fear gripped the sailors. Weeks from land, bein' attacked by an unknowable assailant, and not to mention completely lost. (I'd locked the navigator in the brig three days earlier for wearing culottes after Labor Day.) I had to find that creature, but how? That's when it hit me like a mizzenmast: the shower, the bilge pump, the kitchen sink... the creature was attackin' from the water supply!

Slowly, I lifted the hatch to the ship's giant water tank and peered inside. What I saw shivered every part of me timbers. 'Twas the female trench wraith, ghastly and huge, with teeth like swords and a mouth tube like a fire hose. Aye, she was the female, for all around her, attached to the sides of the tank, were large egg sacs, waitin' to be fertilized with the souls of our crew. With a shriek, the beast was upon me. Crashin' through the water tank, it flopped across the deck after me at an astounding pace. Arrgh, and I may have escaped, had I not been tryin' to outrun a demon in my Versace micro-mini and beige slingbacks by Nine West. With me backed against a wall, the trench wraith's evil suckin' tube began probing my neck, looking for the easiest access to my very soul. Suddenly, a voice came from the ship's rail, "Why settle for ground chuck when you can have filet mignon!" It was Toby! The suckin' tube slowly turned, sniffin' at the air until it pointed at Toby. "This is my fault! And now only I can save the ship!" I've said it before, and I'll say it again, that boy sure made excellent bait. In a shot, the wraith was upon Toby, suckin' his soul for all it was worth. But it was too late, Toby leapt off the rail with all his might, carryin' himself and the trench wraith into the churnin' waves below. As Toby fell, we could hear him yell, "Take care of Colonel Sucky Mooooooouuuuthhh!" Yes, he was a stupid, stupid boy.

When the weather outside is frightful, their tones are so delightful.

Perry Kodos and Nat Kang Cole's Yuletide Sing-Along

Perry Kodos recounts his holiday memories...

"Growing up as young larvae in the exotic land of…Ottawa, my sister and I never celebrated what you call 'Christmas.' However, it is remarkably similar to Lord Ozrap's Twelve Days of Terror, a cherished Ottawa tradition. While you have a red-suited man who enters your home spreading joy, our red-suited man spreads a skin-searing paste. You gather in groups to sing songs of what you call "love and friendship." We gather in groups to defend against Ozrap's throat-nesting wasp minions. The similarities are many. Thus we have recorded this holiday disc in the name of understanding between two cultures. Imagine how much smoother the assimilation will be when one of those cultures decides to violently overthrow and enslave the other. It is our holiday gift to you."

Including These Holiday Favorites:

"All Hail the Electronic Tree"
"Mouth Fight Under the Mistletoe"
"Here's Your Gift, Now What's For Me"
"Ding, Ding, Dong, Eliminate the Weak"
"I Saw Mommy Kiss a Replicant"

"Santa Kang Will Fill Your Socks"
"The Fruitcake Claims a Victim"
"It Is Time to Be Re-Nogged"
"An Obese Man Invaded My Soot Pipe"
"Hush Little Infant, You'll Make a Worthy Slave"

LITTLE SHOP OF HOMERS

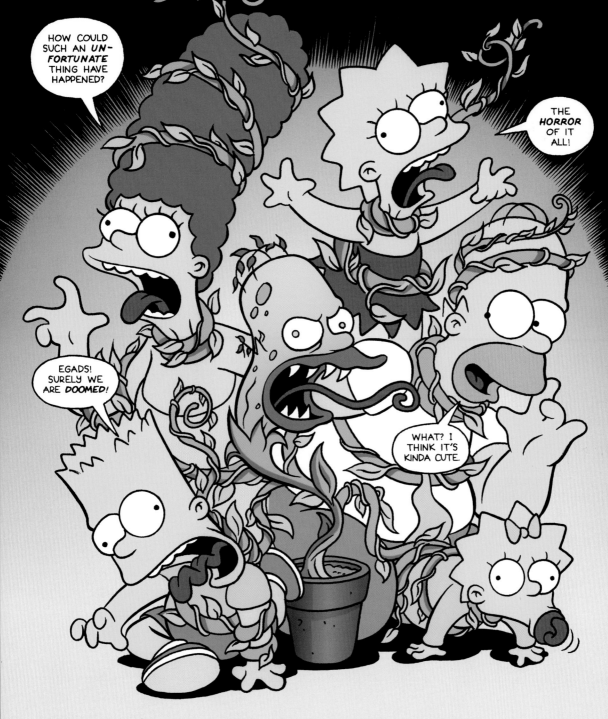

MIKE ALL-DEAD
STORY & INKS

LUIS ESCOBAR
SINISTER
BREAKDOWNS

BILL "SON OF
GODZILLA" MORRISON
PENCILS

MIKE "HEAD ON
PIKE" SAKAMOTO
LETTERING

LAURA ALL-BLED &
NATHAN "KILLER" KANE
COLORS

MOTLEY MATT
GROENING
MR. GREENJEANS

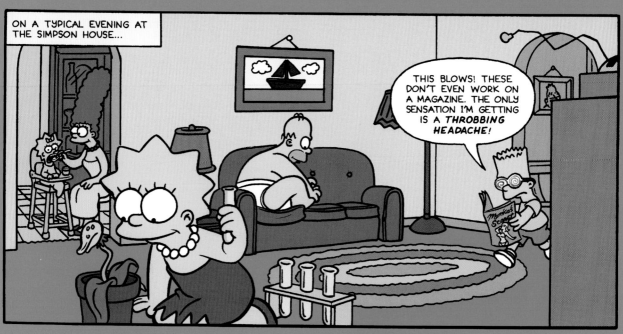

ON A TYPICAL EVENING AT THE SIMPSON HOUSE...

THIS BLOWS! THESE DON'T EVEN WORK ON A MAGAZINE. THE ONLY SENSATION I'M GETTING IS A *THROBBING HEADACHE!*

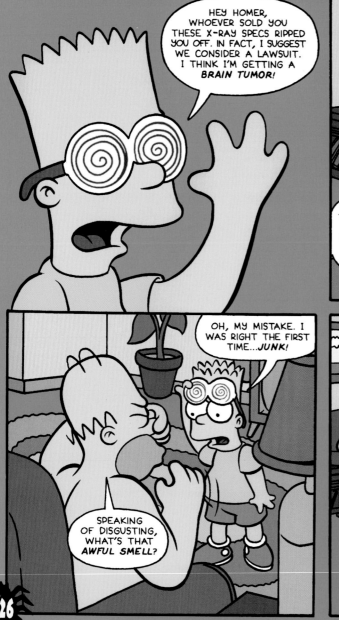

HEY HOMER, WHOEVER SOLD YOU THESE X-RAY SPECS RIPPED YOU OFF. IN FACT, I SUGGEST WE CONSIDER A LAWSUIT. I THINK I'M GETTING A *BRAIN TUMOR!*

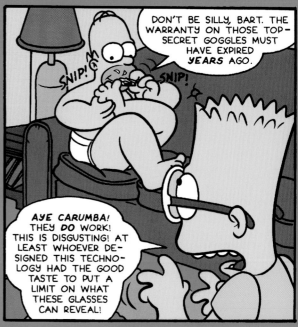

DON'T BE SILLY, BART. THE WARRANTY ON THOSE TOP-SECRET GOGGLES MUST HAVE EXPIRED *YEARS* AGO.

AYE CARUMBA! THEY *DO* WORK! THIS IS DISGUSTING! AT LEAST WHOEVER DE-SIGNED THIS TECHNO-LOGY HAD THE GOOD TASTE TO PUT A LIMIT ON WHAT THESE GLASSES CAN REVEAL!

OH, MY MISTAKE. I WAS RIGHT THE FIRST TIME...*JUNK!*

SPEAKING OF DISGUSTING, WHAT'S THAT *AWFUL SMELL?*

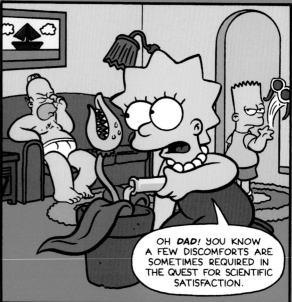

OH *DAD!* YOU KNOW A FEW DISCOMFORTS ARE SOMETIMES REQUIRED IN THE QUEST FOR SCIENTIFIC SATISFACTION.

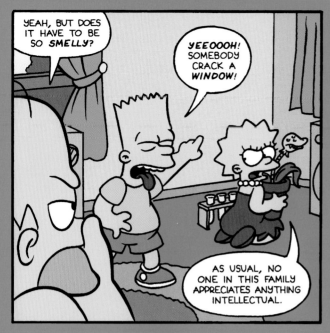

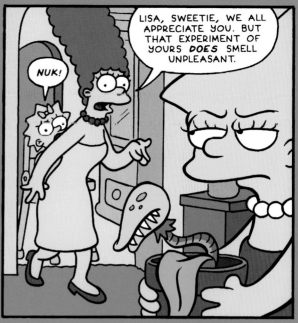

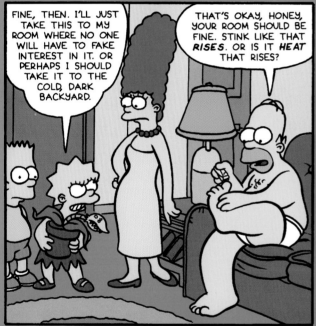

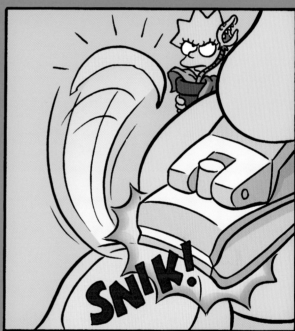

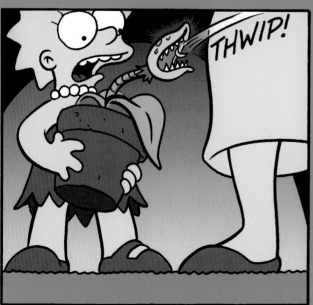

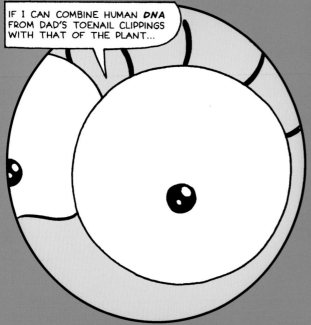

IF I CAN COMBINE HUMAN *DNA* FROM DAD'S TOENAIL CLIPPINGS WITH THAT OF THE PLANT...

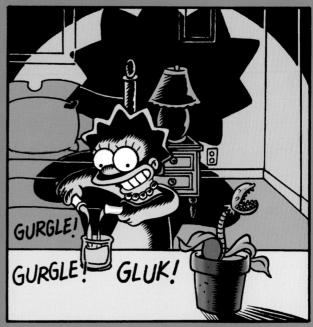

GURGLE!

GURGLE! GLUK!

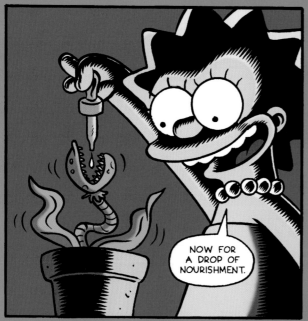

NOW FOR A DROP OF NOURISHMENT.

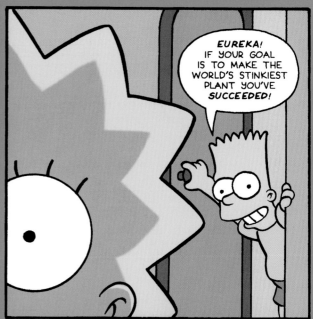

EUREKA! IF YOUR GOAL IS TO MAKE THE WORLD'S STINKIEST PLANT YOU'VE *SUCCEEDED!*

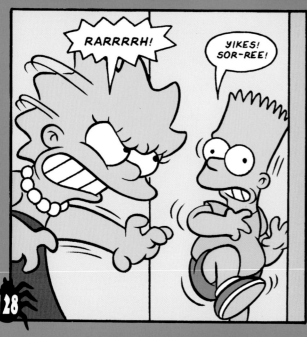

RARRRRH!

YIKES! SOR-REE!

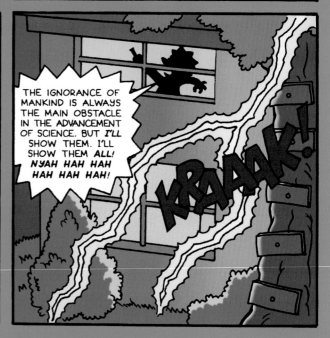

THE IGNORANCE OF MANKIND IS ALWAYS THE MAIN OBSTACLE IN THE ADVANCEMENT OF SCIENCE. BUT *I'LL* SHOW THEM. I'LL SHOW THEM *ALL! NYAH HAH HAH HAH HAH HAH!*

KRAAAK!

THE NEXT MORNING...

LISA, HONEY, TIME TO GET UP AND GET READY FOR SCHOOL!

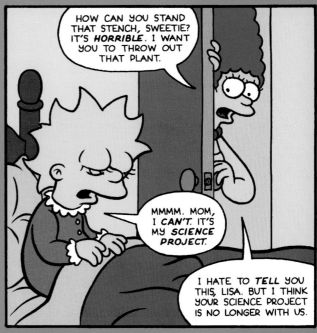

HOW CAN YOU STAND THAT STENCH, SWEETIE? IT'S *HORRIBLE*. I WANT YOU TO THROW OUT THAT PLANT.

MMMM. MOM, I *CAN'T*. IT'S MY *SCIENCE PROJECT*.

I HATE TO *TELL* YOU THIS, LISA. BUT I THINK YOUR SCIENCE PROJECT IS NO LONGER WITH US.

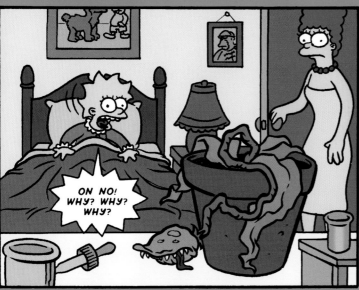

OH NO! WHY? WHY? WHY?

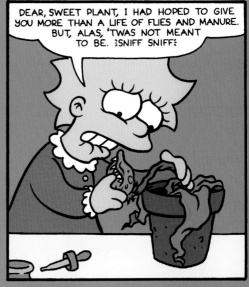

DEAR, SWEET PLANT, I HAD HOPED TO GIVE YOU MORE THAN A LIFE OF FLIES AND MANURE. BUT, ALAS, 'TWAS NOT MEANT TO BE. ⸮SNIFF SNIFF⸽

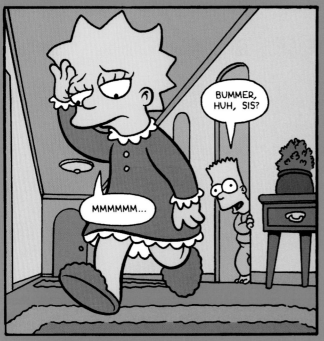

BUMMER, HUH, SIS?

MMMMMM...

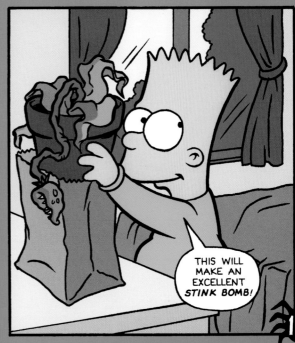

THIS WILL MAKE AN EXCELLENT *STINK BOMB!*

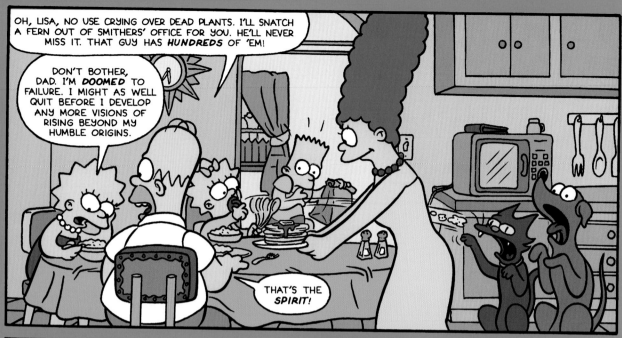

OH, LISA, NO USE CRYING OVER DEAD PLANTS. I'LL SNATCH A FERN OUT OF SMITHERS' OFFICE FOR YOU. HE'LL NEVER MISS IT. THAT GUY HAS *HUNDREDS* OF 'EM!

DON'T BOTHER, DAD. I'M *DOOMED* TO FAILURE. I MIGHT AS WELL QUIT BEFORE I DEVELOP ANY MORE VISIONS OF RISING BEYOND MY HUMBLE ORIGINS.

THAT'S THE *SPIRIT!*

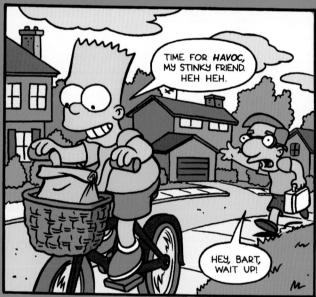

TIME FOR *HAVOC*, MY STINKY FRIEND. HEH HEH.

HEY, BART, WAIT UP!

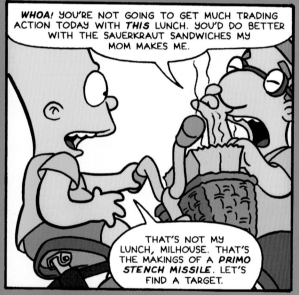

WHOA! YOU'RE NOT GOING TO GET MUCH TRADING ACTION TODAY WITH *THIS* LUNCH. YOU'D DO BETTER WITH THE SAUERKRAUT SANDWICHES MY MOM MAKES ME.

THAT'S NOT MY LUNCH, MILHOUSE. THAT'S THE MAKINGS OF A *PRIMO STENCH MISSILE*. LET'S FIND A TARGET.

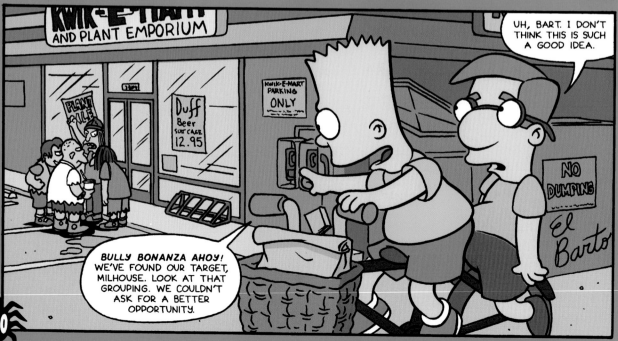

UH, BART. I DON'T THINK THIS IS SUCH A GOOD IDEA.

BULLY BONANZA AHOY! WE'VE FOUND OUR TARGET, MILHOUSE. LOOK AT THAT GROUPING. WE COULDN'T ASK FOR A BETTER OPPORTUNITY.

KWIK-E-MART AND PLANT EMPORIUM

PLANT SALE

Duff Beer SUIT CASE 12.95

KWIK-E-MART PARKING ONLY

NO DUMPING

El Barto

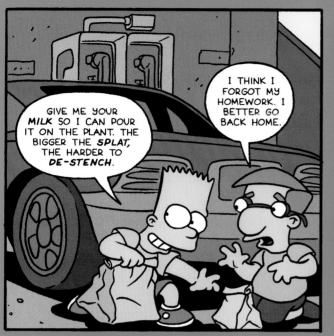

GIVE ME YOUR *MILK* SO I CAN POUR IT ON THE PLANT. THE BIGGER THE *SPLAT*, THE HARDER TO *DE-STENCH*.

I THINK I FORGOT MY HOMEWORK. I BETTER GO BACK HOME.

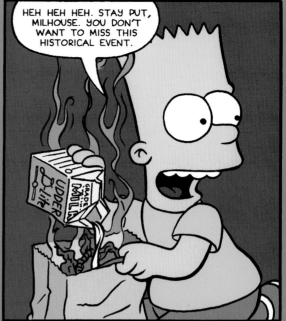

HEH HEH HEH. STAY PUT, MILHOUSE. YOU DON'T WANT TO MISS THIS HISTORICAL EVENT.

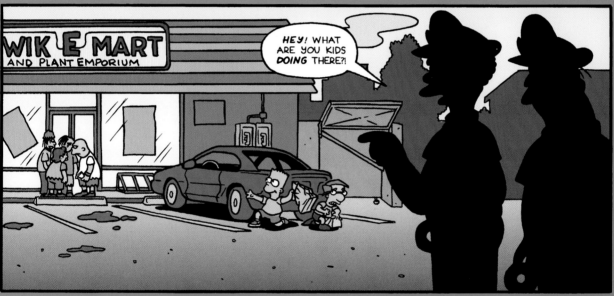

WIK E MART
AND PLANT EMPORIUM

HEY! WHAT ARE YOU KIDS *DOING* THERE?!

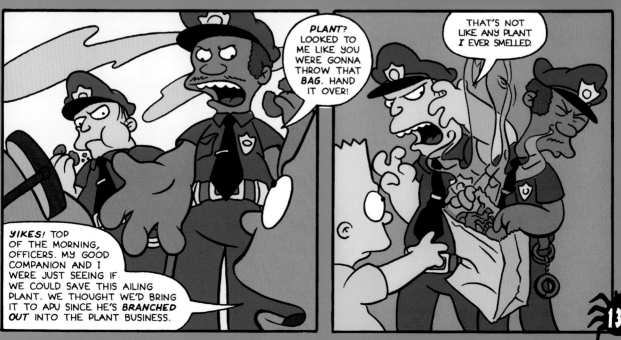

PLANT? LOOKED TO ME LIKE YOU WERE GONNA THROW THAT *BAG*. HAND IT OVER!

THAT'S NOT LIKE ANY PLANT *I* EVER SMELLED.

YIKES! TOP OF THE MORNING, OFFICERS. MY GOOD COMPANION AND I WERE JUST SEEING IF WE COULD SAVE THIS AILING PLANT. WE THOUGHT WE'D BRING IT TO APU SINCE HE'S *BRANCHED OUT* INTO THE PLANT BUSINESS.

131

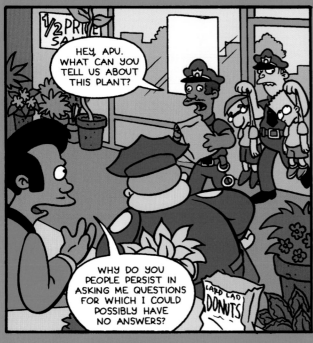

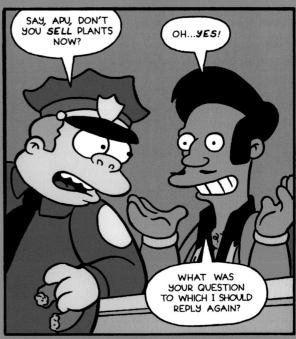

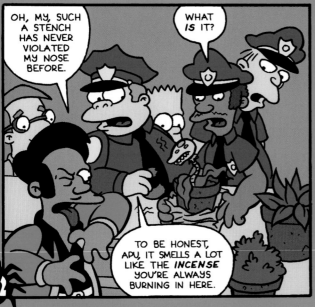

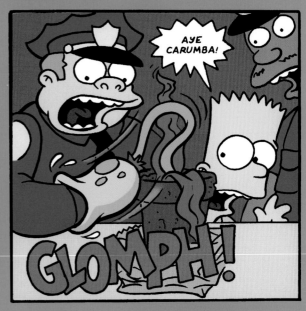

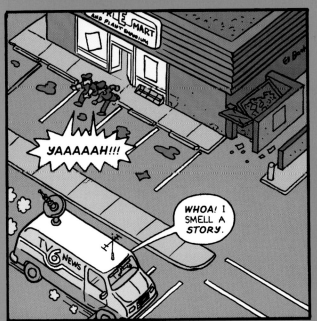

YAAAAAH!!!

WHOA! I SMELL A STORY.

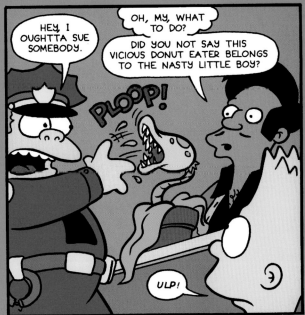

HEY, I OUGHTTA SUE SOMEBODY.

OH, MY, WHAT TO DO? DID YOU NOT SAY THIS VICIOUS DONUT EATER BELONGS TO THE NASTY LITTLE BOY?

PLOOP!

ULP!

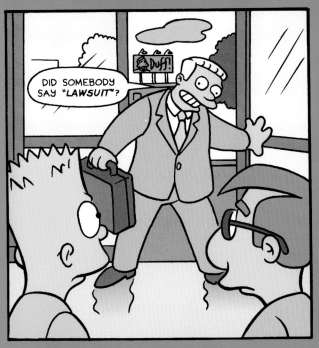

DID SOMEBODY SAY "LAWSUIT"?

≤GULP≥ BOY, ARE YOU IN TROUBLE, BART!

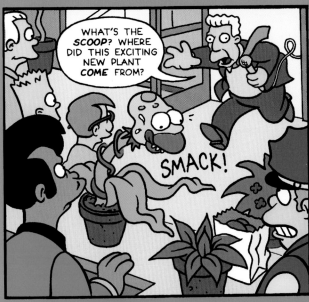

WHAT'S THE SCOOP? WHERE DID THIS EXCITING NEW PLANT COME FROM?

SMACK!

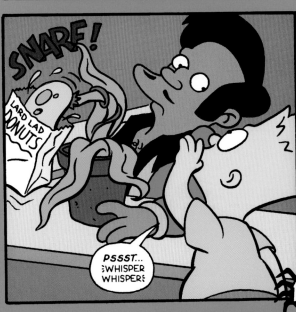

SNARF!

LARD LAD DONUTS

PSSST... ≤WHISPER WHISPER≥

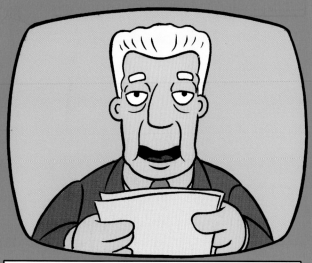

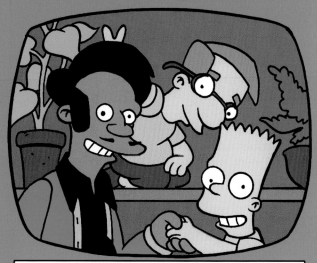

ON THE WAY TO A RUN-OF-THE-MILL *MELTDOWN* STORY AT THE SPRINGFIELD NUCLEAR PLANT, I WAS FORTUNATE ENOUGH TO RUN ACROSS THE FOLLOWING EXCITING STORY...

BART SIMPSON, A BOY GENIUS AND HORTICULTURIST EXTRAORDINAIRE, INTRODUCED HIS LATEST SUCCESS AT APU NAHASAPEEMAPETILON'S KWIK-E-MART AND PLANT SHOP -- AN INCREDIBLE *DONUT-EATING PLANT.*

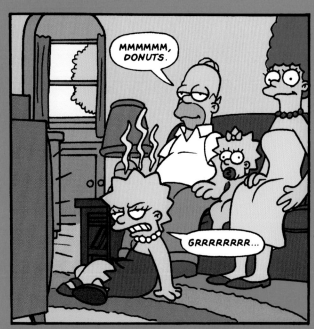

MMMMMM, DONUTS.

GRRRRRRR...

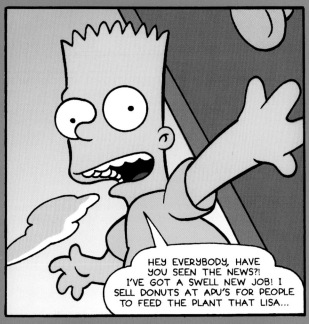

HEY EVERYBODY, HAVE YOU SEEN THE NEWS?! I'VE GOT A SWELL NEW JOB! I SELL DONUTS AT APU'S FOR PEOPLE TO FEED THE PLANT THAT LISA...

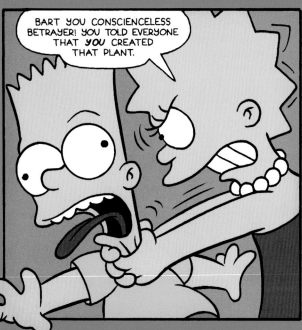

BART YOU CONSCIENCELESS BETRAYER! YOU TOLD EVERYONE THAT *YOU* CREATED THAT PLANT.

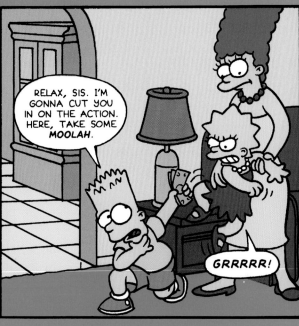

RELAX, SIS. I'M GONNA CUT YOU IN ON THE ACTION. HERE, TAKE SOME *MOOLAH.*

GRRRRR!

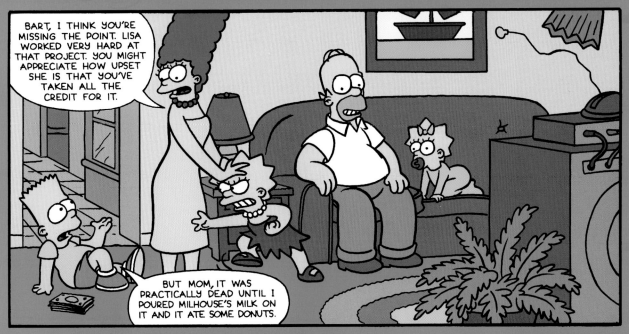

BART, I THINK YOU'RE MISSING THE POINT. LISA WORKED VERY HARD AT THAT PROJECT. YOU MIGHT APPRECIATE HOW UPSET SHE IS THAT YOU'VE TAKEN ALL THE CREDIT FOR IT.

BUT MOM, IT WAS PRACTICALLY DEAD UNTIL I POURED MILHOUSE'S MILK ON IT AND IT ATE SOME DONUTS.

HMMMM... PERHAPS I'VE BEEN TOO QUICK TO JUDGE. OFTENTIMES A *SIMPLE ACCIDENT* CAN BRING ABOUT THE REQUIRED BREAKTHROUGH. MAYBE BART *IS* DESERVING OF HIS CREDIT.

I HOPE YOU'LL FORGIVE ME, BROTHER. I *HAD* GIVEN UP ON THE PROJECT. YOU DESERVE ANY SUCCESS YOU GET FROM THIS ENDEAVOR.

GEE, THANKS, LISA. I'LL STILL GIVE YOU A PERCENTAGE.

OH, HOMEY. ISN'T THIS SWEET?

SHHHH, MY FAVORITE COMMERCIAL IS ON.

...WHEN THINGS SEEM QUEER, LAY RIGHT BACK AND DRINK *DUFF BEER*...

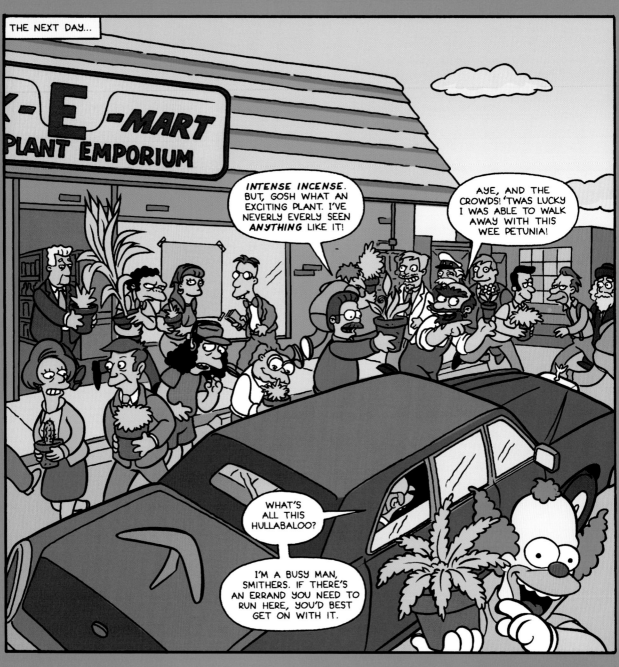

THE NEXT DAY...

K-E-MART PLANT EMPORIUM

INTENSE INCENSE. BUT, GOSH WHAT AN EXCITING PLANT. I'VE NEVERLY EVERLY SEEN *ANYTHING* LIKE IT!

AYE, AND THE CROWDS! 'TWAS LUCKY I WAS ABLE TO WALK AWAY WITH THIS WEE PETUNIA!

WHAT'S ALL THIS HULLABALOO?

I'M A BUSY MAN, SMITHERS. IF THERE'S AN ERRAND YOU NEED TO RUN HERE, YOU'D BEST GET ON WITH IT.

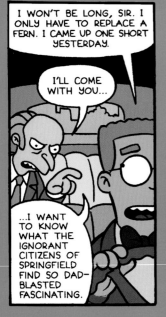

I WON'T BE LONG, SIR. I ONLY HAVE TO REPLACE A FERN. I CAME UP ONE SHORT YESTERDAY.

I'LL COME WITH YOU...

...I WANT TO KNOW WHAT THE IGNORANT CITIZENS OF SPRINGFIELD FIND SO DAD-BLASTED FASCINATING.

BLUE LIGHT SPECIAL AT S-MART. BE SMART, SHOP S-MART!

THAT DID THE TRICK!

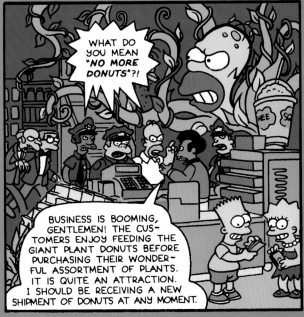

WHAT DO YOU MEAN "NO MORE DONUTS"?!

BUSINESS IS BOOMING, GENTLEMEN! THE CUSTOMERS ENJOY FEEDING THE GIANT PLANT DONUTS BEFORE PURCHASING THEIR WONDERFUL ASSORTMENT OF PLANTS. IT IS QUITE AN ATTRACTION. I SHOULD BE RECEIVING A NEW SHIPMENT OF DONUTS AT ANY MOMENT.

POP! POP! POP!

WHEW!

THANK THE HEAVENS!

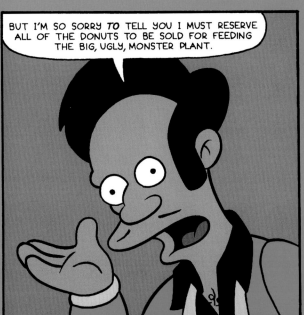

BUT I'M SO SORRY *TO* TELL YOU I MUST RESERVE ALL OF THE DONUTS TO BE SOLD FOR FEEDING THE BIG, UGLY, MONSTER PLANT.

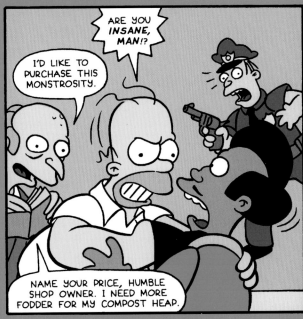

ARE YOU *INSANE,* MAN!?

I'D LIKE TO PURCHASE THIS MONSTROSITY.

NAME YOUR PRICE, HUMBLE SHOP OWNER. I NEED MORE FODDER FOR MY COMPOST HEAP.

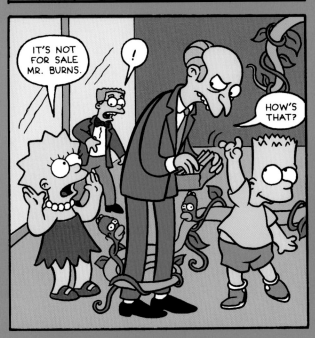

IT'S NOT FOR SALE MR. BURNS.

!

HOW'S THAT?

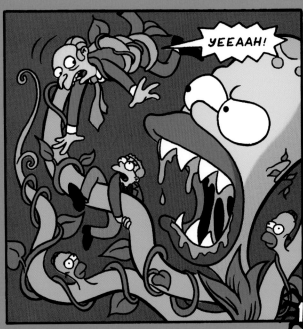

YEEAAH!

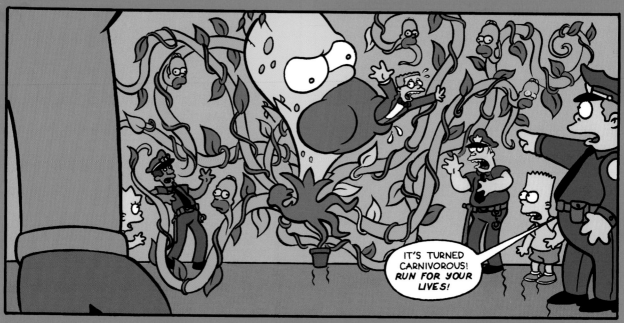

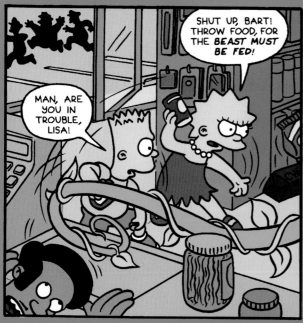

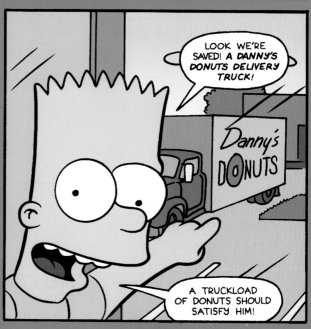

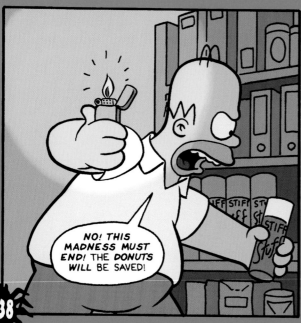

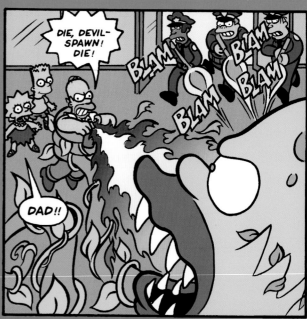

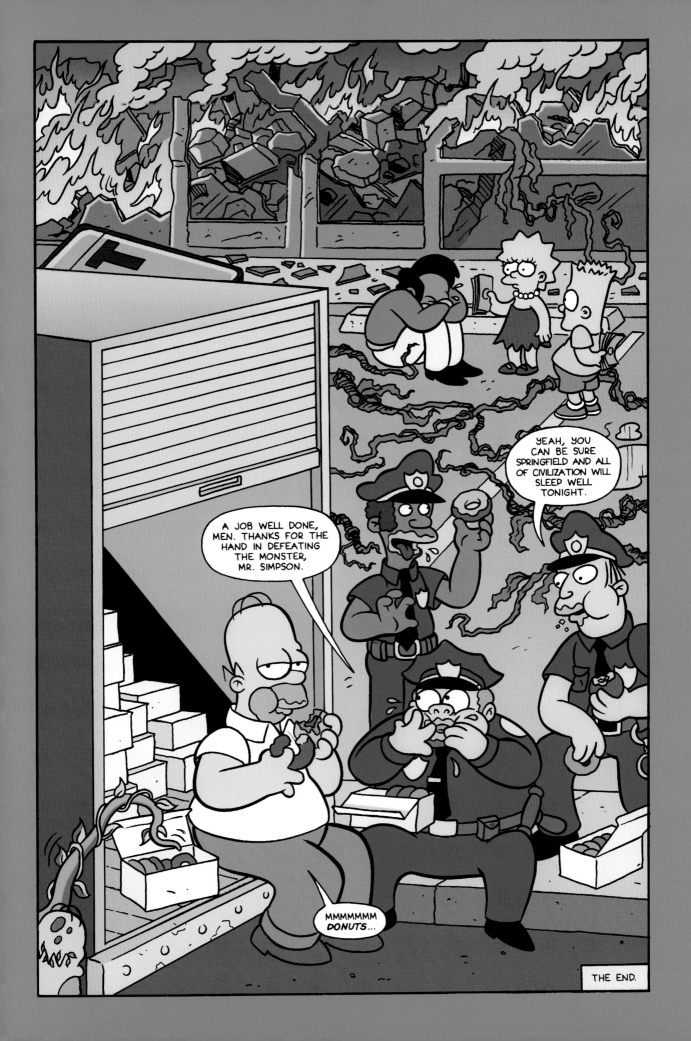

THE END.

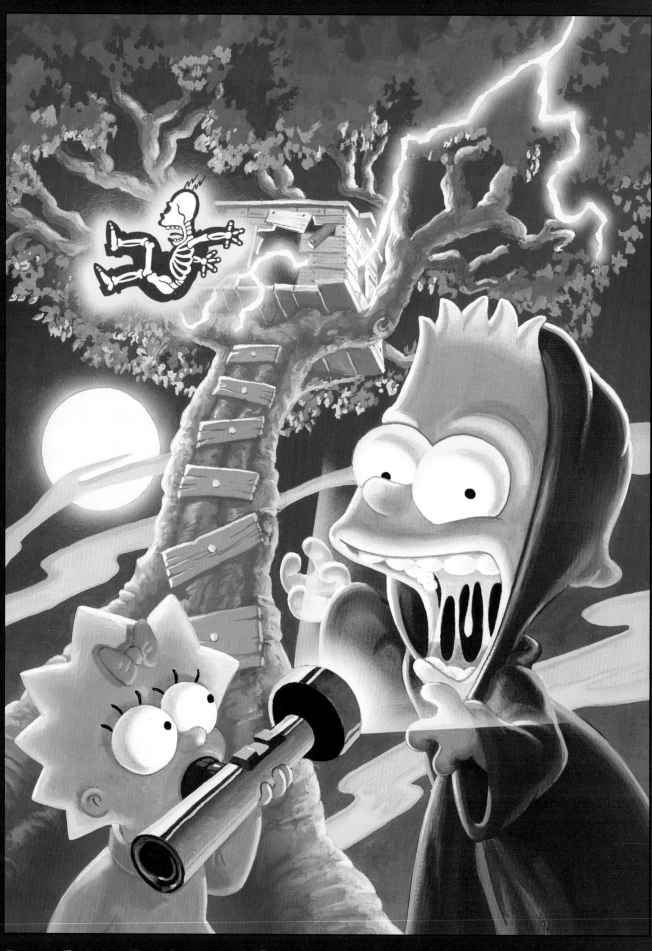

Cover Art to *Treehouse of Horror* #1

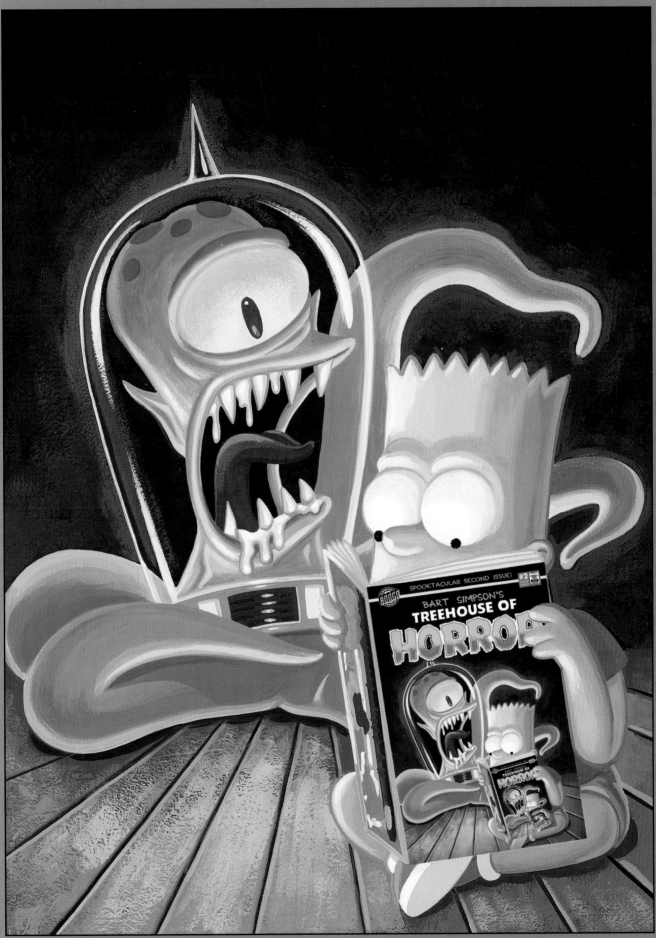

Cover Art to *Treehouse of Horror #2*

Cover Art to *Treehouse of Horror* #3